HUDSON RIVER VALLEY FARMS

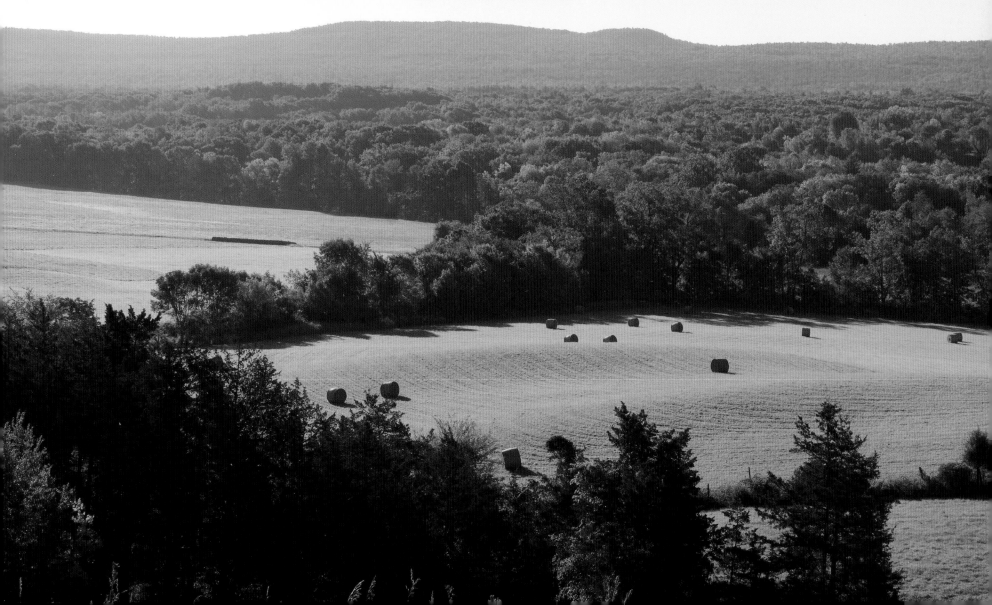

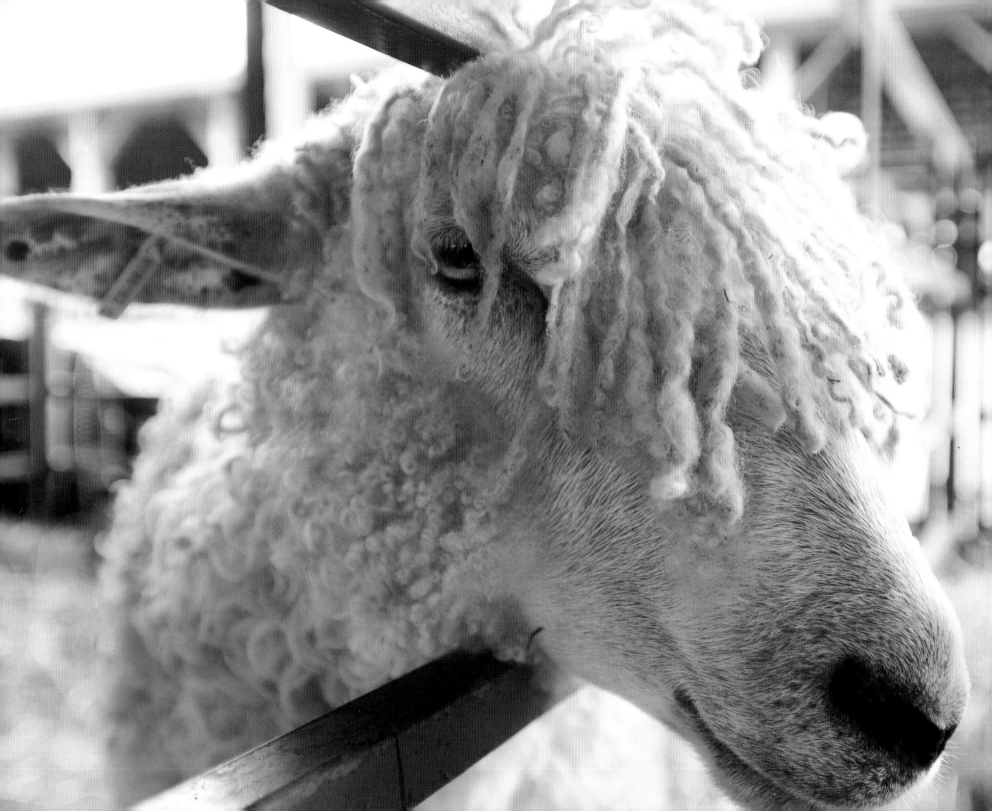

HUDSON RIVER VALLEY
FARMS

THE PEOPLE AND THE PRIDE BEHIND THE PRODUCE

JOANNE MICHAELS

Photographs by Rich Pomerantz

With an introduction by U.S. Congressman Maurice D. Hinchey

gpp®

Guilford, Connecticut

All photographs © Rich Pomerantz
Project manager: Jessica Haberman
Text design: Sheryl P. Kober
Layout: Melissa Evarts
Map by M.A. Dubé © Morris Book Publishing, LLC

Library of Congress Cataloging-in-Publication Data

Michaels, Joanne, 1950-
Hudson River Valley farms : the people and the pride behind the produce / Joanne Michaels ;
introduction by Maurice Hinchey ; photographs by Rich Pomerantz.
p. cm.
ISBN 978-0-7627-4892-1
1. Farms—Hudson River Valley (N.Y. and N.J.) 2. Farms—Hudson River Valley (N.Y. and N.J.)—Pictorial works.
3. Farmers—Hudson River Valley (N.Y. and N.J.) 4. Farmers—Hudson River Valley (N.Y. and N.J.)—Pictorial works.
I. Pomerantz, Rich. II. Title.
S451.N56M53 2009
630.9747—dc22
2009003198

Printed in China
10 9 8 7 6 5 4 3 2 1

For Erik, and his generation, who will inherit the land, as well as the joys and mysteries that go along with it . . .

—JM

Dedicated with love to Celia and Sara
—RP

Let us never forget that the cultivation of the earth is the most important labor of man. Until he gives up the chase and fixes himself in some place, and seeks a living from the earth, he is a roaming barbarian. When tillage begins, other arts follow. The farmers, therefore, are the founders of civilization.

—Daniel Webster

The farmer is the only person in our economy who buys everything retail, sells everything wholesale, and pays the freight both ways.

—John F. Kennedy

CONTENTS

INTRODUCTION

*A*s an advocate for sustaining American agriculture, in particular the protection of the family farm, and a fellow Hudson River Valley enthusiast, I was thrilled to hear Joanne Michaels would be writing a book about the local farms of the region. It is my hope that this publication will impart to its readers a better understanding of the natural resources the Hudson Valley has to offer, as well as a greater appreciation and incentive to support what is being locally grown. *Hudson River Valley Farms* is a celebration of the wealth and abundance cultivated in the soil along the Hudson River.

The renowned Hudson River Valley has long been captivating peoples' hearts with its rich history, natural wonders, and vibrant culture. Farming has been deeply rooted in the heritage of this historic region. Agriculture has played a vital role in the development of the area since its earliest settlements. Today the Hudson River Valley continues to be home to a devoted farming community, producing a variety of goods including everything from hay and honey to fresh produce and dairy products.

The rural beauty of the Hudson River Valley has not gone unrecognized; it has been the creative muse for countless artists past and present. Farming is no exception when it comes to enhancing the splendor of the region. Vegetables, all in perfect rows, grow as far as the eye can see; greenhouses are filled with eye-catching flowers of beautiful varieties; and cows dot the green countryside. These stunning and dramatic images add to the rustic beauty that makes the region such an attractive one.

The farmers market, a long-standing regional tradition, gives people the opportunity to come together while learning more about their neighbors and the cornucopia of goods the Hudson River Valley has to offer. There is no question of the addition this makes to the cultural affluence of the area. Just-picked, locally grown produce is available direct from the farmer, guaranteeing the freshest, best-tasting food.

Due to the bounty of produce grown in the region, an array of fine restaurants has emerged in the Hudson River Valley. The excellent livestock, along with various organic options, is enticing to any chef desiring to offer high-quality creations. Locals are lucky to have the ability to benefit from farm fresh goods not only when they eat in but also when they dine out.

The natural wealth of fertile countryside within the Hudson River Valley brings numerous benefits to this breathtaking region. It is important that we do not let the farms of the Hudson disappear; they remain an important part of the local and regional community and there is much to gain from their presence. While there has been a recent renaissance in small farming in the Hudson River Valley, it is vital that we protect these assets as we would any other resource that profits the region. Like the majestic Catskill Mountains or the stunning Hudson River, farms play an invaluable role in our bountiful landscape. With support from the community, these farms will have the opportunity they deserve to flourish.

This book is not only a tribute to the farms that have enhanced our area but also recognition of the farmers who make it all possible. Without their passion and hard work, our area would be at a serious disadvantage. Because of their efforts, our community can enjoy the benefits of having locally grown, fresh goods of the highest quality.

Hudson River Valley Farms is a tribute to the bountiful lands of the Hudson Valley. It is wonderful that the benefits of agriculture in the region are being documented in a book, enlightening readers about the fantastic effects farming has on the area. From the farmers who ardently tend their fields and livestock, to the new restaurants producing savory dishes made from local fare, farming has brought with it countless advantages to the communities in the Hudson River Valley. Agriculture has added both to the pastoral beauty of the area and to the enhancement of the local culture and economy. This book is a moving portrayal of the magnificent farms and farmers of the Hudson River Valley.

—U.S. Congressman Maurice D. Hinchey

PREFACE

As the author of two guidebooks to the Hudson River Valley, I continually travel throughout this scenic historic region. On my trips I rarely fail to purchase some fresh fruit and vegetables at a local farmers market. The flavor is dramatically better than the taste of produce shipped across the country over days in refrigerated trucks. And once I became accustomed to farm fresh food, it was difficult to enjoy ordinary supermarket fare again.

Over the years, as I drove around the Valley, I passed through stretches of pastoral countryside, often seeing herds of cows at the side of the road, acres of apple orchards, silos bursting with corn, and tractors moving in the distance. I grew curious about the people behind the crops and machinery. Just who was out there? How did they decide to farm? What challenges have they faced now that agribusiness has largely taken over food production in America? I realized agriculture was part of life in the Hudson River Valley that I had not yet explored.

And so I set out on a journey that has taken me from Congers, Sleepy Hollow country, and Pine Island, to Ghent, Preston Hollow, and Castleton-on-Hudson. The forty-four farms included here are representative of hundreds of others I wish I could have visited, but time would not permit. The book follows the Hudson River from the south (Rockland and Westchester Counties), north to the Albany/Rensselaer County region.

Interestingly, few farms are located along the Hudson River. After Hendrik Hudson's exploration in 1609, and the English colonization in the latter part of the seventeenth century, acres of land along the river were granted to wealthy nobles. Farming burgeoned, and for centuries, life on these farms remained self-sustaining and relatively unchanged.

In the mid-1970s, with the advent of agribusiness, the price of milk dramatically plummeted. Many of the farms I visited that had been dairy operations were now transformed into diverse businesses. Out of necessity, dairy farmers were forced to make changes; the alternative was to sell off their acreage to developers.

The owners of some farms took a risk: They began to grow organic produce as well as raise free-range chickens and hormone-free livestock. In recent years they have watched their market grow as the number of people in quest of high-quality milk, cheese, meat, and produce has increased dramatically. These business owners figured out how to maximize their profits from their new niche. Often this has meant leaving their farms and going where the market is—whether it's to Manhattan, Brooklyn, or a parking lot by the local train station. Local farming seems to be reverting back to a somewhat old-fashioned way of doing things. As one farmer pointed out: Organic methods have been used since the beginning of time—before pesticides and chemicals were invented!

I hope this book sparks the curiosity of readers to know their farmers and find out where their food comes from. The idea of eating locally grown foods is particularly appealing, so I included a directory of farmers markets to make shopping directly from local farms easier. Some businesses, including Grazin' Angus, Ronnybrook Farm, and Hahn Farm, have retail outlets on their premises.

In the spirit of agri-tourism, I hope readers will discover new places to visit, like the Rogowski Farm in the Black Dirt region (Orange County) and the Stone Barns Center for Food and Agriculture in Pocantico Hills (Westchester County)—two strikingly different farms. I sincerely hope these small slices of farm life pique your interest and lead you on as fascinating a journey as I have experienced—to the heart of our region, as well as to the center of our existence. The farmers I encountered during my research are fascinating, maverick entrepreneurs as well as creative, grounded individuals.

Local food tastes better because it is better. When you choose to purchase this superior produce, you benefit local families as well as your entire community. Giving local farmers your business preserves open space and the wildlife within it. There is no better investment in our future in the Hudson River Valley.

—Joanne Michaels

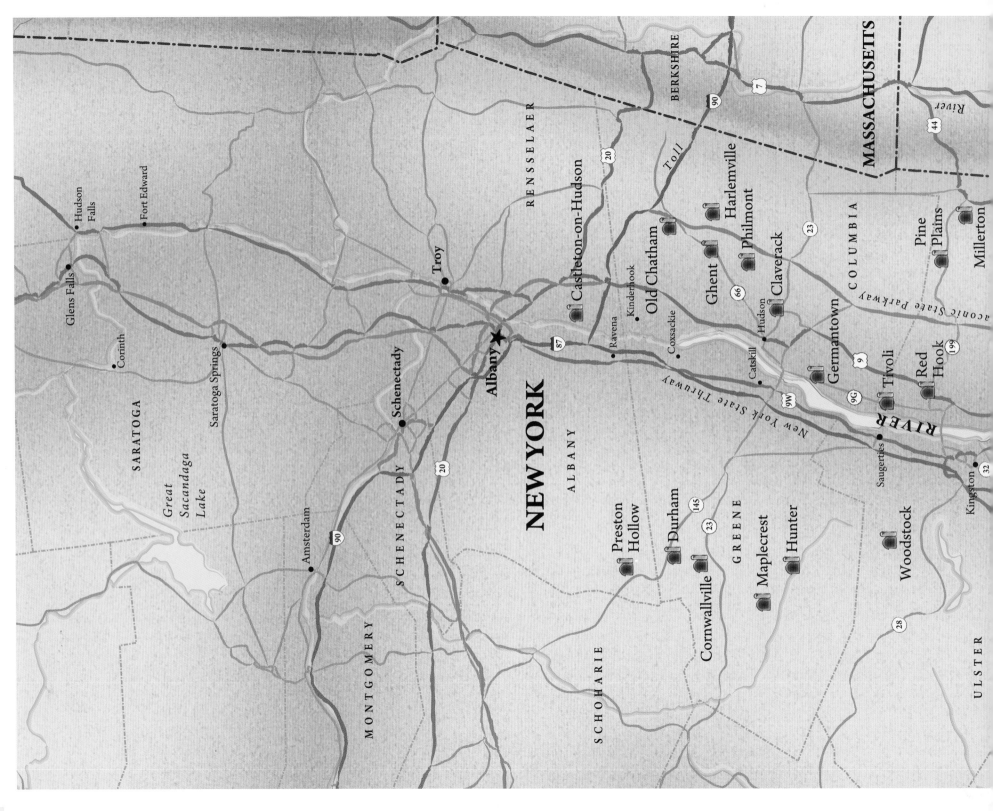

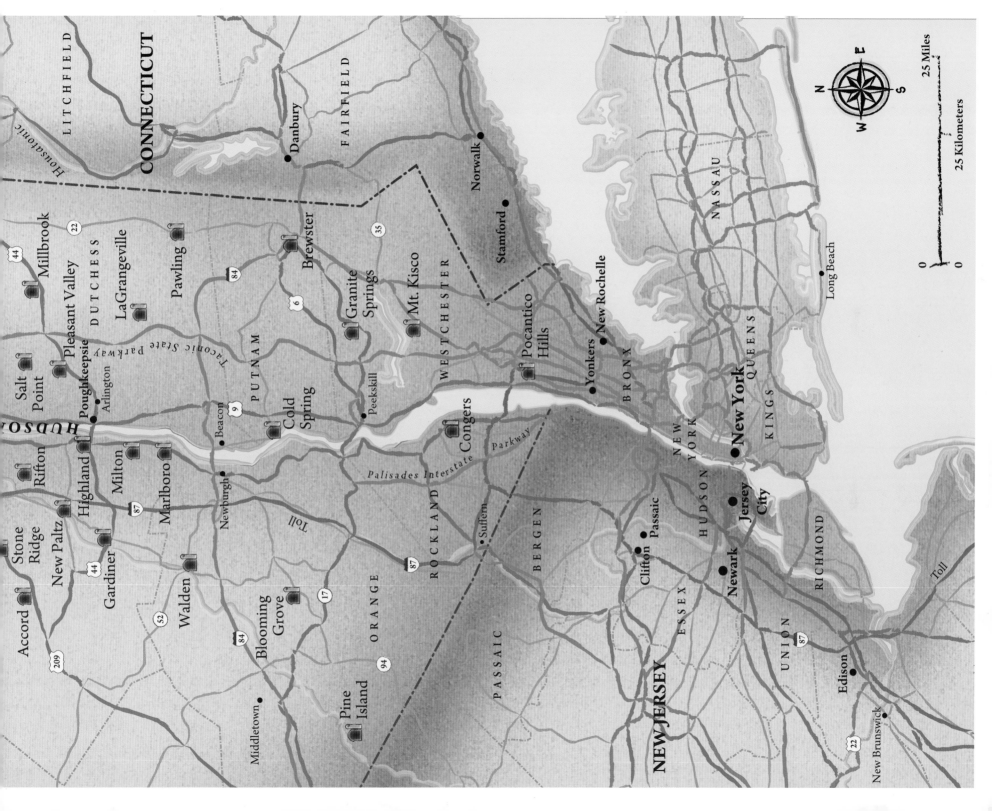

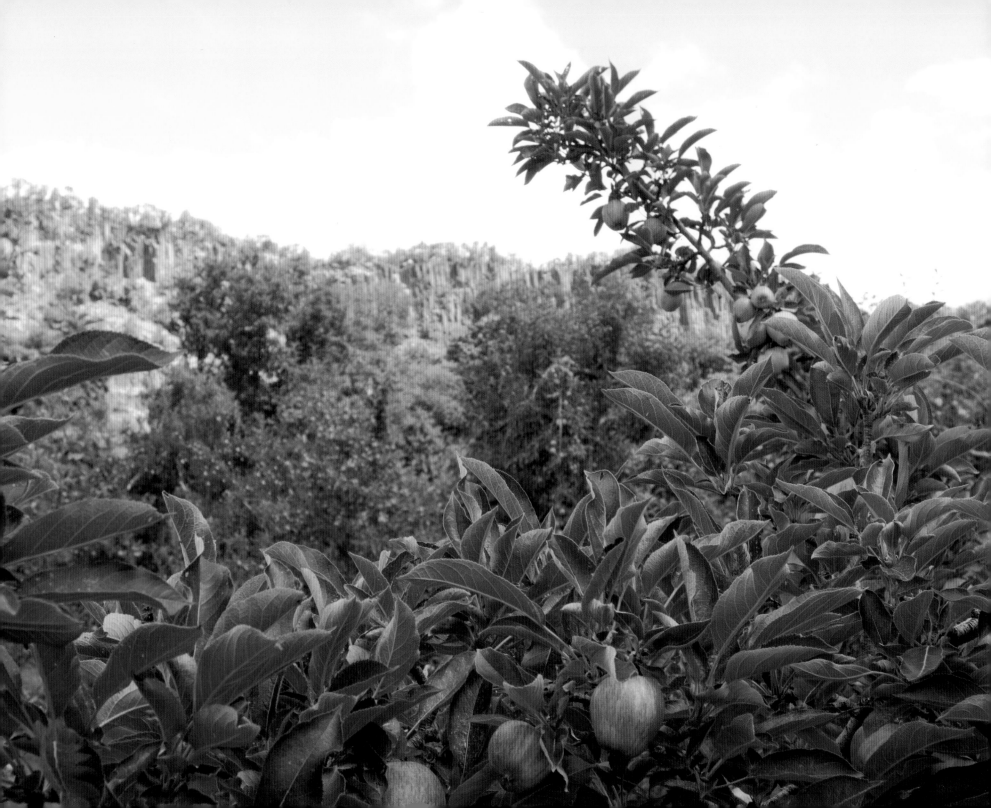

DR. DAVIES FARM Congers, Rockland County

"I've made a living by what I get from the land, but I've made a life from what I've given back to the community."

"I was born in this house seventy-seven years ago," Niles Davies Jr. told me in the family's cozy kitchen. "I've had two heart surgeries and survived colon and prostate cancer, and I still do most of the tractor work." Niles, an imposing presence, is the patriarch of an impressive family, as well as a man who is delightfully forthright.

The farm is named for his grandmother. "Dr. Lucy Meriweather Davies delivered over six thousand babies in Rockland County—and she was a strawberry farmer as well," Niles told me. A descendant of Meriweather Lewis of the Lewis and Clark expedition, Lucy married Arthur Davies, a well-known artist, in 1891, and they bought the home we were sitting in for $6,500. At the time, the farm consisted of thirty-eight acres, a two-story farmhouse, and a barn.

Niles is proud of his heritage, including the fact that his grandfather was president of the American Artists and Sculptors; they organized the 1913 Armory Show in Manhattan where Picasso, Degas, and Matisse were first exhibited to the American public. When Niles graduated from Cornell in 1952 and went into the family business, there were approximately five hundred farms in Rockland County.

Today there are four thousand apple trees, thirty-five acres of vegetables, and two farm stands on the Dr. Davies Farm. Cider is pressed and hayrides are offered during apple-picking season. "We had to adapt to the changing market," Niles explained. "Once we were wholesale only; now pick-your-own and cider are major sources of income." The Davies now retail most of their corn crop, and school groups from all over Rockland County come to pick apples. "The retail aspect has kept us going," Niles remarked, going on to mention they are one of only two farms remaining in Rockland County.

The government has taken land from the farm under eminent domain a few times: when building Route 304, then for sewer construction, and a third time for a reservoir. "It's difficult to resist selling the property; our land was recently appraised at $400,000 per acre," Niles revealed, pleased his family has done its part to maintain open land in Rockland County.

Niles serves on the board of both the Rockland Center of the Arts and the Helen Hayes Hospital. "I've made a living by what I get from the land, but I've made a life by what I've given back to the community," he said. In 2007 the Davies donated about seven acres of prime land in Congers to Rockland Center of the Arts. "It's an outright gift with no tax benefits," he added.

After visiting the Davies farm, it was evident Jan and Niles incorporated their philosophy of generosity into life in the county. When I asked if he soon planned to retire, Niles replied with conviction: "The farm will go on," explaining that he has had good reason to make changes in his busy existence but has chosen to continue working. "I've had every disease there is and I still run the place!"

A seasonal worker from Jamaica, who has worked for the Davies family for ten years, collects tomatoes. *Opposite page: a* dramatic rock cliff provides a backdrop for the apple orchard.

STONE BARNS CENTER FOR FOOD AND AGRICULTURE

Pocantico Hills, Westchester County

"Our goal is to spark interest in people and get them involved with the farm so they return on a regular basis."

*U*pon arrival here, one sees the landmark stone barns, lush English gardens in full flower (if you are lucky enough to visit during summertime), a spectacular greenhouse, and vegetable fields bursting with an array of crops. The entire scene is reminiscent of an idyllic farm from another age. But a closer look reveals this picturesque operation is intertwined with technology as well as sustainability and organic farm practices.

For almost a century, the land here was part of the Rockefeller family estate. In an effort to modernize his family farm, during the 1930s, John D. Rockefeller Jr. commissioned architect Grosvenor Atterbury to design a complex of stone farm buildings. Frederick Law Olmsted also contributed to the endeavor. Later on, in the 1970s, Peggy Rockefeller, wife of David Rockefeller, became involved in farming and raising cattle here. After her death in 1996, her husband carried out her wish to preserve and restore the stone barns. Five years later, in 2001, he gave the buildings and eighty acres of land to the nonprofit Stone Barns Restoration Corporation. The Center opened to the public in 2004 and is supported by memberships, foundation grants, and corporate donations, as well as sales from the cafe and farm store.

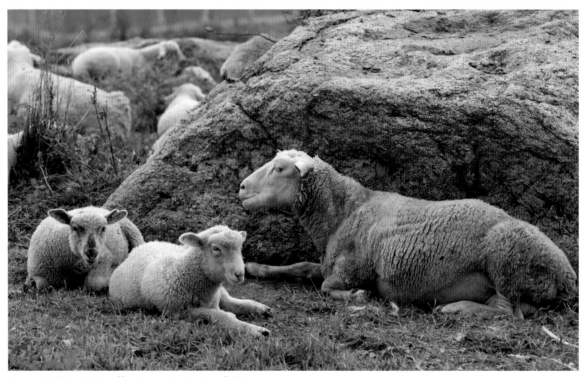

A ewe with her two offspring relaxing in a field.

Erica Helms, managing director of the Center, took me on a tour with the head of livestock operations, Craig Haney. Traveling in a golf cart–like vehicle along a path through the woods, our first stop was to visit the Berkshire pigs. While the sheep, geese, and chickens roam freely and are moved every day to a different pasture locale, the pigs live in a controlled environment. I couldn't help but wonder if that difference affected the taste of the pork. "Our mission is not just about raising animals for the restaurant here," Craig emphasized. "The goal is to spark interest in people and get them involved with

the farm so they return on a regular basis." To that end the Center reaches out through workshops, lectures, and school programs and as a gathering place for the exchange of ideas between farmers.

The mission of Stone Barns is to be as self-sufficient as possible using what is generated on the farm. They have successfully meshed traditional agricultural practices with modern technologies, including a computer-monitored greenhouse environment and movable electric fencing.

The cart we rode in was powered by biodiesel made from kitchen grease processed with methane and lye, an alternative fuel system set up and maintained on the premises by Jack Algiere, manager of the fruit and vegetable operation at the farm. He explained how forty-two gallons are made at one time, costing only seventy-five cents each—an inexpensive way to run the farm cars that travel from one end of the property to the other. "I just connect people with chemistry," he remarked.

Jack oversees six acres with amazingly diverse crops including lettuce, celery, carrots, fennel, beets,

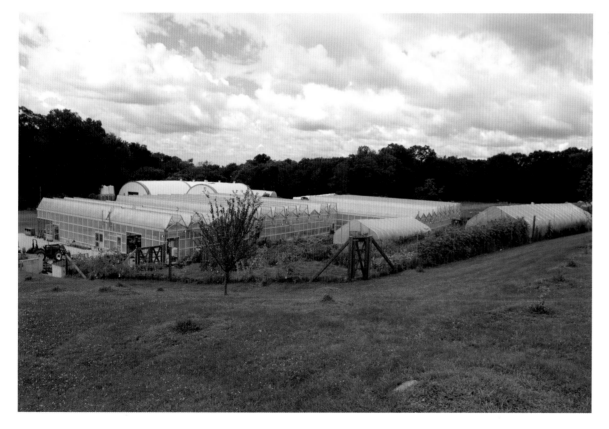

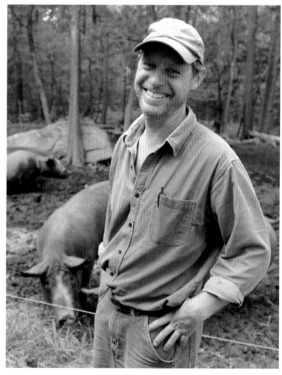

Top: entrance to local farmers market. *Directly above:* livestock manager Craig Haney with the pigs. *Left:* innovative greenhouses where greens and vegetables are produced year-round.

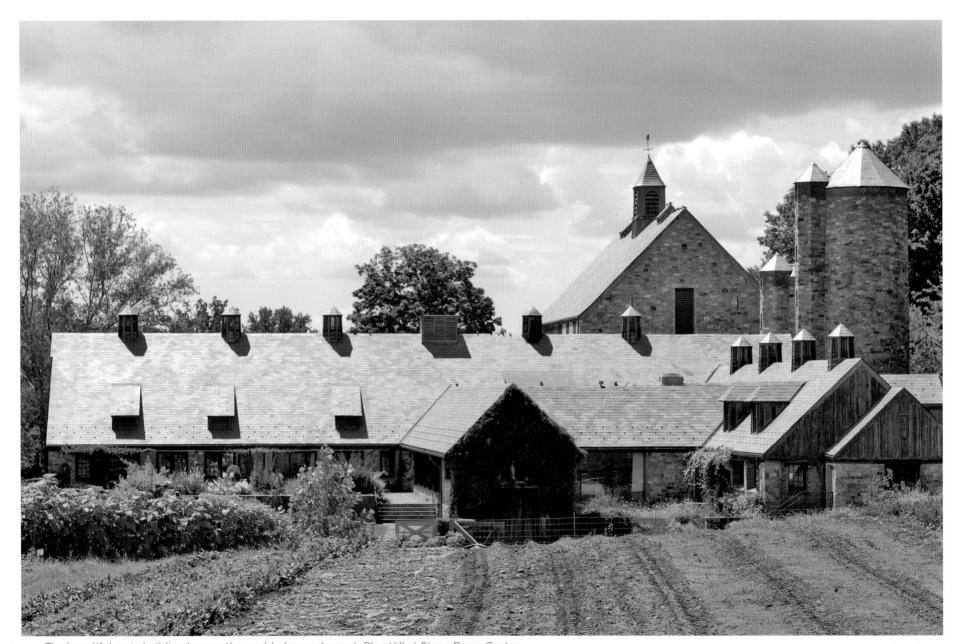

The beautiful main building houses the world-class restaurant, Blue Hill at Stone Barns Center.

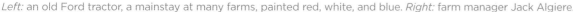
Left: an old Ford tractor, a mainstay at many farms, painted red, white, and blue. *Right:* farm manager Jack Algiere.

chard, spinach, onions, leeks, garlic, broccoli, cauliflower, cabbage, bean sprouts, tomatoes, potatoes, squash, corn, beans, melons, sunflowers, and grapes. There are even three acres of organically grown corn. And what about controlling pests? "I'm there the day they show up, and I just pick them off by hand," Jack said. "I walk the entire property daily and notice everything—what is ripening, what needs weeding, but also what insects are arriving."

The land is continually changing and that's a challenge, Jack admitted.

The farmers work with the environment rather than resist nature: Two-hundred varieties of produce are generated year-round without using chemical fertilizers, pesticides, or herbicides. The only addition to the soil is "black gold" compost, a pathogen-free mixture of leaves, grass clippings, livestock manure, hay, and kitchen scraps from the restaurant. The

farm may be small in area, but it is exceedingly diverse and productive. Six crop rotations annually preserve nutrients in the soil in both the field and the 22,000-square-foot greenhouse, an amazing structure built to make maximum use of sunlight.

The Stone Barns Center truly celebrates, teaches, and involves the community in a fun and educational experience; it is simultaneously a campus and a farm, combining the best of both worlds.

CABBAGE HILL FARM Mt. Kisco, Westchester County

"The greenhouse is heated with renewable energy, and our electric bill averages $70 per month."

ntering the tall, white electronic gates of Cabbage Hill Farm, off Crow Hill Road, in northern Westchester, is like being transported back in time. The nonprofit Cabbage Hill Foundation, organized in 1985, seeks to increase public awareness about sustainable agriculture through an educational working farm. Part of their mission is to conserve rare and endangered breeds of animals, as well as bring consumers and farmers together. And on the first Friday of every month, the 175-acre farm is open for public tours.

My guide to these rolling hills filled with heritage breed animals, Kate Carney, introduced herself while holding a tiny Shetland goose (a heritage breed) barely ten days old. Kate, along with Kevin Ferry, both graduates of SUNY Cobleskill's agriculture program, manage the day-to-day operations and reside here. Despite the apparent tranquility, this is a busy enterprise.

Greens are grown year-round in greenhouses fed entirely from fish tank water, a by-product of the on-site aquaponics operation. Another greenhouse contains flowers and herbs; one thousand tomato plants are planted annually. No chemicals or sprays are used. The greenhouse is heated with renewable energy; the entire electric bill averages only $70 per month. Vegetables and greens are also organically

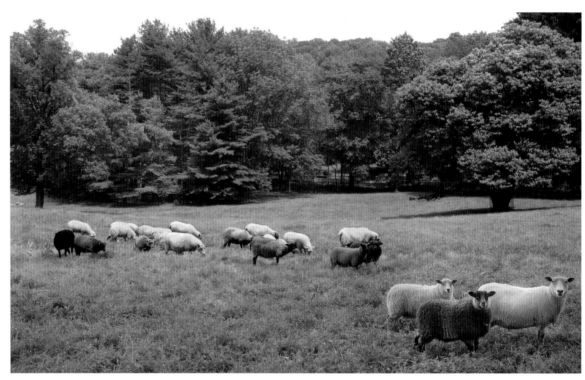

Devon and Shetland sheep grazing

grown in outdoor hoop houses and raised beds using compost made from the farm animals.

Grazing over this beautiful expanse of farmland are heritage breed sheep and Devon cattle. There are also Highland cattle, known as "Queen's Beef" in England, adapted to produce low-fat beef from pasture alone. Their double-layered coat eliminates

the need for a layer of fat, resulting in a healthy beef with excellent flavor. All cattle are grass-fed, hormone- and antibiotic-free, grazed on conservation land, and humanely slaughtered. The farm is also home to geese and about thirty Shetland ducks (they can't fly), as well as Rapanui chickens from Easter Island.

Breeds such as Narragansett Turkeys, Charlaix Sheep, and Large Black Pig, which roamed around America and Europe five hundred years ago, can be seen here. Shetland sheep, renowned for their wool, thrive on grazing alone and their meat is a delicacy—a grass-fed lamb is particularly tasty. "We send the wool out to be spun," Kate said, showing me an amazingly soft Shetland sheepskin. Nothing goes to waste at Cabbage Hill.

Aquaponics—raising fish and vegetables together—is a large part of the farm business. Four enormous fish tanks contain trout, tilapia, striped bass, and Atlantic salmon eggs from Florida. After a year, the fish are about one pound, ready to be sold at the local farmers market or directly to local restaurants. Before leaving the farm, the fish are purged with a salt bath and thoroughly cleaned to avoid the muddy taste from being in the tank for twelve months.

Kate pointed out the excellent recycling system. Bacteria in the fish tank water are de-nitrified. Fish nutrients supply the plants by using their water. Vegetable-based fish food is used, and the water is filtered before irrigating any plants. Of course, the water is continually recirculated. Interestingly, the same water has been used since 1985 and only one gallon per day needs to be treated and removed.

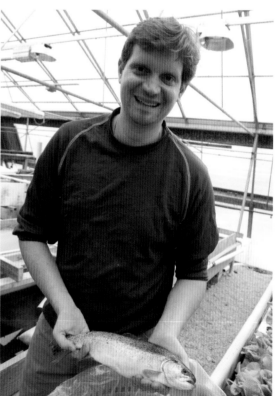

Left: black Shetland ram. *Center top:* Narragansett turkeys, a traditional but rare breed from New England. *Top right:* Kate Carney admiring two Shetland ducklings. *Bottom right:* Kevin Ferry holding a steelhead rainbow trout. *Center bottom:* a hungry Shetland lamb ready for its next meal.

"I wasn't much of a student, but I know apples!"

Bob Stuart's fruit farm covers about two hundred acres and goes back five generations, to the year 1828, when James Conklin, his great-great grandfather, bought the original acreage. Originally a dairy farm, it was converted to fruit by Bob's grandfather. "He wanted the easy life," Bob said, explaining that fruit is less work; cows have to be milked twice a day.

Today Bob does the growing and pruning at the farm, while his wife, Betsy, sells the plants and manages a bakery chock-full of fruit pies and other tempting treats. "Being successful means maintaining a fair price, high-quality fruit, and good customer service," Bob asserted. He uses the least amount of chemicals possible on crops that include apples, pumpkins, squash, and an array of vegetables, all harvested from the last week of July through Christmas. There are five greenhouses as well as pick-your-own pumpkins and apples in the fall.

"I'm the true definition of a farmer," Bob declared proudly. "I wasn't much of a student, but I know apples!" Bob's father, Lee, planted several standard apple trees back in the 1950s that were bred for flavor, as opposed to dwarf trees that are shorter with more yield per tree. The newer varieties of apples, like Fuji and Gala, are flavorful and look good—their trees yield large perfect apples.

"I don't pick the fruit before its time," Bob emphasized, explaining how critical it is to harvest fruit "when it's ready, not when you are." It's important not to pick apples too early. "Just cause it's red doesn't mean it's ready," he said. "I taste the fruit and can tell when it's time."

Bob is somewhat bemused by the fact that when the apples are mostly large, people ask for small ones. He told me the size of apples depends on the weather. "The more sun, the smaller and more flavorful the apples are." When the season is overcast and rainy, expect large apples with little flavor. "Remember that drought we had in 1999.... The apples that year were some of the best tasting ever!"

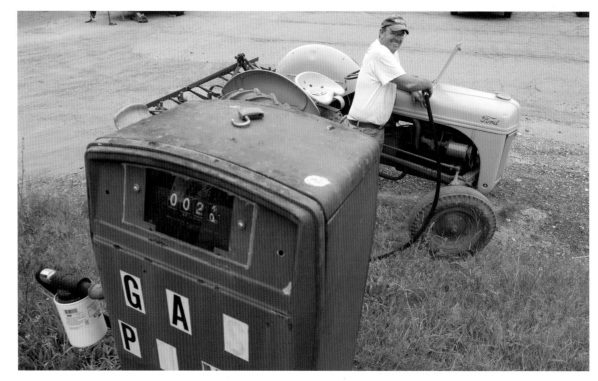

Bob Stuart fills his old Ford tractor from his antique but still functional gas pump.

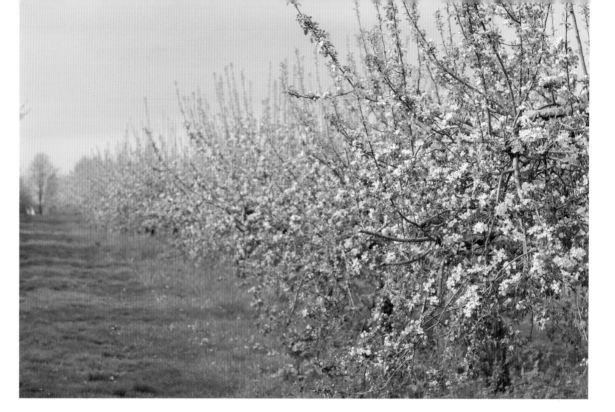

Clockwise from above: peaches on the tree; apple blossoms fill the orchard on May Day; red apples ready to be picked; tuberous begonias fill a greenhouse.

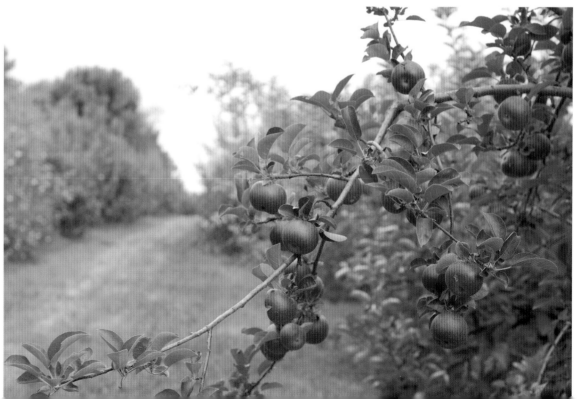

RYDER FARM Brewster, Putnam County

"Our family hangs on to its heritage."

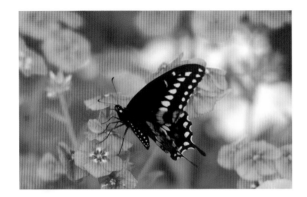

"Several family members live and work here," Betsey Ryder shared. For example, her brother-in-law, Herbert Hall Gibson, raises sheep, while she is in charge of the crops. "I'm the family historian," she said proudly, showing me a copy of a comb-bound paperback book she compiled, "The Ryder Family Bicentennial Update, 1795–1995. Descendents of Colonel Stephen Ryder and his wife, Betsey Nichols." We ended up sitting in the parlor of the Ryders' eighteenth-century farmhouse, also known as The Sycamores, with portraits of her grandparents, Elizabeth (who Betsey is named after) and Stephen, staring at us from the wall.

The entire Ryder clan gets together every Fourth of July for a potluck supper and shareholder meeting at the family farm. About two hundred Ryders (not including spouses) gather from as far away as California. The family reunion tradition began more than a century ago, and later the shareholders meeting was planned for the same day. Betsey's mother makes her red, white, and blue flag cake, and a group photo is taken every year.

When Betsey's great-grandfather, Eleazer Ryder, moved to Brewster, New York, from Massachusetts in 1795, he could trace his lineage back to 1610 in England. Eleazer grew flax that his son, Stephen, often helped him load in an oxcart; they then headed south to Ossining, where produce was shipped down the Hudson River to New York City, a four-day round-trip to Ossining and back.

John, Betsey's husband, is largely responsible for the house standing today. The structure was sinking, and he dug under the foundation and replaced it. Both of them have a passionate love for the farm.

Betsey and John have been married for ten years and live in their own home, next door to The Sycamores. There are 125 acres at the Ryder Farm: nine acres are vegetables, eight acres are hayfields, sixty acres are fenced pasture, and the rest is woodlands and wetlands. The business, now owned by a family corporation, had been a dairy farm. These days Betsey participates in two farmers markets—one in Manhattan and the other in Brewster—and manages a small Community-Supported Agriculture (CSA) group. After growing up in Baldwin, Long Island, she studied nursing in college and for the past thirty years has worked full-time in the emergency room of Danbury Hospital in addition to managing the farm.

Betsey with her husband John holding some of the farm's bounty. *Left:* giant Swallowtail butterfly on dianthus flowers grown for sale at the farm. *Opposite:* view of the farm from the upstairs of the farmhouse.

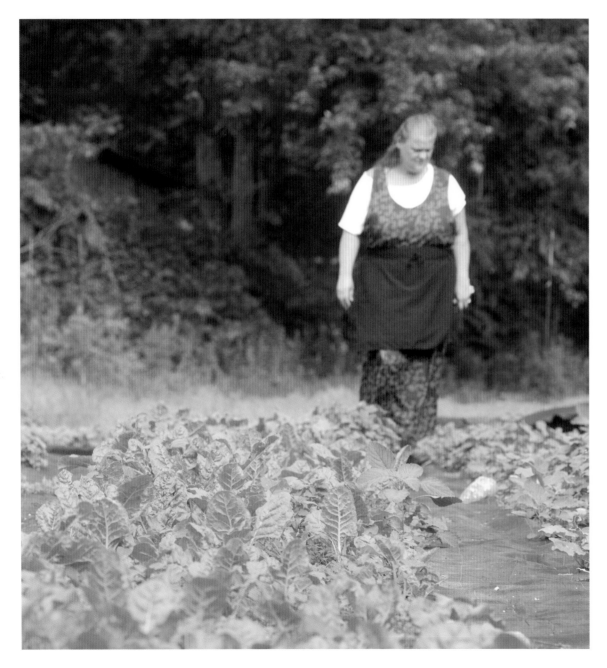

In the early 1970s, the Town of Southeast rezoned the area for single-family houses and property taxes soared. Ryder Farm was able to get farm tax abatements under the state's Agricultural District Law. "We would have lost the farm to taxes in the 1970s; the agriculture property tax abatement saved us," Betsey said triumphantly.

Left: Betsey Ryder walking in rows of greens. *Top:* parlor of antique Ryder homestead. *Bottom:* signs mark farmstand location to people driving by.

SAUNDERS FARM Cold Spring, Putnam County

"The farm is more a way of life than a way to make a living."

Owning land in Putnam County has changed over the centuries, but some things remain constant—the rambling white frame 1740s farmhouse where Alexander Saunders's grandfather spent weekends and many summers, for instance. An industrialist with a foundry to run, Alexander Saunders consolidated two or three farms and passed the land on to his five children in the mid-1940s.

"Nowadays," Alexander remarks, "10,000 pounds of beef and 10,000 bales of hay translates into $10,000 in taxes." While farming is his passion and pastime, the foundry business in Cold Spring is the major source of his support. He employs only one person to do the baling for him during harvest season and says "The farm is more of a way of life than a way to make a living."

Alexander took me for a ride in his Jeep to show me some of the ninety acres of farmland beyond the house—a place he clearly loves—and the thirty-four classic Black Angus cattle that roam the pasture. "Look at that little one; he was just born last night . . . there's no clip in his ear!" As Alexander opened the gate and greeted the cattle, they began to bellow back and gather near. As we disappeared in the Jeep, their squawking faded in the distance and we made our way around the farthest reaches of the Saunders property where some Morgan horses

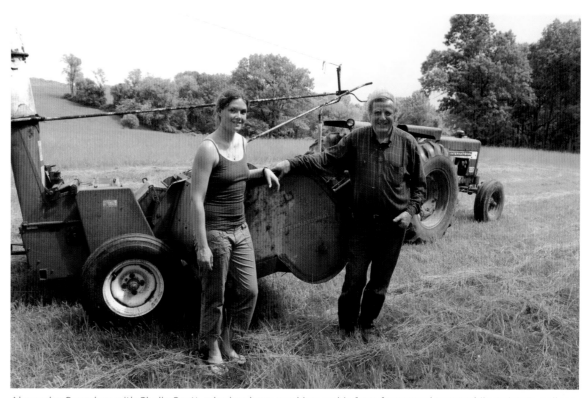

Alexander Saunders with Shelly Scott, who has been working on his farm for several years while going to college.

were grazing. On that early spring afternoon, the fields were alive with the sights and smells of new growth and I felt far removed from civilization.

Each spring Saunders Farm hosts an outdoor art show, with large works of sculpture and huge paintings displayed in this place where space is plentiful.

Alexander's mother, well into her nineties, lives on an additional fifty acres of adjoining property. The greenhouse adjacent to her house and nearby chicken coop keep her busy; a variety of vegetables grown here are sold to the Valley Table Restaurant in nearby Garrison. "The rats have been getting at

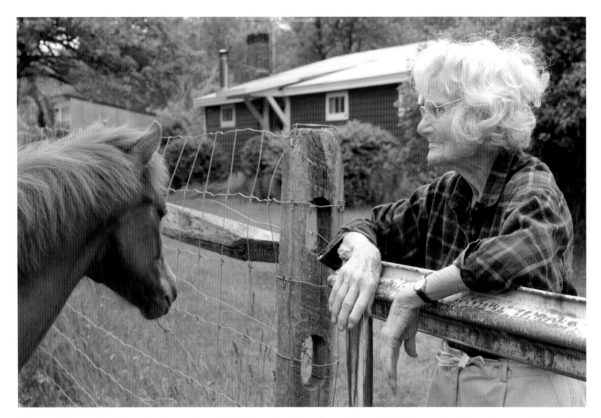

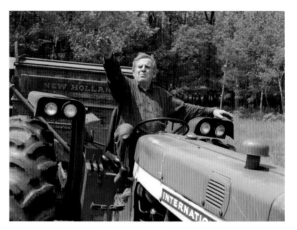

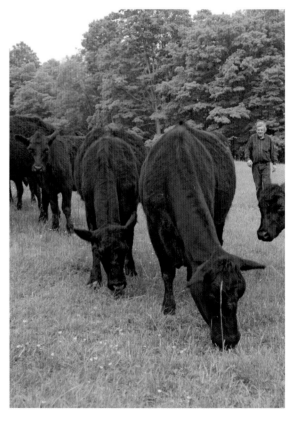

Above: Alexander Saunders's mother, Marie Louise Saunders. Top right: Alexander Saunders on his tractor. Bottom right: grass-fed beef cows. Opposite page: horses grazing.

the eggs lately," Alexander observed, reminding me of a downside of farm life. "My mother's job is to gather the eggs."

As I was leaving, Alexander casually mentioned that the property I had just seen was in some sense a historic one. The first fund-raiser for Pete Seeger's ship *Clearwater* was held here in 1968. At the time, Con Edison was attempting to build a power plant in the scenic Hudson Highlands. Alexander's father wanted to get corporate funding to stop what would

have decimated the area's natural beauty. He considered having them finance a concert on his grounds to raise money to fight the power plant. He knew corporations would be hesitant to donate money to a music festival and would feel more comfortable with a tangible investment involving the heritage of the region. He proposed building a replica of a famous ship that could be used for educational purposes. And so *Clearwater* was born. "We'll build the ship and the money will come!"

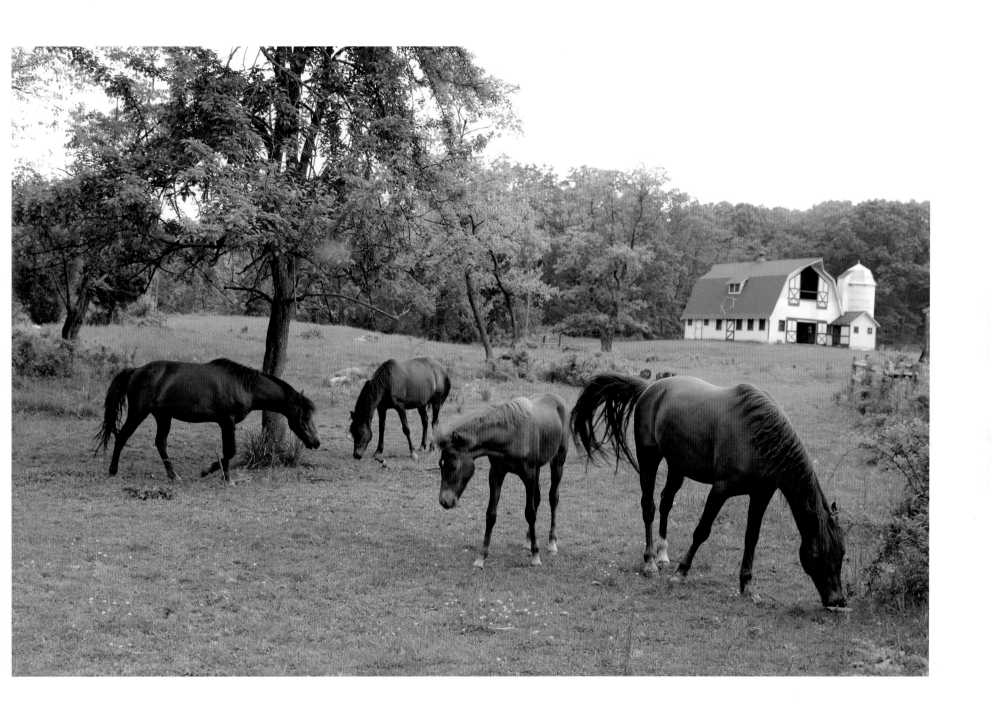

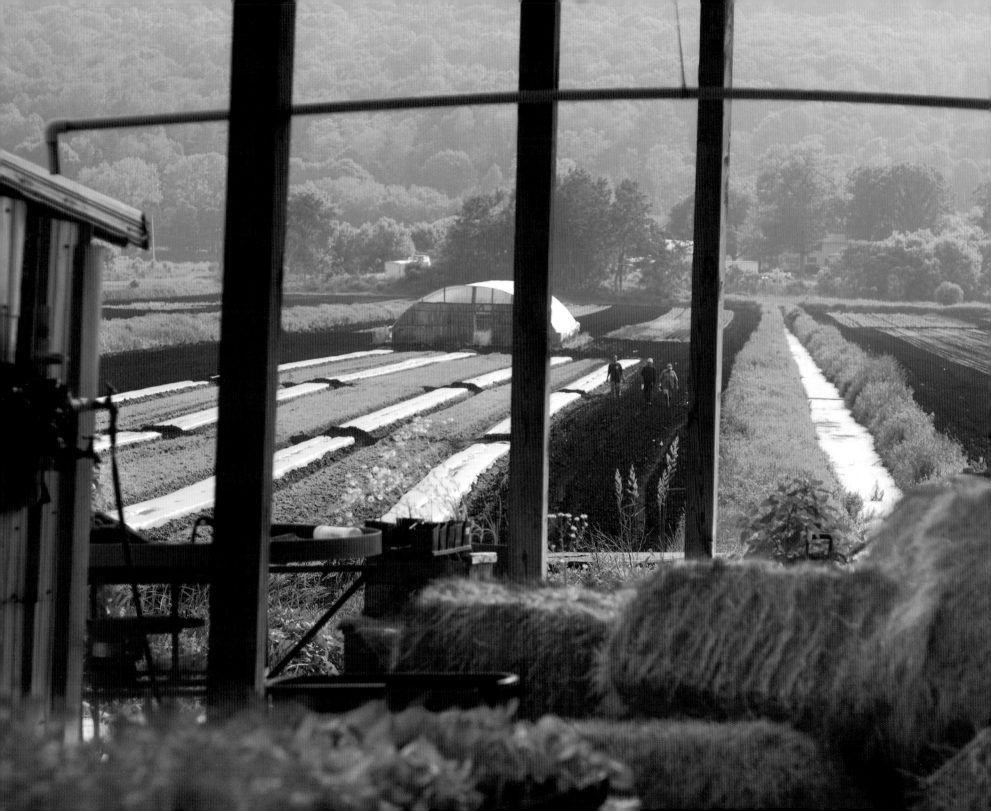

ROGOWSKI FARM Pine Island, Orange County

"To create community . . . that is vital to the lifeblood of my family and this place."

*P*ine Island may sound like a romantic destination, but the reality is a world unto itself: close to major interstate highways, yet tucked away off the scenic Pulaski Highway. Many Polish people, including Cheryl Rogowski's grandparents, settled in Pine Island to farm. "My mother's mother was one of the first settlers in the Black Dirt region," she told me. Acres of black dirt are largely what one sees through the car windows here while driving on roads reminiscent of rural England. In 1955 Cheryl's father purchased the first acres of Rogowski Farm; today there are 150.

Cheryl, the former controller at Sterling Forest, now runs the business, while her brother and sister are involved with marketing and accounting. "I'm pretty much like a CEO," she said, explaining that she oversees several aspects of the farm. Rogowski's produces more than 250 varieties of crops annually. Some are grown in "caterpillars," the small year-round greenhouses visible just outside the market. Visitors can pick their own herbs and cut their own flowers.

I was curious to know what made Cheryl leave her career and return to the family business. "I'm totally in love with my farm; she possesses a magical beauty," Cheryl answered. Her feelings come from a deep spiritual connection to this special place.

"When I make my daily rounds of the fields, I'm just amazed at the way the landscape constantly changes as only a living creature can." She also appreciates how gratifying it is to be involved in a profession where one can see things through from start to finish.

Cheryl told me how the take-out restaurant evolved when the leftover food from the markets was going to waste. "Leftovers were what I grew up eating," Cheryl explained, saying that her mother made entire meals out of what the farm was unable to sell, like imperfect fruit and vegetables that ended up being canned, a major source of income for the

Rogowski Farm in the 1960s and 1970s (and they still do some canning today).

Penny, the manager, served a delicious lunch the day I visited the farm. Several colorful, nutri-

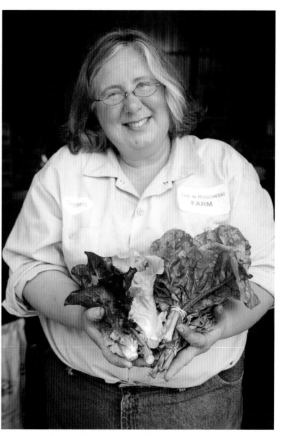

Right: Cheryl Rogowski holding salad greens. *Left:* Cheryl's mom. *Opposite page:* workers walking in from the field at the end of the day.

tious salads adorned my plate—including a three bean salad, potato salad, and kale salad, each with its own fresh, distinctive flavor, a wonderful repast on a warm spring afternoon.

The Rogowski Farm is "certified naturally grown." They exercise integrated pest management, a cost-effective system that uses a minimum of chemicals. "My father cleared this land by hand, using saws—without chemicals," Cheryl said. "He used no machinery or even mechanical cultivation." As the years went by, the farm began to use chemical spray but stopped in the early 1980s. Cheryl explained chemicals were a necessity for large onion cultivation. "I set the nozzles for spraying in the mornings before going to school," she said. Cheryl believes her mother always suspected the spray presented a health danger and protected her children

from exposure. "My mother was a registered nurse and refused to let me get involved any more closely with that work."

Today the diversified crops on the farm include only three to five acres of onions; years ago, at peak production, there were seventy-five acres with just that one crop. "This may be the last generation of onion farmers in Pine Island," Cheryl told me. "The price we get today for onions is the same as it was twenty years ago."

"The farm is the heart of the community," Cheryl noted proudly, pointing to how the Rogowskis partner with schools on Earth Day and the Chamber of Commerce to sponsor other events. "To create community . . . that is vital to the lifeblood of my family and this place."

I was delighted to discover after our meeting that Cheryl had recently received a John D. and Catherine T. MacArthur "genius grant" in the amount of $500,000.

Left: young tomato plant in the black soil. *Right:* cultivator blades. *Opposite page:* workers weeding the field: salad greens on the left, chives on the right.

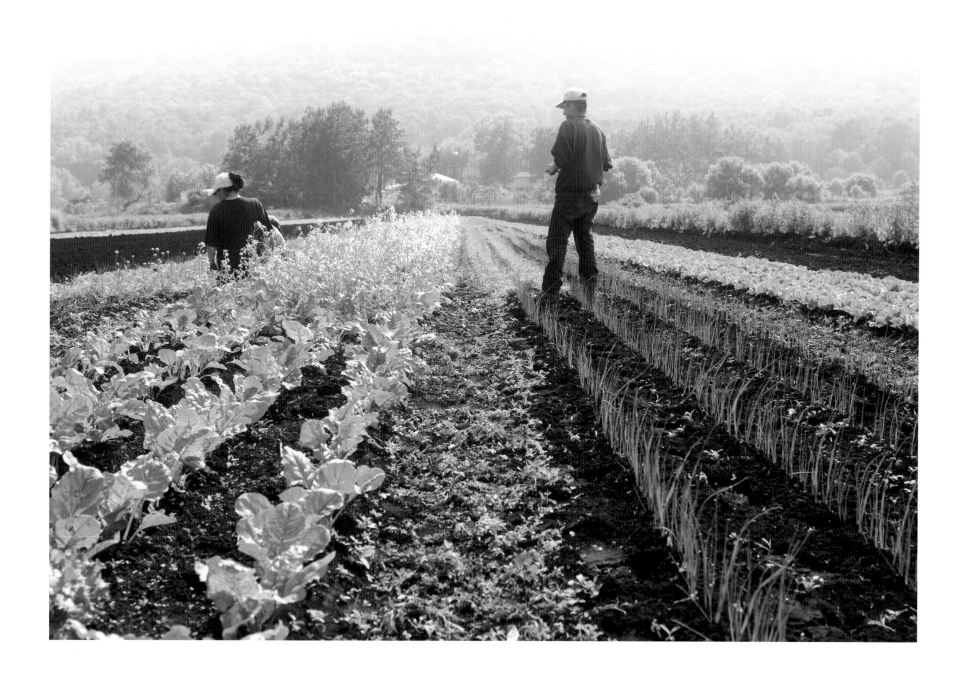

BLOOMING HILL FARM Blooming Grove, Orange County

"Don't buy food from strangers . . ."

Blooming Grove, a residential area filled with modest homes, is an unlikely place to find a charming farm flourishing, but that's what Guy Jones has created in Orange County near the New Jersey border. It's hard to fathom that 250 years ago the area was known as the American Bread-basket and produced grain for the Revolutionary War army. Blooming Hill is one of only a few farms that still remain in the area. Ironically, the farm is located down the long driveway that accompanies a suburban house owned by Guy and Cindy Jones, proprietors of a multifaceted operation including a market, bakery/cafe, and greenhouses perched along the banks of the Wallkill River.

A short walk from the parking lot stands the hub of activity, a large barn with a bustling bakery as well as a small restaurant serving items made with produce grown at Blooming Hill. Visitors were enjoying drinks and light lunch al fresco the day I visited, sitting at a few picnic tables beyond the bins of fresh salad greens, carrots, potatoes, beets, onions, and herbs. Local products are also sold, including a selection of goat, sheep, and cow's milk cheeses.

Guy, a tall, gracious man with a full head of gray hair, greeted me warmly, while carefully paying attention to what was going on in the store. While speaking with me, he overheard a woman's confu-

sion about the huge plant she had in hand and was about to purchase. Immediately, he excused himself and explained how much water the plant required. The weekend retail business is an important element of his farm.

Herbs for sale. *Opposite page:* Blooming Hill Farm's store, filled with beautiful fresh produce for sale. Guy Jones's sister gestures to a customer in back.

Although the low-key, multipurpose barn at Blooming Hill is stocked with gourmet treats, the atmosphere isn't fancy. The business originated in 1980 when Guy and his wife moved to the Hudson Valley from New Jersey. They decided to open

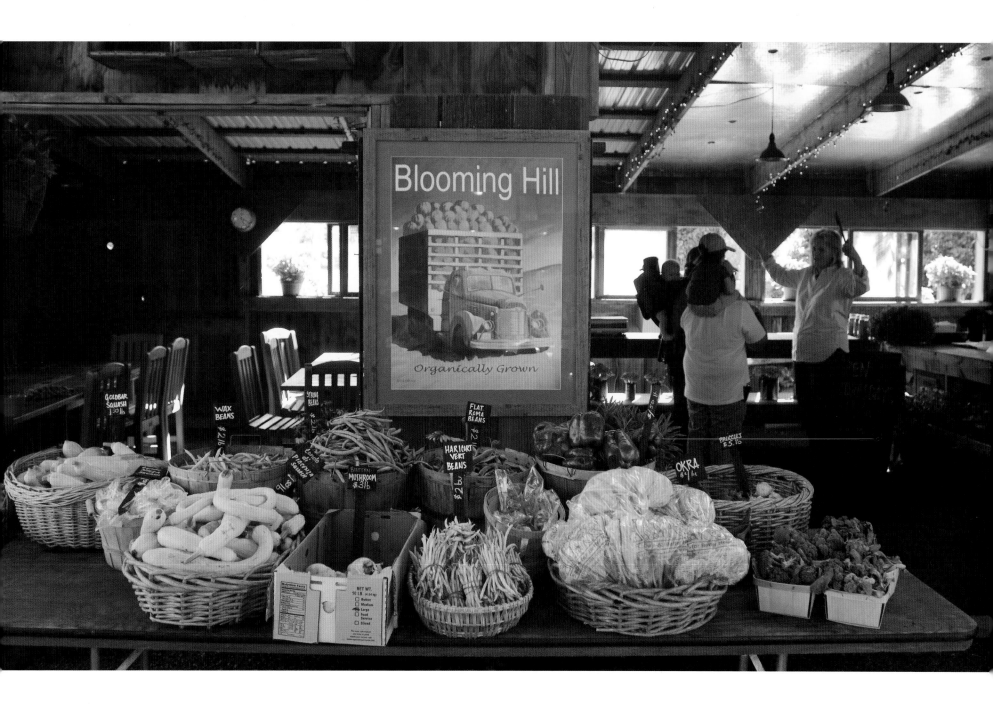

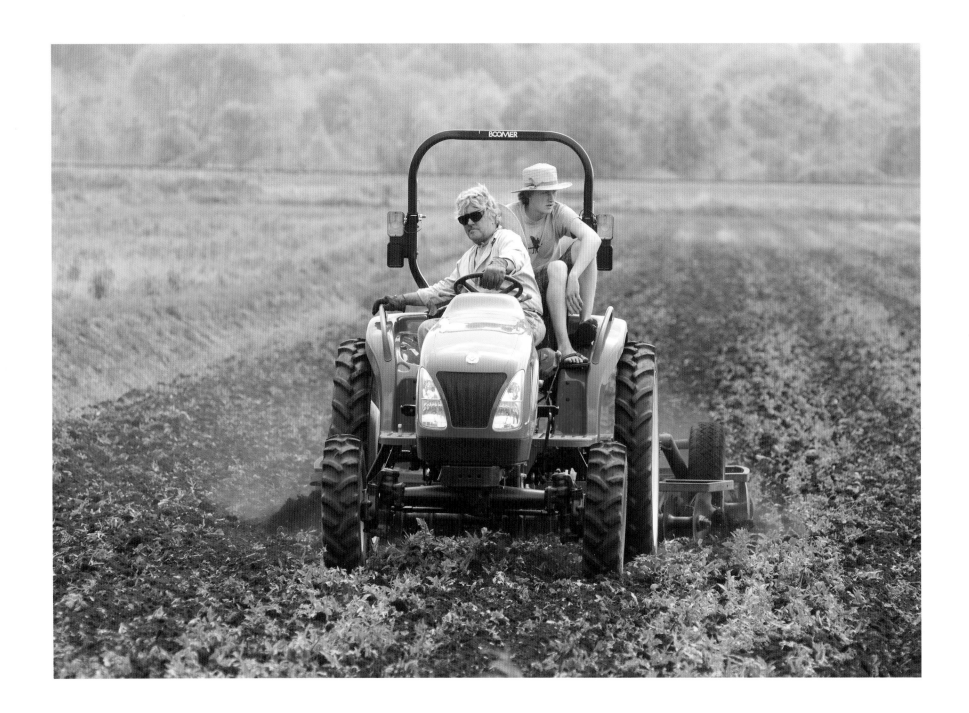

a weekend farm stand, selling hay, honey, maple syrup, and other local products. Gradually they began growing crops year-round in greenhouses. On weekdays Guy and Cindy would wholesale the produce. Within a few years, the barn/store evolved.

Guy is clearly interested in the farm as a vital means of bringing together the community. On weekends you might find live music as well as craftspeople selling their wares. The small community garden started a few years ago is now thriving

and sprawls over 110 acres. Guy also farms forty acres in Chester as well as the twenty-five in back of his home. The Blooming Hill Community-Supported Agriculture group has 150 members in Orange County as well as 150 in White Plains (Westchester County). *Organic. Seasonal. Local.* These are words he uses frequently to describe what he does, supplemented by the maxim on Blooming Hill's Web site: "Don't buy food from strangers; support local farms."

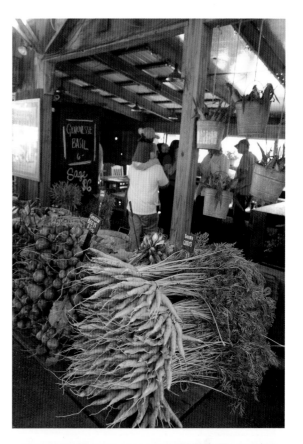

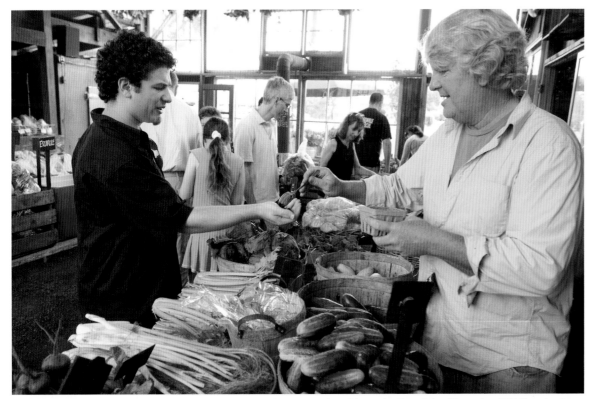

Above: Guy Jones offering samples to customers during weekend brunch. *Top right:* Blooming Hill Farm's store, with heaps of fresh produce for sale including carrots and beets. *Bottom right:* fresh string beans for sale. *Opposite page:* Guy Jones and his son plowing.

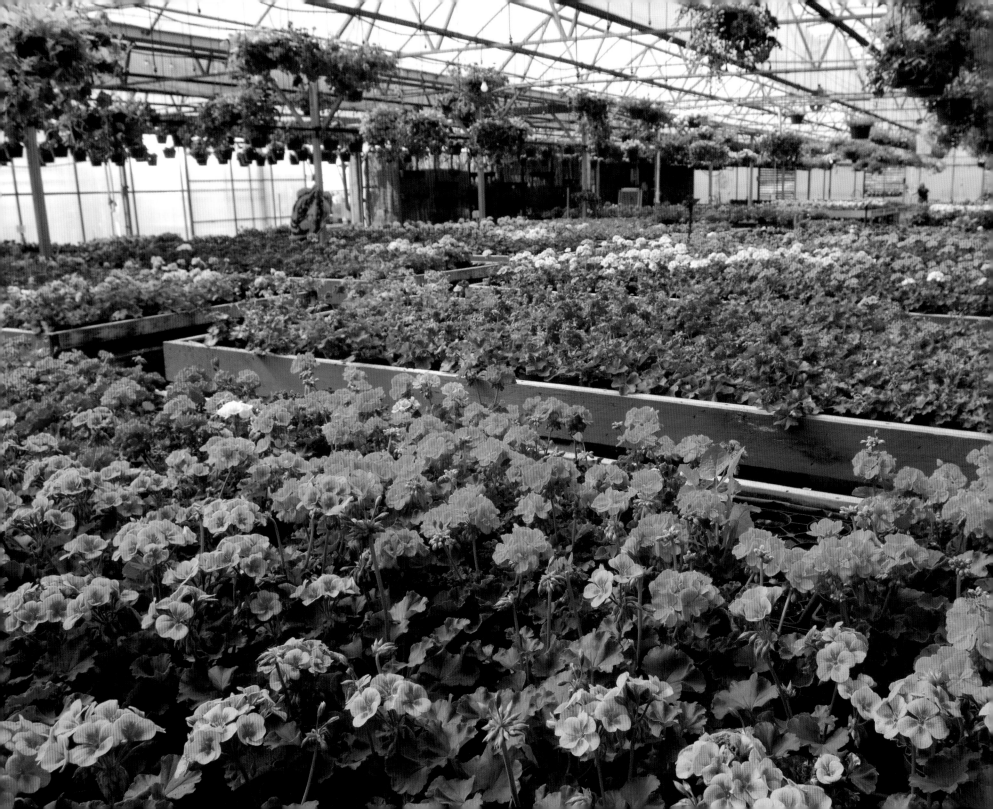

"We made a greater profit when we were selling three pounds of tomatoes for $1 than now, when tomatoes are $3 per pound!"

A tall, relaxed, easygoing man, Rich Hodgson invited me into his office. Hodgson's Farm may be one of the best nurseries in the Hudson Valley with an array of unusual offerings, but it had rather unexpected origins. "After World War II, my father raised chickens in Newburgh, that was our family farm until 1983, when we moved to Walden," Rich explained. What with tons of manure from fifty thousand chickens, the Hodgsons bought land to spread the stuff around. The next logical step was to grow vegetables, which they did, and sold them at the New York City farmers market. At the time, farmers markets were few and far between.

In 1980 Rich purchased fifty-two additional acres and expanded the small farm to grow fruits and vegetables as well as cut flowers. He now runs an enormous business, with four huge greenhouses in addition to the large nursery itself. A lovely small waterfall on the property advertises his latest offering: installing ponds and waterfalls for customers. "I actually went to Pond College in Chicago to learn how to do it," he told me, slightly amused at this new sideline.

Rich's passion for plants goes back decades; he studied horticulture in college at Delhi, New York, in the early 1970s. Due in part to this background, the variety of flowers at the farm is amazing—including calla lilies and alstroemeria in pots of soil, the first time I had seen them sold as anything but cut flowers. Rich explained the necessity to change and adapt as well as to continually find new varieties of flowers. "What we used to grow no longer can be sold," he said. "Tastes change."

Growing is the most satisfying—and frustrating—part of the business. "So many things can go

A greenhouse filled with six-packs of annuals in an array of colors. *Opposite page:* geraniums and hanging baskets of petunias for sale.

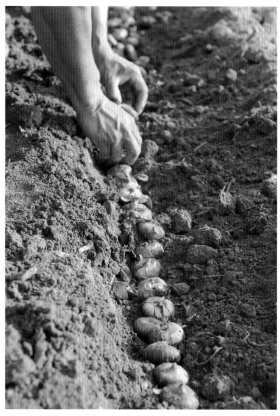

wrong," Rich said, explaining how bad weather and disease are always problems and how every year brings different weather conditions.

Profitability is the hardest part of the equation now; basic expenses, such as fuel, have been skyrocketing, wreaking havoc with finances. "Overhead used to be reasonable, now it costs $100 round-trip for gas to be at a farmers market. We made a greater profit when we were selling three pounds of tomatoes for $1 than now when tomatoes are $3 per pound."

Big box stores have taken over the market for the hard goods that independent garden centers like Hodgson's used to sell. "We may beat them on quality, variety, and service, but we have to offer more than that," Rich explained, adding that Hodgson's hosts weekly classes on composting and other aspects of gardening by experts who speak about their specialty. They also offer classes on how to build a pond—the idea being that people will purchase services and materials from the nursery afterward. "We have had to diversify in order to survive," Rich reflected.

As we were saying good-bye, Rich remarked that he almost had to cancel our meeting. The day before, on a trip to the New York City farmers market at 2:30 a.m. (which is when he has to start driving to Union Square), he fell asleep at the wheel. Luckily, he survived with only minor injuries. "It gives you an entirely different perspective," he told me. "I don't want to farm until I drop dead like my father who was a workaholic; I do see myself retiring and moving on!"

STOUTRIDGE VINEYARD Marlboro, Ulster County

"I want to show visitors how this cherry tree here made this particular brandy."

There aren't many winemaking operations that employ gravity rather than mechanical pumps. "We don't filter the wine either," Steve Osborn, owner of Stoutridge, explained as we pushed through huge heavy doors into the dramatically lighted wine room filled with two enormous casks. "They are aged here," he said beaming, proud of the fact that his dream of owning and operating a state-of-the-art winery and distillery has been realized. A visit to Stoutridge is like being transported to California's Napa Valley. The limestone ridge surrounding Marlboro is ideal for winemaking: The mountain behind the town blocks the winds, and the fertile soil is just right.

Steve subscribes to the slow wine philosophy of winemaking, using minimal intervention and the force of gravity in the winemaking process. "I'm not a winery guy, I'm a grower," he explained. For instance, his brandy is derived from fruit, whiskey from corn and rye, and vodka from corn, all crops grown locally. Vodka is harder to make from apples than from corn with its high carbohydrate content.

"Without the distillery here, the economics wouldn't work. Agri-tourism is the last refuge of agriculture," Steve said, talking about small farmers building up the Hudson Valley as a destination for visitors to enjoy the fruits of their boutique businesses. "Sustainability only works if your business survives," he reminded me.

Steve will soon be selling thirty different products that will continually change; none will be made in large quantities. The flavored vodka line, for example, will be harvested from a local pick-your-own farm in Marlboro and packaged with the Stoutridge logo. Each bottle will be made from fruit from one or two trees. "I'll pay two times the market price to watch the fruit carefully," he says. "I want to

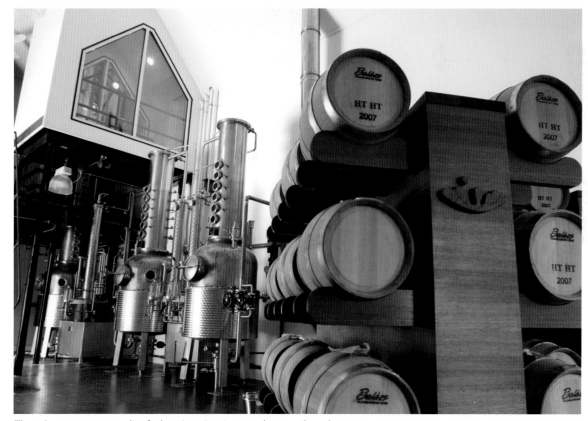

The winery uses a gravity-fed system to store and move the wine.

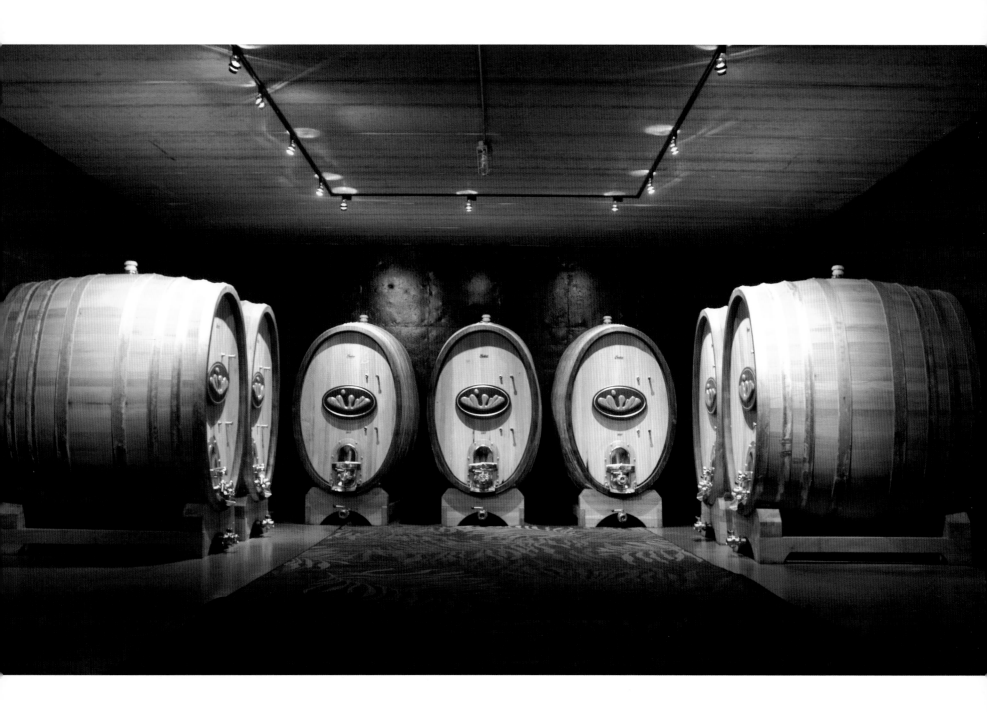

Left: young grapes on the vine. *Right:* Steve Osborn corking the bottles at Stoutridge. He's a hands-on owner who enjoys every step of the wine production process. *Opposite page:* Stoutridge winery keg room.

capture the fresh farm flavor of the fruit and show visitors how this cherry tree here made this particular brandy." Steve believes people appreciate the authenticity of a product and enjoy seeing the local farm where the fruit in their liquor originated.

Steve and his wife, Kimberly Wagner, were chemists in another life. She has a Ph.D. in chemistry from Harvard, and they worked as business consultants in the pharmaceutical industry for several years before accumulating enough savings to build Stoutridge.

Interestingly, their winery is located on the property of an old distillery that dates back to the mid-nineteenth century. At the turn of the twentieth century, it was converted to a commercial winery, but Prohibition closed it in 1919. The building was torn down in 1923 by a new owner. In the 1930s and early 1940s, Legs Diamond's still was on the property, Steve told me. "He'd fill false gas tanks with alcohol at the end of the long driveway!"

WILLOW TREE FLOWER FARM Milton, Ulster County

"My dream is to plant and grow fields of lavender . . . and create a mini-Provence right here in Milton, New York!"

Like its lovely name, the 50-acre Willow Tree Flower Farm is spread over some of the most beautiful farmland in southern Ulster County. "I think you need to be possessed to farm, you have to have a calling. . . . It's like going into the ministry," Maria Mikkelsen told me as we sat amid an array of perennials on a warm spring afternoon. Maria explained that the work is physically demanding and most nights she is in bed at 9:00 p.m. and up by 6:00 a.m. She used to grow annuals as well but now buys them from various vendors. The work was overwhelming.

Selling directly to consumers isn't easy in the area they farm. "All my plants are perfect and healthy, but there is not a big enough market here for high quality," she said, explaining why she'll continue the wholesale business but diminish retail sales.

Maria and her husband, BJ, had been marketing executives in the travel industry in Manhattan before moving to Milton in 2002, and she still maintains a consulting business. BJ's father was an apple farmer in Denmark, as was his grandfather on the central Danish island of Fyn. "BJ grew up with an affection for the outdoors . . . and he can fix just about anything," Maria said proudly. Recently BJ bought a piece of machinery but had no one to unload it. He devised a winch so he could do the job

himself. "He's the engineer and knows how to evaluate the irrigation system, the roof on the house, and other structural concerns with the outbuildings," said Maria, who takes care of the plants. "I understand fungus, bugs, things like that."

Lately they have had more bad days than good ones, but farm life seems to go in cycles. Maria observed, "We have had blight, bad weather, our largest wholesale buyer bagged out on us." She added a caveat to would-be farmers: "Gardening is very solitary work. I'm a gregarious person who had a marketing career and got used to dealing with people every day. But my dream is to plant fields of lavender: I want to grow it and sell it and have a mini-Provence right here in Milton, New York!"

Potted perennials for sale. *Opposite page, clockwise from top left:* purple coneflower, cream coneflower (Echinacea), pink hollyhock, yellow daylily (Hemerocallis "Yesterday's Memories"), blue salvia with yellow achillea.

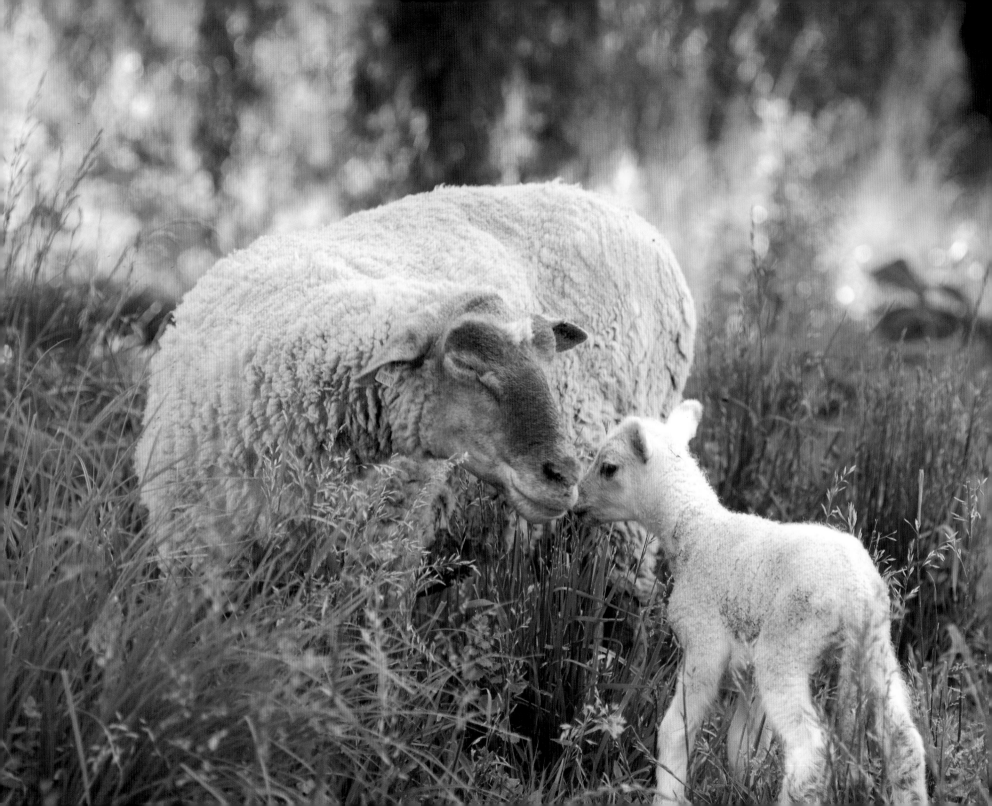

FOUR WINDS FARM Gardiner, Ulster County

"I go through the tomatoes—by hand—looking for bright orange eggs easily visible on the green leaves of the plants."

Jay Armour grew up in the Long Island suburbs with little exposure to farm life. "My mom grew tomato plants around the house shrubbery," he said, explaining his introduction to agriculture. After college Jay traveled to Kenya, where he admired the combination of urban and rural lifestyles some residents there were able to enjoy.

"I like the small family farm," he explained, gesturing toward his four acres of plants and twenty acres of pasture land. While Jay did a short stint on a small farm in Huntington, Long Island, his livelihood came largely from teaching in the New York State prison system for more than a decade. His wife, Polly, a technician who regularly sampled water at landfills, was exposed to hazardous chemicals in her line of work. When Polly became pregnant, she quit her job and started a small heirloom seedling business. Interestingly, the heirloom vegetables and tomatoes have become the farm's big cash crop. The Armours also grow lettuce, chard, beets, carrots, beans, and squash in two greenhouses year-round; the fields are used only in the warm weather months.

I asked about the drift of pesticides from the neighboring Tantillo's farm during the season when there is fruit spraying. Jay explained that a 50-foot buffer zone is mandated by the Northeast Organic Farming Association (NOFA) and the two farms cooperate to alleviate the problem. Spraying is done in the early morning hours when the winds are usually calm.

I wondered how Jay combats infestation without using pesticides. There are three problem pests, he told me. The Colorado potato beetle affects the

Four Winds Farm's irrigation system. *Opposite page:* a newborn lamb nuzzles its mother.

tomato and potato plants. "We use plastic fabric to combat that one; it doesn't let the insects in," he said, describing a rather primitive but effective approach. "I also go through the tomatoes—by hand—looking for the bright orange eggs easily visible on the green leaves of the plant." The flea beetle affects

Top left: Jay Armour, of Four Winds Farm. *Bottom left:* grass-fed beef cattle in the field. *Top right:* tidy rows of greens.

radishes, mustard greens, and arugula by sucking the juices from the leaves. A covering fabric is also used to deter this pest. Far worse is the worm that causes the Armours to lose 35 percent of what they grow; it eats Swiss chard and beets. "I pull out the affected leaves and feed them to the cows and sheep," he smiled, explaining how he seemed to be spending too much of his time picking leaves to feed his cows. "They just love those leaves and get excited when I bring them these treats!" Crop rotation helps the soil and actually slows down the insect cycles; it takes the beetles longer to get to the tomatoes.

Jay also explained that his animals are raised as a source of manure, to fertilize the gardens. "We have a no-till system; we plant in permanent beds and the manure reduces the growth of weeds." This is better for the soil and might be considered a rather old-fashioned system of cultivation, he explained. However, it also allows more carbon to be stored in the soil and greenhouse gases are reduced. Using such natural methods also results in plants having a more even growth rate over the years.

The Four Winds Farm is certified organic. "People looking for local produce once had to go to Manhattan to buy it," Jay reminded me. "Now, I can sell $2,000 worth of tomatoes in a day . . . and I don't have to travel farther than the local farmers market in town!"

TANTILLO'S FARM Gardiner, Ulster County

"I vowed I'd never marry a farmer!"

*W*hen I walked into the cozy kitchen at Tantillo's Farm, I was amused by the sign hung outside the door: MARTHA STEWART DOESN'T LIVE HERE. Bev Tantillo and her family reside here, and her life has been nothing like Martha Stewart's.

A straightforward, hardworking woman who doesn't aspire to be anyone other than herself, Bev was raised on a dairy farm in Vermont started by her father in the early 1930s. She ended up marrying a farmer herself when she was in her late teens, and they've been married now for more than forty-five years. Her husband, Len, took over his family's farm in 1968. All three Tantillo children, now married and in their thirties and forties with families of their own, are involved in some aspect of the farm and live on the property, although each family has its own residence. In fact, Bev's nine grandchildren, who range in age from fourteen to eighteen, also work part-time in the family business.

Their 130-acre property includes houses, woods, swamps, and support land where wheat, corn, and rye are grown for sale to other farmers. On the farmland itself, the Tantillos grow pumpkins, squash, cherries, peaches, plums, pears, and rhubarb. They use an Integrated Pest Management program. "If I don't see a bug, I don't spray for it,"

Bev said, emphasizing her logical approach to a complex topic. She mentioned how toxic chemicals are exported by America to countries where they aren't banned; then we import the produce sprayed with those same poisonous substances, she told me, with obvious disdain for this hypocritical practice, devastating to the health of farmworkers abroad.

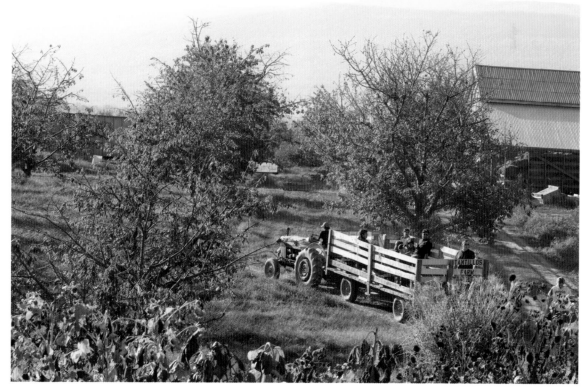
A tractor pulls a wagon filled with apple picker-tourists into the orchard, under a view of the Shawangunk Mountain Range.

tural tourism has eliminated much of the need for migrant labor.

"I vowed I'd never marry a farmer; I saw the hard life when canning vegetables and grinding horseradish for my father as a teenager," Bev recalled. "My mother was one of fourteen children from a truck farm around Saratoga Lake." But then she reflects how everyone in the family seems to love the farm. "There's a freedom here," she observed. When I pointed out she was the matriarch of a farm dynasty, Bev smiled and said, "I guess I am, but I really never think of myself that way!"

Left: Raffaela making one of her famous pies. *Middle:* Grandma Libby, matriarch of the Tantillo family, worked daily at the farm until she passed away in 2008. *Above:* Raffaela's husband, Charles, busy in the bakery.

Tantillo's retail market supplies a decent amount of the family's income. Bev opened the ice cream bar and bakery in recent years, believing this kind of business would have great appeal to families. "I don't want to deal with berries," Bev told me with conviction, explaining how delicate those fruits are, and how difficult it is to keep them in perfect shape so they don't lose their appeal to consumers. The Tantillos buy strawberries, blueberries, and raspberries locally for pies; they grow corn for biofuel only.

Every member of the family has a specific talent, and each is involved in a compatible aspect of the business; perhaps this is the secret to their success. Bev loves being outdoors and enjoys interacting with customers at the store. Len runs the orchard and supervises the farming operation.

More than half the farm's produce is cherries, apples, and pears. When I asked who harvested the crops, she told me: "We have Mexican workers and our grandchildren out there, as well as lots of pick-your-own visitors!" In this respect, agricul-

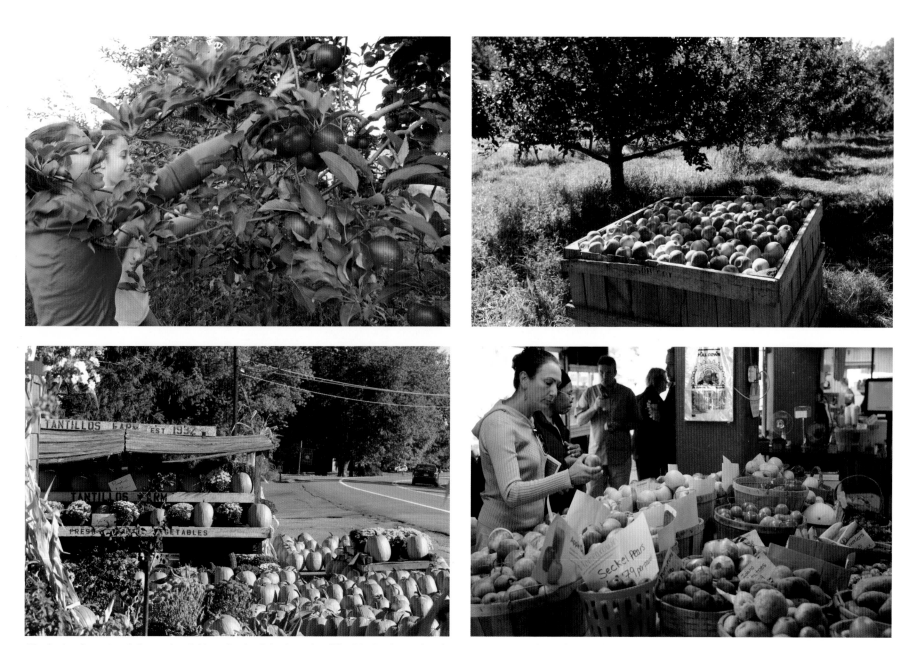

Clockwise from top left: apple picking; fresh picked apples fill a bin in the orchard; a customer examines the produce inside Tantillo's farm stand; pumpkins and mums for sale at Tantillo's Farm roadside stand.

LIBERTY VIEW FARM Highland, Ulster County

"Survival is all about marketing."

pon opening a box of farm fresh eggs from Liberty View Farm, a small feather is barely visible floating atop the eggs. This isn't a peculiar oddity, but rather a planned personal touch from owner Billiam van Roestenberg. Despite the fact sales from Dutch heirloom variety chickens (all grain-fed with organic feed from Lightning Tree Farm in Millbrook) average one hundred dozen eggs per week, one feels as though Billiam personally checks every carton himself.

Billiam bought the property and renovated what had been a fairly dilapidated farmhouse, intending the place to be a weekend retreat. But after selling his pet supply company in Manhattan, he decided to move to the Highland farm and become a full-time farmer. Billiam soon became involved with the Community-Supported Agriculture organization in New Paltz.

The toile wallpaper and matching drapes in the dining room date back to the oldest American wallpaper fabric company, Scalamandre. Billiam chose this pattern, a reproduction from the 1780s, as an homage to George Washington and Benjamin Franklin. These days Billiam hosts gatherings here, often revolving around political issues, one of his passions. "Every day, even here in America, we often have to fight for our rights," he reminds me. "The

Billiam van Roestenberg. *Opposite page, clockwise from top left:* eggs from a variety of chicken varieties; chicks; chickens in the coop; a black and white rooster.

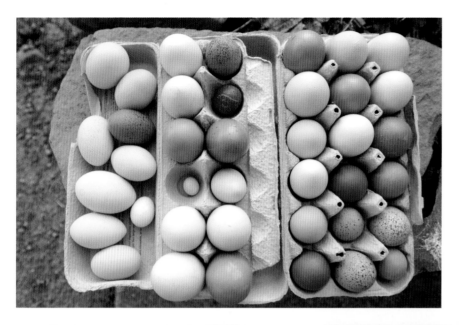

Apple trees featuring names chosen by donors.

name Liberty View Farm celebrates this ongoing quest for independence."

The pastoral apple orchard at Liberty View Farm offers stunning views of the Shawangunk Ridge and contains approximately one thousand trees in need of pruning three times each year. Billiam uses a mix of clay and vegetable oil in the mix he disseminates to deter pests. "Without expensive pesticides, I can pay employees $11 per hour to pick and spray the fruit, instead of putting money into chemical purchases," he explained proudly.

In keeping with his environmentally sensitive business philosophy, Billiam decided to open his orchard to the public and have visitors prune for him. At the same time, he envisions Liberty View Farm as a destination. Visitors can watch eggs being laid, gather vegetables, and cut flowers—a terrific educational excursion for children.

Billiam recently invested $60,000 in a new electrical and irrigation system for the apple trees. To recoup this substantial expense, he devised a "Lease a Tree" program. For $50, an individual or family is assigned a tree for apple-picking season, a fairly unique Valentine's Day, Father's Day, or holiday gift. The idea has been so popular, visitors can now "Charter a Chicken" and "Adopt a Beehive." These programs donate 10 percent of the produce to feed the hungry in the county. When I remarked about his creative approach to farming, Billiam replied, "Survival is all about marketing. I'm just trying to find ways for farmers to be financially self-sufficient . . . so we don't have to watch our land turned into subdivisions!"

HONEYBEE LIVES New Paltz, Ulster County

"Every third bit of our food is due to honeybees pollinating our crops."

*T*sat down with apiarist Chris Harp in a clearing behind his home on a late summer afternoon. A strikingly tall man with chiseled features, we immediately became engrossed in conversation about a recently published book, *A Spring Without Bees: How Colony Collapse Disorder Has Endangered Our Food Supply.* I didn't even realize there was an active hive behind me.

Chris mentioned that honeybees only sting to protect their colony or if they are inadvertently stepped on or brushed off. Interestingly, the practice of *apitherapy* (being intentionally stung) has been shown to ease the pain of arthritis, shingles, and multiple sclerosis. "Every third bit of our food is due to honeybees pollinating our crops," Chris informed me. He followed with a startling statistic: We have lost the majority of the bee population, more than three-quarters of it, over the past twenty years.

A renowned "bee doctor" in the Hudson Valley, he is able to diagnose a specific problem in a hive and return the habitat to health. Chris cares for about 250 hives in the northeastern part of the country. He also removes hives and catches swarms. Less than 1 percent of beekeepers do what Chris Harp does; 99 percent are involved in conventional beekeeping. "Bees are an amazingly intelligent species," he remarked, likening them in that respect to dolphins.

Honeybees entering and leaving a hive.

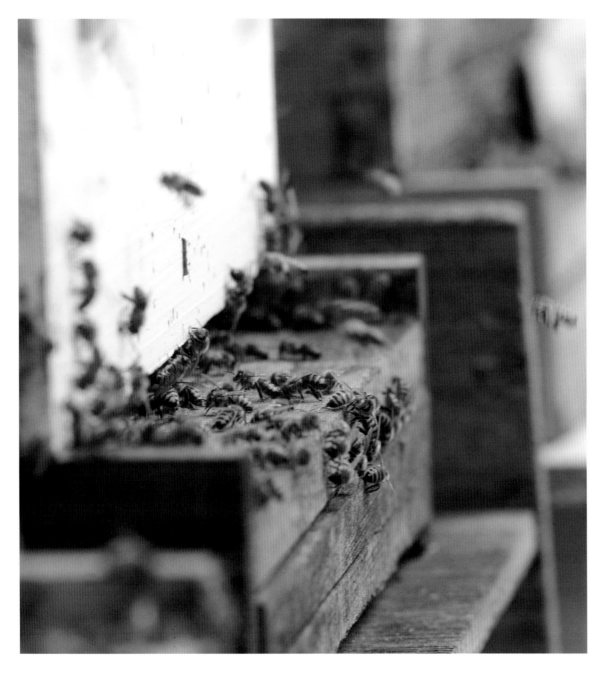

Chris explained how he became a professional apiarist after taking pre-law courses in college at SUNY New Paltz more than twenty years ago. At about that time, he bought the house he currently lives in, along with a colony of bees living in the wall of one outbuilding. "I called an exterminator and he finished them off," Chris said. That winter he bought a beehive and started over "to pay them back for what I had done. . . . I wanted to replace the colony I destroyed—in a box, not in the wall, however!"

For eight years Chris went to class with an expert who taught conventional beekeeping methods. Then he discovered biodynamic farming in relation to beekeeping. He countered my skepticism, saying, "When there is a solar eclipse in another part of the world, it's not a good time to plant; it's true!" The *Biodynamic Agricultural Planting Guide* by Stella Natura, based on Rudolf Steiner's observations, details "root days" and "fruit days." This philosophy also claims there are certain times of the month that are best to work with hives; in fact, before Chris learned biodynamic techniques, he lost bees to pests.

Bee colonies collapse due to stress on the hive and malnutrition. There are "professional pollinators" who travel throughout the country. Large apple orchards pay them to bring in one hundred hives for a couple of weeks and locate them strategically in the orchard. In recent years, however, even these professionals are losing their bees. The constant moving is stressful to the colonies, Chris explained. "When

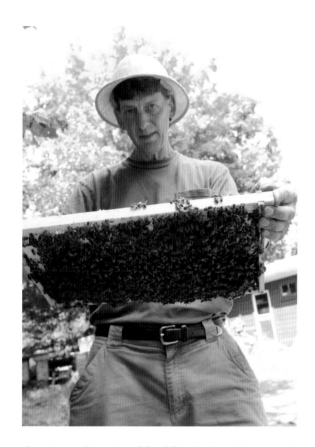

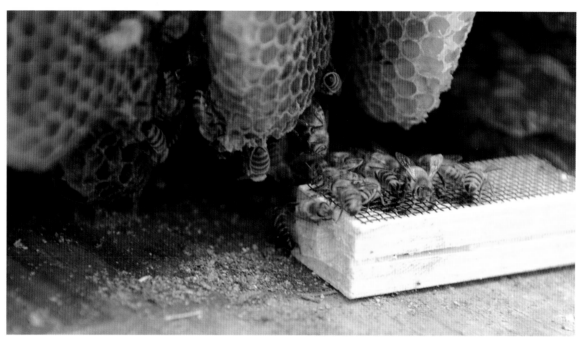

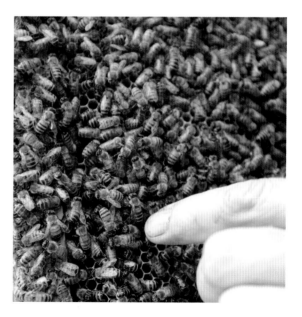

there is no diversity of food for the bees due to agribusiness farming methods, the embryos weaken and become susceptible to bacteria and viruses." Feeding them badly means no nectar is produced. "Developing bees have to consume high-quality food, not corn syrup, which is cheap and available."

Students now come from all over the country to take the beekeeping classes Chris offers during the winter through his nonprofit organization, HoneyBee Lives, and learn from a steward of these treasured creatures.

Clockwise from top left: Chris Harp holding a honeycomb covered with busy honeybees; a new queen bee is introduced into a hive; Chris Harp pointing out different kinds of honeybees; Chris Harp pointing at mites in debris from the hive. They are connected to severe die-offs in bee hives nationwide. *Opposite page:* honeybees enter and leave the hive.

SAUNDERSKILL FARMS Accord, Ulster County

"This land has been farmed by twelve generations of Schoonmakers."

When travelers like myself stop at an oasis on Route 209 between Stone Ridge and Ellenville, enticed by a busy market/bakery and greenhouse bursting with colorful flowers in season, most of us don't consider where we are. The shop at Saunderskill Farms is part of the second oldest farm in New York State, dating back to 1680. Named for the tributary of the Rondout Creek that flows through it, the original three hundred acres was granted to Lieutenant Hendrick Schoonmaker by Peter Stuyvesant in 1663 as payment for military service. The land has been farmed by twelve generations of Schoonmakers.

I met Dan Schoonmaker and his wife, Kathy, in the farmers market. The aroma of freshly baked pies and coffee wafted through the air. All kinds of irresistible treats surround shoppers: hanging baskets of flowers, pots of herbs, ripe tomatoes, sweet corn, several varieties of apples, and an array of vegetables, as well as cider, sandwiches, and salads for takeout.

Dan and Kathy, married for thirty years, have three daughters, all in their twenties; the oldest manages the bakery and the youngest works on the farm. Their oldest daughter is getting married soon, and her husband-to-be will also become part of the Schoonmaker farm, in partnership with Dan's brother and father.

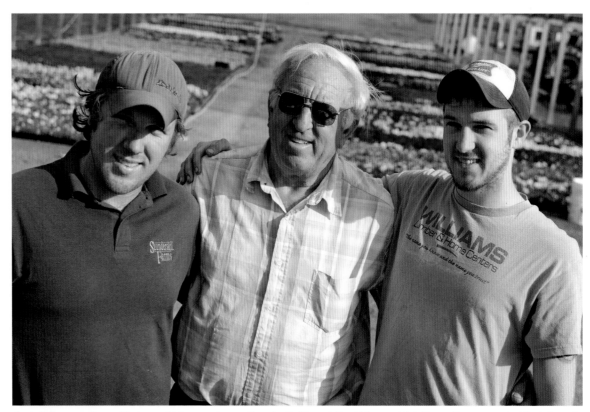

Jack Schoonmaker with two of his grandsons, Randy (left) and Scott Long (right), on the second oldest farm in New York. *Opposite page:* greenhouse packed with flowers ready to go to market in June.

A recent addition to the wholesale operation and greenhouses, the retail store opened in 1997 and now makes up about 25 percent of the family business. The Accord farm includes eight hundred acres of vegetables, flowers, and orchards, as well as thirteen greenhouses, Kathy explained, showing me a photograph with an aerial view of the magnificent countryside. The stone manor house

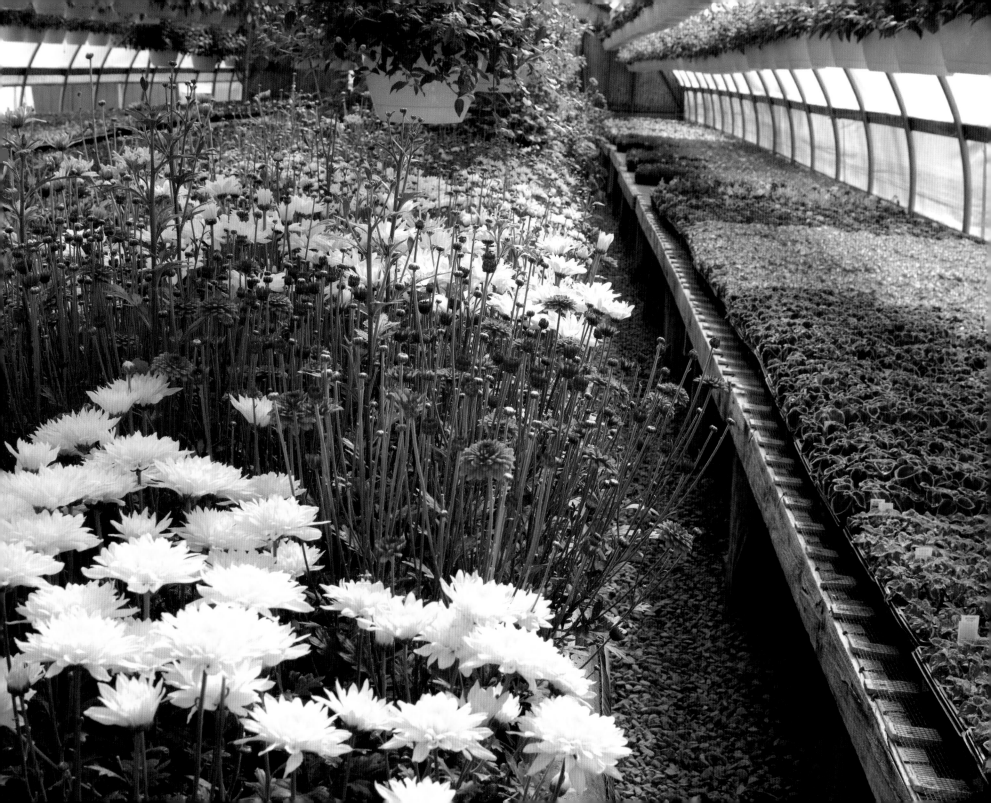

on the property dates back to 1787 along with a barn that once housed oxen used to pull barges on the nearby Delaware & Hudson canal.

Dan told the story of his great-grandfather, whom he is named after. One winter day he took a team of horses to Ellenville and came down with a terrible sore throat that became infected. He passed away, in his late forties, before the doctor made it to Accord. Minnie Schoonmaker, his widow, took over the farm. "When she walked into a room, people stood up; she was a formidable figure in the area back then," Dan said proudly. "She was probably the only woman running a farm alone in Ulster County at the time!"

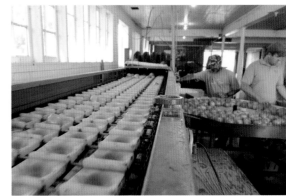

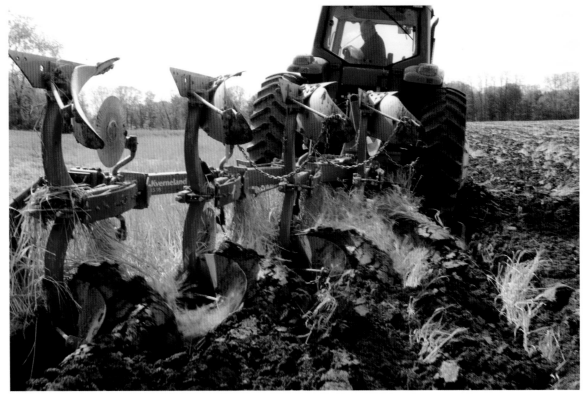

Clockwise from top left: string beans ready to be picked in August; a machine sorts tomatoes by weight, drops them into a hopper, and workers pack them for shipment to market; plowing the field. This exact row will be planted with the string beans above; truck packed with six-packs of impatiens ready to go to market.

DAVENPORT FARMS Stone Ridge, Ulster County

"Growing and selling are combined here; that's what makes it all work."

To residents of Ulster County, the name Davenport is synonymous with farming. The family has lived here for five generations, beginning in the 1840s with Isaiah Davenport, who used to deliver produce to the local groceries and Catskill hotels by horse and wagon.

Nearly two centuries later, brothers Barth and Bruce Davenport are keeping up the family tradition in twenty-first-century style. Fruits, vegetables, bakery items, and gourmet treats are all sold to customers at the Davenport roadside shop on Route 209 in Stone Ridge, started by their father in the 1960s. The fact that the store is so close to the farm eliminates the need for a distributor: "Growing and selling are combined here; that's what makes it all work," Barth emphasized.

Less than a mile from the retail outlet, Barth, who loves working outdoors, showed me around the four-hundred-acre spread owned by his family. Only one hundred acres are farmed with an array of crops; three hundred acres are leased out to one of their cousins for corn only.

In early May the tomatoes, melons, peppers, broccoli, and squash had recently been planted. Barth explained how a great deal of their produce is sold to local chains, including Hannaford. I had no idea the large food stores purchased crops from local farmers.

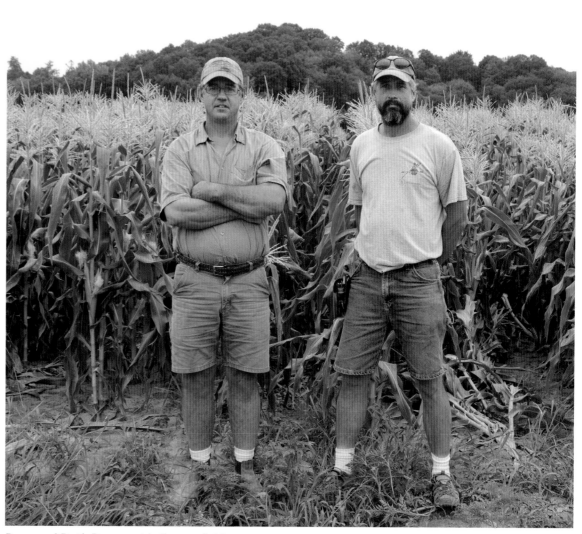

Bruce and Barth Davenport in the cornfield.

Davenport family members are involved in every task at the farm: planting and harvesting, as well as the greenhouse and retail operations. Barth pointed to trailers on the property and explained that the same four or five people come north from Florida every season to harvest their crops.

Both Barth and Bruce obviously love what they do, and there is a relaxed ambiance around both the farm and the store. During the winter months, Barth works as a ski instructor at Windham Mountain; his wife is a teacher. When I asked if either of his two children would become involved in the farm, he told me his son is an accountant in Manhattan and it was unlikely he would make such a drastic career change. "Then again, you never know," he laughed, acknowledging that when he was young he changed his mind several times before coming home to the family farm.

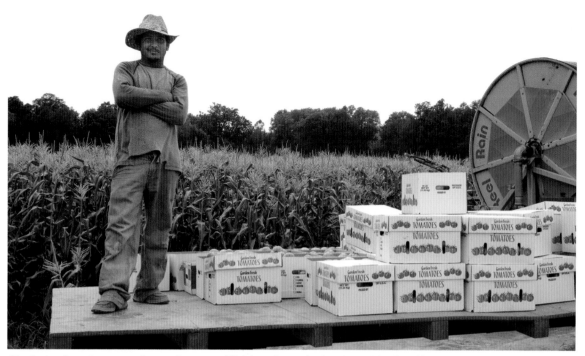

Clockwise from top: one of a small group of field workers who has just picked and boxed tomatoes; an expansive field of blue ageratum the Davenports grow to be sold as cut flowers; a honeybee collecting pollen on a sunflower. *Opposite page:* antique fixtures in the farm store date back to the 1940s.

STONE CHURCH FARM · Rifton, Ulster County

"I realized these must be the best-tasting ducks in America, yet not one restaurant offered them on their menu!"

The enormous stone structure dates back nearly 150 years, having served as a school, meetinghouse, and all-purpose center of Rifton. Since 1982, it has been home to Robert Rosenthal and his wife, Noeli.

Paths and gorgeous gardens lining the banks of the Wallkill River attest to the couple's enormous

improvements on both the house and grounds. "We bought animals—some free-range chickens, pheasants, and guinea hens—and sold cut flowers," Robert said, noting there was not much of a market for locally farmed products at the time. His industrial design and architecture background from Pratt weren't much use on the newspaper route he took

on back then. "It paid the bills," he said, smiling.

I wondered where those wonderful European heirloom ducks I had seen featured on menus were. Stone Church Farm was renowned for meticulously raising heritage breed ducks from Sweden and France, to be served in the finest restaurants. "We couldn't sell them in the Hudson Valley in those early years," Robert recalls.

Finally, the Culinary Institute became a customer and Robert started raising chickens, rabbits, and quail at small farms with whom he contracted. "I brought in the breeding stock and provided the diet to feed the birds; I oversaw everything," he explained, saying how the farmers were happy to have a year-round business. Eventually, the Stone Church natural chicken's reputation spread and restaurant orders grew.

Robert surveyed his customers and discovered what was missing from all their menus was high-quality duck. The standard being served was American Pekin, a bird that tended to be on the fatty side. "I realized if I could fill this gap, I might have a good business." Robert was unable to find any duck growers locally; it was difficult, as free-range ducks require a great deal of land, so he started traveling to Pennsylvania. On one trip he met a Mennonite farmer who was a "backyard grower," with twenty-

five different breeds of ducks. "I realized these must be the best-tasting ducks in America, yet not one restaurant had them on their menu!"

Seeing that the Mennonite farmers grew poultry with old-fashioned methods, Robert contracted with them. He refers to this period as running "a test kitchen"; they experimented with several breeds before settling on six. "The ducks from Normandy, France, became our biggest seller; we were selling eight hundred per week."

There were eight identical farms. "We raised Normandy and Duclair ducks, the best ever in America," Robert said proudly. "There are a few things that contribute to growing the best ducks—the breed, the land, and the method of growing." This leads to excellent taste and texture. "You really must eavesdrop on the animals; find out what they want and they will give you what you want." This may appear to be an unlikely response from an exceedingly logical person, but if you think about it carefully, it *is* logical—and the most successful farmers of livestock would probably concur.

Unfortunately, due to the fact they were taking the ducks across state lines after slaughter, the USDA shut down their business. Robert and Noeli are in the midst of a new venture on the land at Stone Church Farm, an ecological food research center, where they will breed, hatch, and grow heritage poultry and meat according to French traditional methods.

The garden at Stone Church Farm. *Opposite page:* Stone Church Farm; Robert Rosenthal.

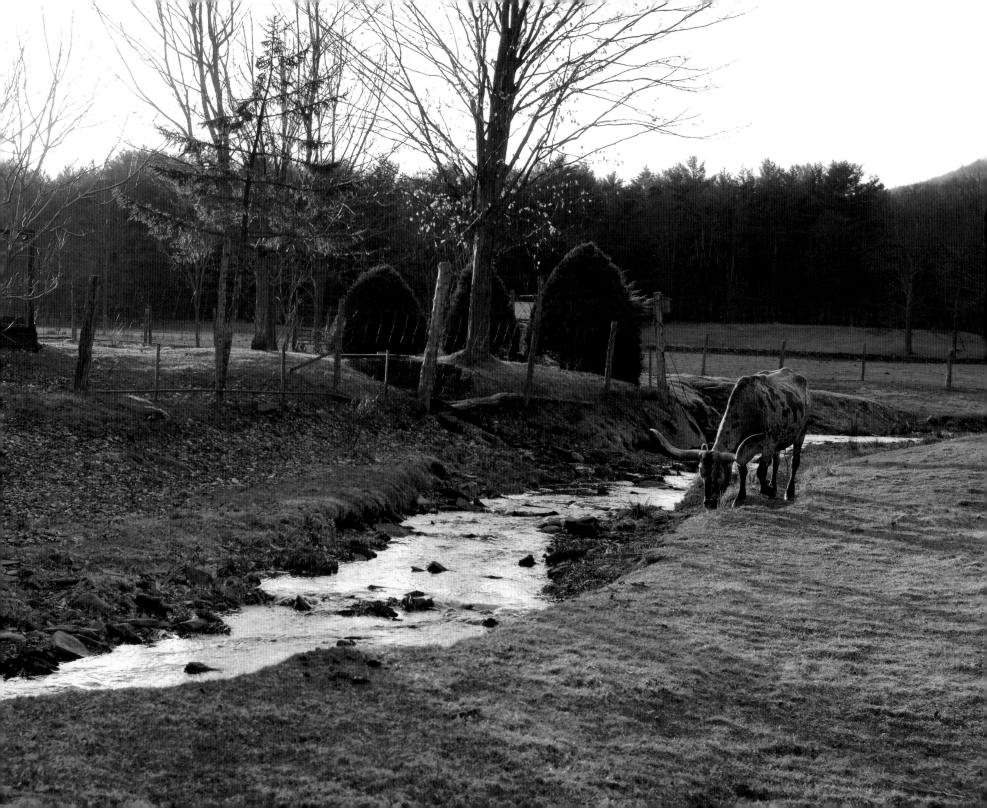

LONGYEAR FARM Woodstock, Ulster County

"The Longyears arrived in Ulster County in the mid-1700s."

The Longyear Farm dates back to 1946, when Stanley Longyear Sr. returned from World War II and fulfilled his dream—to own a farm. He purchased the forty-acre Schoonmaker Farm, at the end of Schoonmaker Lane, and raised cows, chickens, and pigs, creating a wonderful life for his expanding family. His wife, Marion, still resides in a house on the property at the age of eighty-seven and is proud that the Longyears arrived in Ulster County in the mid-1700s.

Although the dead-end road that opens up into the farm is close to town, it feels completely removed from civilization. Overlook Mountain and the Catskills surround the barns, a maple syrup house, and a large, cozy log home, creating an insular homestead in an idyllic setting.

Stanley Longyear III took over the farm from his father in 1989 and expanded it, creating a nearly 100 percent sustainable operation with fresh eggs and beef. Just about everything on the farm is recycled and put to use. One Christmas, Stan purchased Longhorn cattle for the farm as a present for his wife, Kathy, a Texas native; their brand, III (for Stanley III), appears on all the horns. "In the Longhorn world, it's all about horn length . . . that's what makes them valuable," Kathy explained. "Longhorn cattle are a little smarter, and you can use everything on them." In fact, the beef from these animals is lean and contains less cholesterol than chicken. The cattle are ready to be slaughtered after eighteen months to two years; that's when the beef is just right.

Kathy, who is employed as a clerk by the Town of Woodstock Justice Court, noted that if it weren't for the New York State agricultural exemption, the family farm couldn't exist. After Stan passed away

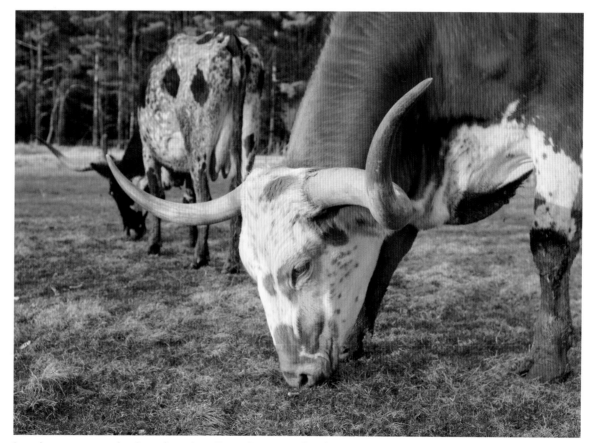

Longhorn cows grazing in early spring. *Opposite page:* a longhorn grazing near a stream at dusk.

The farmwork appeals to Matt, despite the fact that cows have to be fed twice every day, no matter what is happening in your life. "You also become fairly expert at ministering to the cows and their ailments since you can't put them in the car and ride off to the vet!"

Matt is making changes and taking the business in a different direction. He's raising a new breed of Longhorns and is marketing the beef through a local retail outlet, Sunfrost, less than a mile from the farm. Currently, the store supplies scraps for the pigs at the Longyear Farm. "Those pigs eat better than many people in this country do!"

Matt recently learned to hay, a process that includes cutting, fluffing, raking into rows, and baling up grass in the fields during the hot, dry weather. They store the three thousand bales harvested during June and July, avoiding the expense of buying hay. Excess bales are sold to fellow farmers.

"My father loved the farm, he enjoyed growing things, making maple syrup," Matt said, going on to explain that those long horns I had just touched were alive. Filled with blood, they continue to grow throughout the life of the cow.

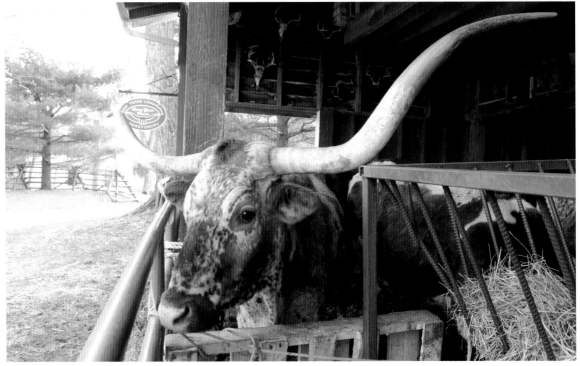

Left: Matt Longyear. *Above:* a longhorn cow in the barn maneuvers horns around poles and machinery effortlessly. *Opposite page:* Matt Longyear moving the cows from the barnyard out to the pasture.

in 2005, their son, Matthew, and his wife, Heather, decided to continue the family farming tradition, all the while working full-time jobs: He's a lineman for Central Hudson Electric Company, and she is a teacher. Matthew's brother, Stanley Longyear IV, is also involved with the business. "It's not like work if your heart is in it," Matt told me, as we walked through the barn and he proudly showed me fourteen cows and one bull.

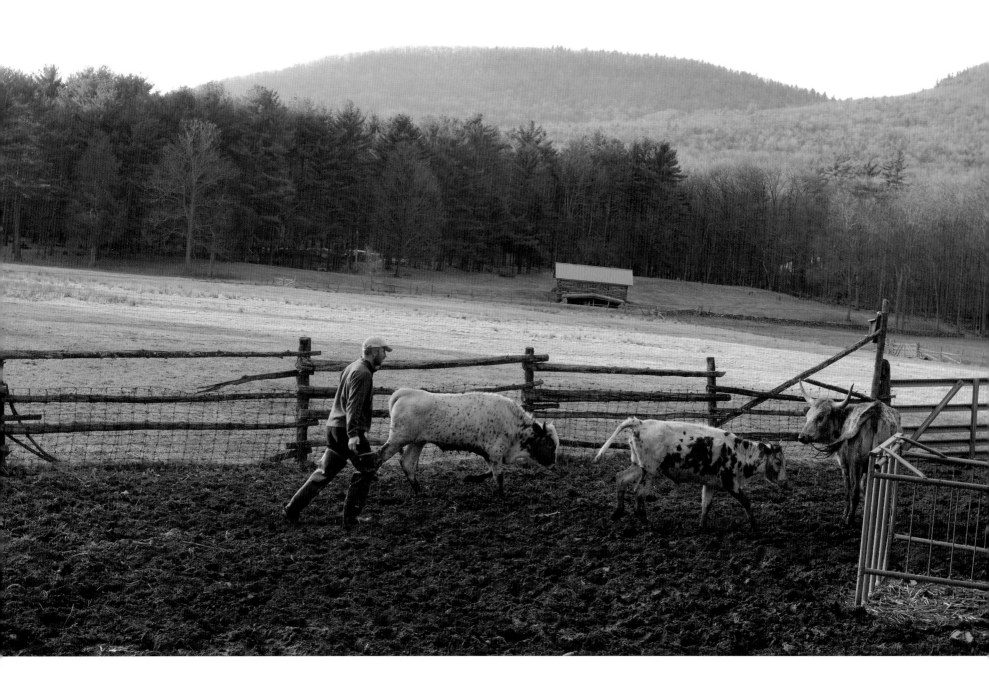

MISTOVER FARM Pawling, Dutchess County

"This was his dream, to have this place; I'm just grateful it was completed before he passed away . . ."

*I*wasn't one of those people who grew up riding horses; it was something I started to do in my forties," Carol Paterno explained, standing in the magnificent dressage training facility she built with her late husband, Michael, in 2000. The 160-acre property includes thirty-two immaculate horse stalls as well as an enormous indoor arena heated for winter use.

Carol's in-laws owned five hundred acres of land across the street from what was then an old dairy farm. When that farm went up for sale, Carol and Michael bought the land and transformed it into Mistover. The farm is named for their trainer Jayne Marino's family home on Cape Cod; she is now full partner with Carol, after Michael's death from colon cancer. "This was his dream, to have this place; I'm grateful it was completed before he passed away in September 2001," Carol told me. "Jayne is a professional horseperson. I'm the businessperson. I love what we built, but this is not what I would have done." Nevertheless, Carol and Jayne are carrying on Michael's dream quite successfully.

Carol took me into the feed room, lined with beautiful wooden cabinets and barrels filled with oats and barley. Each horse has a bucket with its name on it along with charts posted on the walls with variations in the usual feeding routine. Vita-

mins and medicines for the horses are kept here as well. The horses get grain twice a day, although some require five feedings. Other horses are allergic to the pine shavings on the stall floors, so their stalls are provided with cardboard shavings. We passed five washing stalls on the walk to the tack room. Feeding, cleaning, and walking are all included in

the monthly board of $1,850 for a twelve-foot by twelve-foot stall.

There are few vacancies and it's apparent why. Every horse at Mistover is treated with love and care and given individual attention. The farm is a dynamic entity, a "living, breathing thing," as Carol described it. "Working with horses is dealing with

fellow beings on the planet and each one is independent with a distinct personality; there is a daily give and take with fellow creatures that makes this life so worthwhile. It may not be wonderful all the time— there are people involved with the care of the horses and all of them have their lives and problems—but they are a great group of people, and Mistover has a special energy because of each one of them."

"Taste the difference a little grass makes!"

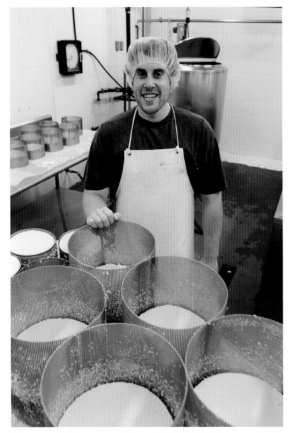

Director of cheese-making, Colin McGrath, a graduate of the Culinary Institute of America (CIA) in nearby Hyde Park, thoroughly enjoys his work. *Opposite page, clockwise from top left:* goats foraging on low branches while a group of schoolchildren passes by; Margo Morris gently greets a brown friend; sheep and cows grazing in the field; cheese curing on metal racks in a custom built cheese cooler.

The mission of two-hundred-acre Sprout Creek Farm—to connect people with animals and nature, as well as one another—is immediately in evidence upon arrival. Margo Morris led me into an enormous farmhouse kitchen where there was a large towel-padded playpen with two baby goats. "If they nurse, they can develop an arthritis-like virus" passed on through the mother's milk. "So, we keep them here, pasteurize the milk by heating it to 180 degrees, which kills the virus, and it's then cooled and given to the goats in baby bottles." When I wondered how she figured out this system, Margo told me: "I had to learn by reading, doing, and making mistakes. . . . As a woman, I wasn't taken seriously by neighboring farmers and it was often difficult getting information from the local grapevine."

Out of this experience, Margot revealed, grew a "feminine version of farming," designed to nurture the land, plants, children, and animals. "This environment is a place where you can give and get back—food and affection—as well as watch how things work." From birth to death, Sprout Creek Farm melds reality and a means to deal with it.

Agriculture, education, and environmental awareness come together here with enticing programs for both children and adults. There are goats, sheep, cows, chickens, ducks, and pigs, as well as all types of vegetables and herbs being grown. Several people were planting an orchard when I visited—a memorial to a man who had worked on the farm and had passed away. Grasses and pasture are grown to feed the animals. Classes are offered to students from all over the region—thirty-six residential children and approximately forty day students ages five to eleven. Children watch the entire process: Grass becomes the milk that is transformed into cheese. The farm encourages visitors, and it's quite a treat to taste the antibiotic-free cheeses from the cows and goats. Colin McGrath, the director of cheese making, graduated from the Culinary Institute of America (CIA) and enjoys telling people why these grass-fed animals are different—and produce better cheese.

A farm is a dynamic complex of interacting systems. At the heart of this bustling community is Sister Margo, formerly a high school teacher at the Convent of the Sacred Heart in Greenwich, Connecticut. She left in the late 1980s after years of running a small farm at the school, a place she described as rather "cloistered."

"We have no big foundation behind us; we just figure things out as we go along . . . and we are still figuring them out each day!"

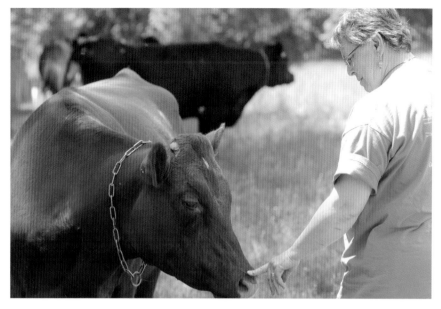

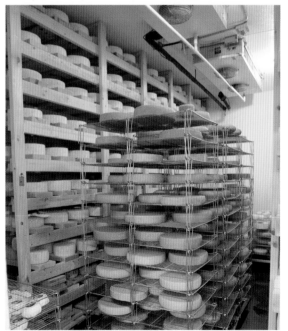

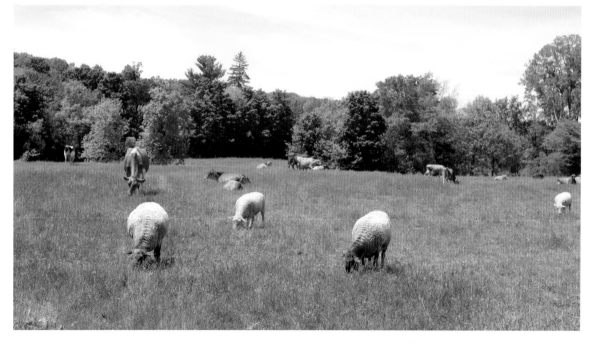

WIGSTEN FARM Pleasant Valley, Dutchess County

"You won't find my Romanesco tomatoes at Wal-Mart!"

Paul Wigsten is the fourth generation of his family to farm in Dutchess County and the third generation at the location in Pleasant Valley, a dairy operation until the early 1970s. "You can trace our roots back to dairy farmers in Ireland," Paul told me. "Wigsten's Ice Cream was quite well-known locally during the 1960s."

Paul and his wife, Robin, explained the reasoning behind this transition. "Neither of us wanted to milk cows twice a day, and I had always grown crops," Paul said, going on to describe how he does the tractor work and Robin handles the financial aspect of the business. Crops are staggered for seasonal reaping, but weather, of course, is the controlling factor. No sooner had this been mentioned, than our conversation was interrupted by thunder, lightning, and a downpour.

At one point Paul spent twenty-five years in the cattle trade. "I sent a 747 to Iran every year filled with cattle," he remarked, adding he also exported to Nigeria, Colombia, Costa Rica, Bermuda, and Spain. That business ended when these countries began breeding their own cattle. Paul then moved into commercial real estate in Manhattan for a decade before returning to the farm.

Paul and I hopped in his truck and minutes later we were traveling through the fields. The sun had just come out after the passing thunderstorm. "You can't touch tomatoes when they're wet," he noted, again emphasizing how farmers are prisoners of the weather. If there's a drought, he hooks up the irrigation system that covers forty acres.

Paul pointed with pride to twenty types of melons and an array of heirloom varieties of potatoes with names like Pride of Wisconsin, Keuka Gold, Yukon, and Laratte. "On Independence Day we make Fourth of July Potato Salad made with red, white, and blue potatoes!" he boasted. The fifteen types of heirloom tomatoes, as well as "ugly tomatoes" (the purple and yellow varieties), keep people coming back for more. There also are onions, leeks, and green and yellow varieties of round zucchini.

The crops are on a five-year rotation schedule, and at any time half the farmland is in hay; the changeover keeps the soil healthy by continually using different nutrients. Compost and manure fertilize the crops, and red worms, ordered over the Internet, add to the mix.

In addition to his farmwork, Paul is the produce buyer for the restaurants at the Culinary Institute of America (CIA) in nearby Hyde Park. With the price of California produce increasing, due to rising costs of fuel and transportation, local crops have become more attractive. "I like the weird stuff," Paul told me, explaining how vital it is to keep on the cutting edge for his CIA work. "Mesclun lettuce was the rage a few years back; now it's baby mix," he said, explaining how food fads are as fickle as those in the fashion world.

A case in point is the Ramapo tomato, a New Jersey variety developed years ago that went out of production. Recently, agronomists decided to bring it back. "They bred seeds at Rutgers, and I can't wait to try it," Paul mentioned, excited at the prospect. He claimed any farmer can grow corn and tomatoes. "I like to grow vegetables for restaurants that appreciate the unusual and are willing to pay the price," he said. "You won't find my Romanesco tomatoes at Wal-Mart!"

Clockwise from top left: Wigsten's farmstand table at the farm; Paul Wigsten arranging the vegetable display at a farmers market; fresh produce for sale at Wigsten's table at a Saturday farmers market; watermelons; round yellow zucchinis. *Opposite page:* "ugly" heirloom tomatoes for sale.

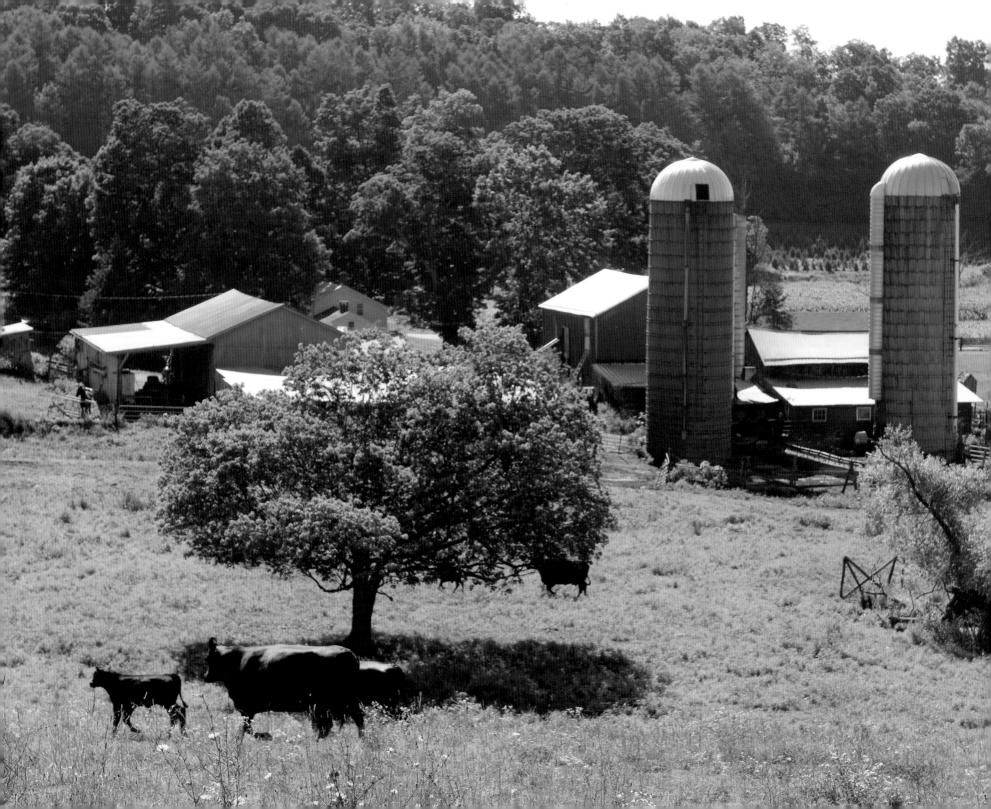

HAHN FARM Salt Point, Dutchess County

"I'm happiest when I'm on my tractor, unencumbered by distractions."

On a warm spring afternoon, Thomas Hahn related the story of his seven-generation farm in rural Dutchess County. We were sitting in a golf cart he uses to travel the six hundred acres that make up the Hahn Farm, looking out on a pastoral expanse of land. "Years ago farmers grew a little of everything and were self-sustaining, like my grandfather," he explained, going on to say how most specialized in dairy farming during much of the twentieth century. When, in the 1980s and 1990s dairy farms started to disappear, his farm began selling hay and beef (including their locally renowned homemade hamburgers) for "the freezer trade" in a small store at the entrance to the farm on Salt Point Turnpike.

Diversity proved to be the key to survival for the Hahns. On autumn weekends since 1990, they welcome thousands to a fall festival. "Everything about our farm feeds off October," Thomas told me, mentioning their store donut machine sells more than twenty thousand at harvest time. They've also hosted a couple of Cajun festivals featuring zydeco music and more recently have begun growing Christmas trees and boarding horses. They are also open for educational tours, so school children can see close-up baby chicks, pigs, turkeys, goats, sheep, and alpacas. I was surprised to hear about this range of activities as I looked out on the tranquil landscape.

"Not everyone has the personality to have a public farm," Thomas observed, telling me about his three wives. In fact, he was one of only a couple of farmers I met who had divorced and remarried. "My second wife would ask me, 'What do I *have* to do today?' My third wife asked 'What *can* I do

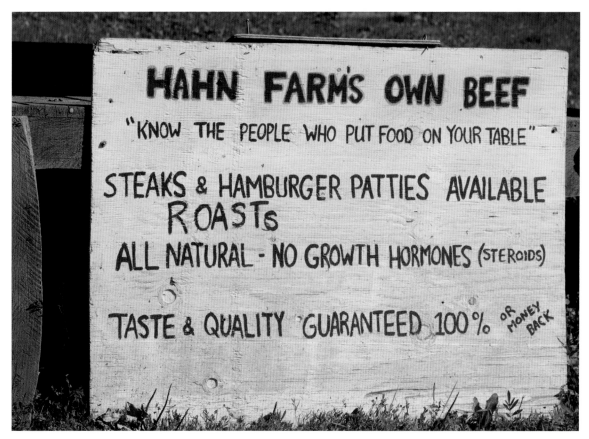

Sign at the roadside stand. *Opposite page:* barns at Hahn Farm.

today?'" Thomas explained how that difference in attitude made a world of difference in their lives together. His stepson, who has been working with him for several years now, will eventually take over the farm.

The alpacas were Thomas's current wife's idea. Lolita, Giselle, and Anita arrived from Massachusetts in December 2004. Gus and Oliver were born the following year; and in 2006, Butler, Cowboy, and Betsy Ross joined the camelid family. "They're like big pets," Thomas remarked, adding that their fiber (it's not called wool) is sold in the farm shop as well.

The retail shop at Hahn Farm doesn't sell its products to restaurants, just direct to the public on Saturday mornings. Locals and weekenders purchase beef, pork, and chicken—all are grain- and grass-fed from crops grown on the farm. The two slaughterhouses they use are both in the county—one is in Pine Plains; the other, for chickens, is in Oak Hill.

"We are going back to what farms used to be—self-sustaining—and hay is our biggest income," Thomas told me. "I'm happiest when I'm on my tractor, unencumbered by distractions," he reflected. "I enjoy getting up and getting at it; that's a farmer's life."

Above: a young calf, just two days old, is ear tagged before it can run away. *Right:* Hay for sale. The retail shop sells direct to the public on Saturday mornings. *Opposite page:* Hahn Farm's expansive spread of land makes it a great venue for the annual October fall festival.

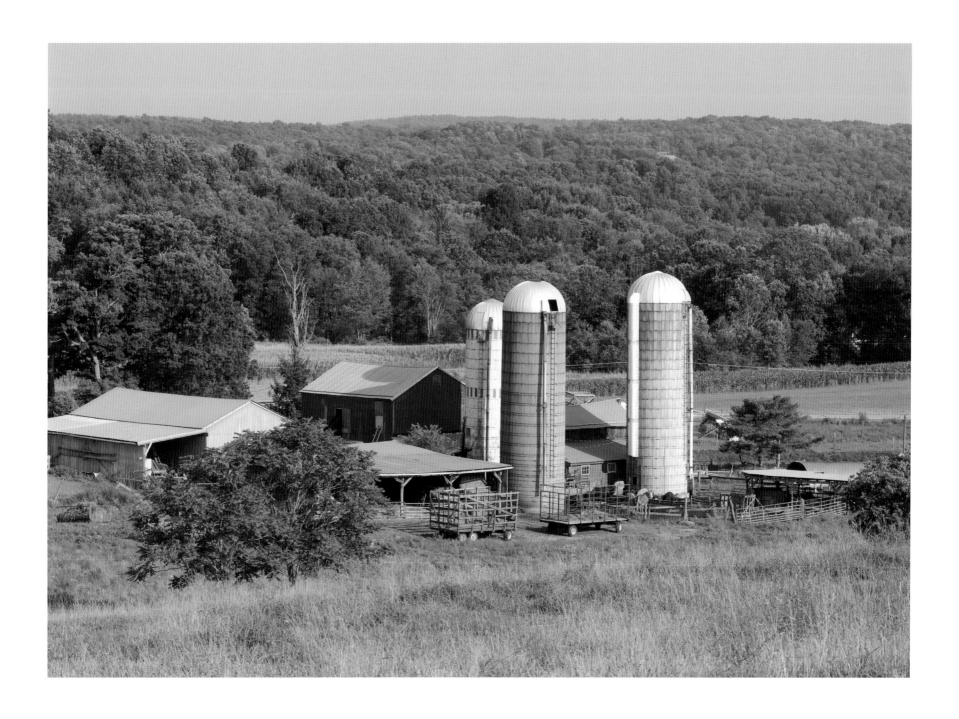

MILLBROOK FARMHOUSE CHEESE Millbrook, Dutchess County

"We treat the goat's milk like gold."

We always had pigs," Dawn Carolei told me, explaining how her children were members of 4-H throughout their school years. "And all my daughter wanted for her tenth birthday was a goat." So she got one, a female. And every morning she took care of her new pet. The goat was bred in order to get milk. Little did anyone suspect this family pet would eventually lead to Dawn's cheese business and a partnership with her friend, Diane Massone.

Millbrook Farmhouse Cheese evolved gradually over the twelve years after Dawn's children fell in love with goats. The women discovered they had an abundance of goat milk. They obtained state certification in order to sell the milk at a local farmers market. The small farm operation has continued to expand. In their spare time, the women market their cheeses to restaurants and develop different products, including a hard cheese line, as well as a goat cheese Camembert, mozzarella, and ricotta.

When I visited, three sows had recently given birth to two litters, producing eleven baby goats in all. There were eighteen total: Four were pregnant, and the rest were yearlings (dry goats). Approximately fifty babies will be born this year. "Some people have no idea where milk or cheese come from, but not our kids!" Dawn told me.

Neither of the women has given up her day job. Dawn works for the Dyson Foundation (they lease eight thousand acres of pasture land to the farm), and Diane is an administrator at the Millbrook School.

After sampling the cheese, I noticed a more flavorful, milder taste compared to commercially produced goat cheese. "Our cheese is easier to digest; the fat globules are smaller and the cheese is handled delicately," Dawn explained. "We treat the goat's milk

Diane holds a kid. *Opposite page:* goats are naturally curious.

like gold. Really, we keep the goats happy and they produce excellent milk!" In larger operations, fat globules are easily broken during processing, releasing acid and changing the flavor of the cheese. The sharp taste arises from mishandling of the milk. The way the milk is processed and how the cheese is aged combine to affect its flavor. Mixing cow and goat's milk preserves the unique goat flavor without the cheese becoming "too goaty," according to Diane. "That pungent flavor turns off many people!"

The women are farmers who care deeply for the animals they raise: They individually tend their goats from birth. "The quality of life of our goats is important to us," Diane emphasized. "They have access to over eight hundred acres of pasture 24/7."

The goats have been given no antibiotics. "Our own hay is given to the goats so we know exactly what is in their feed," Dawn added. Diane fell in love with the creative aspect of the business: taking raw material (controlling how the goats live and what they eat) and finally making cheese. In more than a decade of being involved on the farm, she says, "Raising goats and making cheese have never become routine; every year I learn something new!"

Before I left the farm, Diane and Dawn took me through the barns and introduced me to their extended goat family. Each animal has a name and, they claimed, a distinct personality. From what I observed, the women are right . . . goats are not only stubborn but can be loving, affectionate creatures.

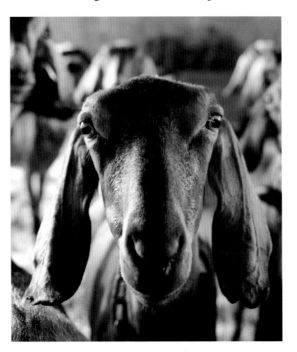

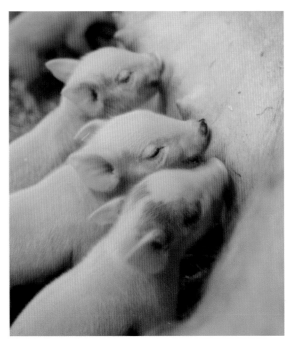

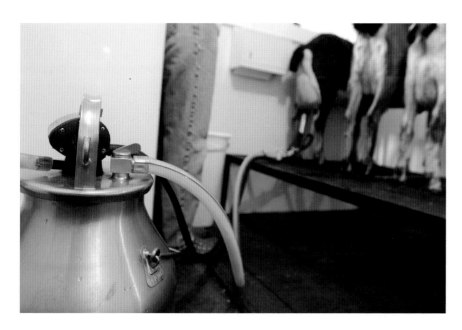

Clockwise from top left: milking the goats; feta cheese is made by hand; the final product; this chart helps keep track of births and feeding schedules. *Opposite page, top left to right:* Diane fills a bucket with milk to feed a pen full of kids; hand-feeding a very young kid; curious goats in the barn; several day-old piglets grab a meal.

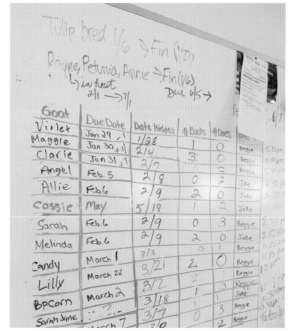

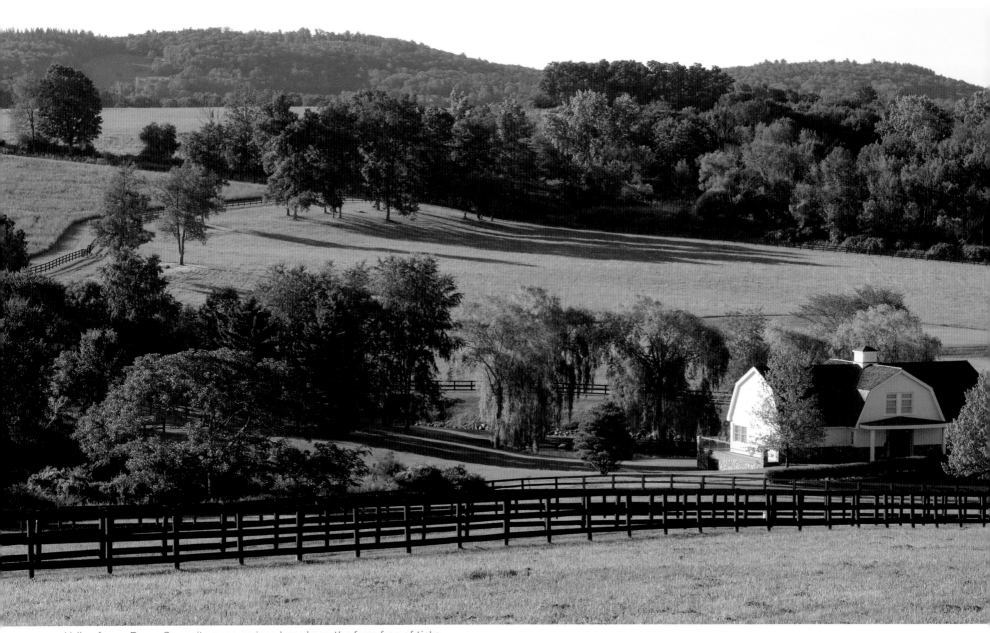

Yellowframe Farm. *Opposite page:* guinea hens keep the farm free of ticks.

YELLOWFRAME FARM Millbrook, Dutchess County

"You won't hear any engines here; just the sounds of a manure spreader and birds singing."

*Y*ellowframe is a sprawling manicured horse farm of 125 acres bordered by two farms that are thousands of acres on each side. There is little chance of development encroaching here as it did back in the late 1970s on the Tobers's weekend home in Croton Falls, New York. This change in the landscape is what got them to head north at the advice of Paul Fournier, their farm manager for nearly thirty years. "You won't hear any engines here, just the sounds of a manure spreader and birds singing," Donald Tober remarked, as we sat on the terrace of one of the guesthouses on a summer Sunday afternoon.

Paul gave me a tour of the grounds in a golf cart. I asked about the tall grasses that lined the mowed paths and the possibility of ticks that spread Lyme disease lurking, a major health problem in Dutchess County. "I let the guinea hens out regularly," Paul remarked, explaining that they consume hundreds of ticks at a time.

Millbrook is the center of all things equestrian in the Hudson Valley, and the Tobers own fourteen horses. Ten are retired animals that they have saved by taking them in; four are their own. Miles of horse trails meandering through acres of manicured land are visible, but an entire world exists in this picturesque corner of the region that most visitors never experience.

Don, gracious, friendly, and proud of his farm, is one of the governors of the Millbrook Hunt, founded in 1907; the group currently has seventy-six active members. The landowners groom acres of trails as a communal effort: Their respect for the land makes the camaraderie of the hunt possible. Landowners must grant permission to allow the horses and hounds to cross their property at different times of day.

Foxhunting in America began in eighteenth century Virginia and Maryland, where local planters imported red foxes from England. George Washington was a regular participant. The hunt begins its season in October and is full of rituals, tradition,

Donald Tober, owner of Yellowframe Farm, is one of the governors of the Millbrook Hunt, whose beautiful October opening day is filled with pageantry. *Opposite page, clockwise from left:* groomer leads a horse out to be ridden; Yellowframe Farm fields; a horse being groomed.

and strict rules. It also offers gorgeous pageantry—members get decked out in tan riding breeches, black and orange coats, and velvet caps. The horses follow hounds, whose sense of smell enables them to track the scent of foxes (or strategically placed fox urine) at great speeds. The aim is to chase, not kill, any foxes.

Barbara Tober, the chair of Manhattan's Museum of Arts & Design (previously the American Craft Museum) and former editor-in-chief of *Brides* magazine, has been riding since she was a child in Yellowframe township New Jersey, hence the name of the farm. "You *can* go home again," Don said, telling how he had the originally red buildings painted yellow to please his wife. When he's not enjoying weekends at Yellowframe, Don is CEO of Sugar Foods Corporation, manufacturers of Sweet'n Low, among other products.

As evident from their lifestyle, the Tobers know success is more than what money and hard work can bring—it's peace of mind. They say they love to get to the farm Thursday night so they can wake up there on Friday morning. At a stage in life when most people in their position are retiring, they seem energized by the challenges of life in both New York City and the country, at work and at play. As Barbara casually observed, "Being successful is all about problem solving and knowing how to get things done."

IRVING FARM Millerton, Dutchess County

"You can source the same coffee beans; but the taste depends on how they are mixed and roasted."

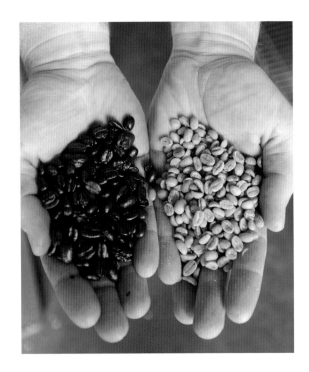

The distinctive aroma of roasting coffee wafts through the air as soon as you step into the renovated nineteenth-century carriage house outside the village of Millerton. The partnership that produced Irving Farm dates back to 1996, when Steve Leven and David Elwell, friends from Syracuse University, opened a cafe on Irving Place in Manhattan. (They now own another place—also called Irving Farm Café—in New York City at 56 Seventh Avenue.)

A friend in the coffee business suggested they become more involved with their product. "So a couple of years after opening the first cafe, we began roasting our own beans, and bought this five-acre property," says Steve. In the late 1990s Irving Farm was run-down and required work, but Steve had experience in construction and began gradually making improvements. The result is the current beautiful cedar shingle complex. Obviously, coffee beans can't grow in the Hudson Valley, but exciting new flavors evolve by blending a combination of estate-grown beans from throughout the world. Steve, a former film major, pointed to huge burlap bags neatly stacked and marked in a storage area with their place of origin: Hawaii, Panama, Costa Rica, India, Indonesia, and Africa.

Roasters have to create a unique style all their own. "You can source the same beans; but the taste depends on how they are mixed and roasted," Steve explained. Premium beans are larger, hence bigger is better. Irving Farm uses large beans exclusively. Darker ones are more acidic than those that are lighter. The elevation at which beans are grown largely determines taste. Because of the small roasting environment here, taste can be controlled. After tasting the coffee, I agreed that it's particularly flavorful.

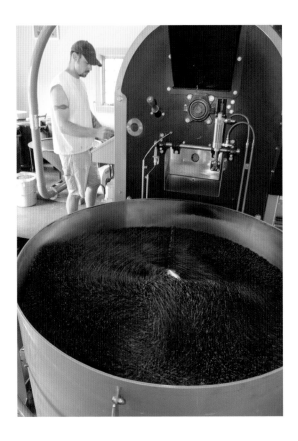

Steve and David have a goal for the near future—that their coffee should be 100 percent fair trade and sustainable, which means it will be purchased only from sustainable, fair-trade farms. Irving Farm is in the process of switching to recyclable packaging that will state "organic fair trade" on the label.

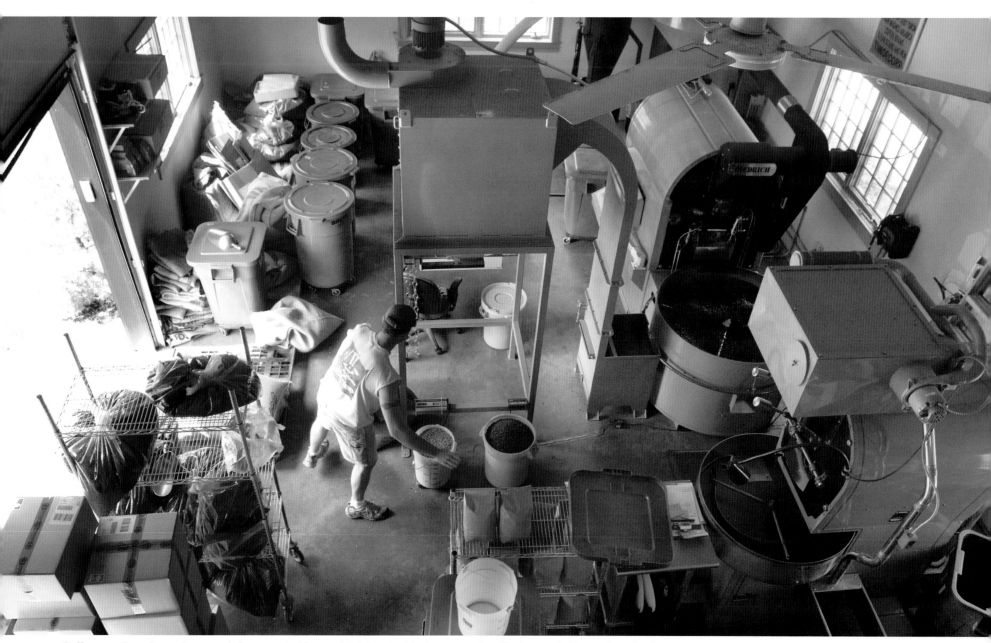

Coffee roasting. *Opposite page, left:* unroasted beans (right) get added to roasted coffee beans (left) to adjust the flavor; *right:* Clyde Miller operates the machinery.

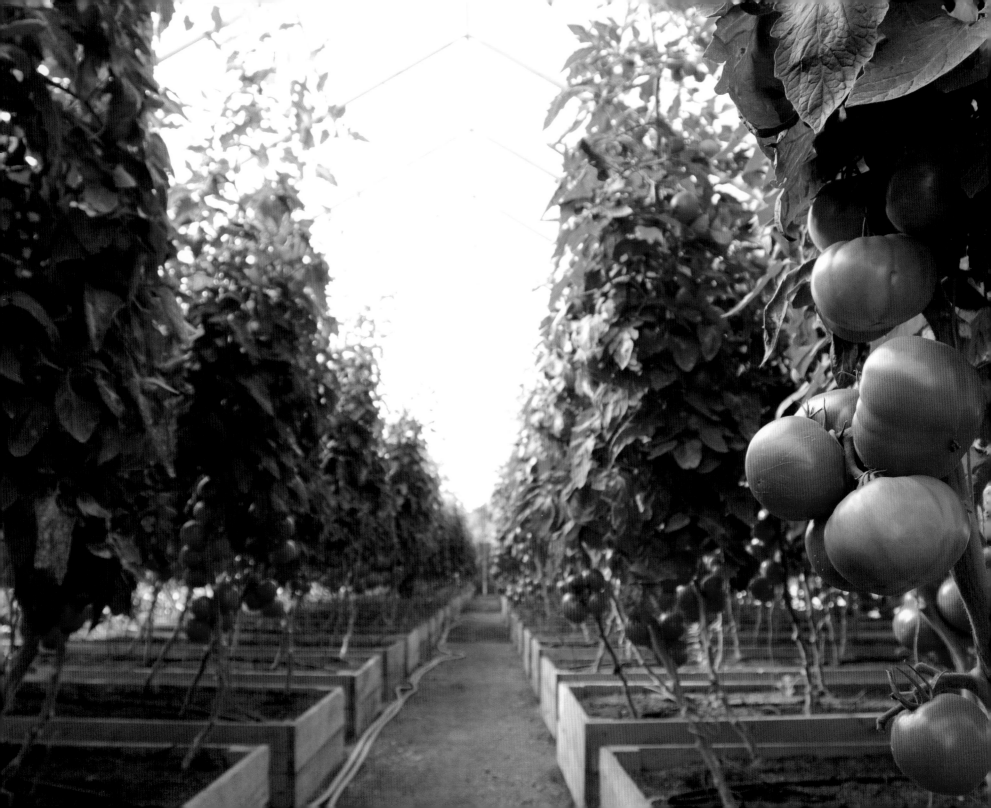

McENROE ORGANIC FARM Millerton, Duchess County

"Organic farming is not new . . . the government has brainwashed farmers into thinking chemicals and fertilizers are the way to go."

I had heard over and over again how organic farming on a large scale is impossible—until I met Ray McEnroe, who farms 770 acres and is known affectionately as Raymee by his fellow farmers. This straight talker works from an office in an enormous field filled with huge mounds of manure being moved by bulldozers, yet is also surrounded by magnificent panoramic views of the Berkshires and rolling hills of Dutchess County. "I didn't know what a broccoli plant looked like twenty years ago," he told me, explaining that he never did conventional gardening, he just began farming organically.

After Ray's father died in the early 1980s, he and his wife bought the dairy farm from his mother. Ray started out growing three acres of certified organic crops in 1988. Gradually, over the past two decades, he continued to transform his father's dairy farm into an enormous viable organic vegetable business. In season there are two to three tons of tomatoes produced every week. The McEnroe Farm is now the largest organic farm in the Hudson Valley.

Ray's motivation came in large part from his new business partners, one of whom had experience with organic farming in Vermont, the other a financier in Manhattan. In 1990 he started to wholesale the organically grown vegetables, and by 1994 he sold off what remained of the cows. Dairy farming just wasn't profitable any longer.

There are 150 beef cattle grazing on the hillsides along with 130 sheep and lambs. There are also chickens, turkeys, and pigs. Certified organic grain now costs $800 to $900 per ton and soybeans are $1,400 per ton. The only way for farmers to survive financially is to grow their own feed. Ray loves being involved in the whole business—growing crops and watching the harvest, as well as dealing with the animals. "And I enjoy eating the asparagus, tomatoes, all the crops," he said.

"To me, farming is all about clean food," Ray explained. "If you have good soil and enrich it, plants will grow out of any infestation." He conceded that flea beetles are a problem with the broccoli. But of the 1,500 broccoli plants the McEnroe Farm planted with a machine, only one plant was destroyed by disease and the others were fine. "It was a sick plant to begin with," Ray said. "The others had taken root better and this one had a defective immune system." Ray believes his theory holds up with animals as well. "If there is a sick turkey or chicken, the others will peck it to death," he told me, noting that he had seen this on the farm.

Ray McEnroe in one of the tomato greenhouses. *Opposite page:* a greenhouse filled with tomatoes. They are started in November and are grown through the winter in successive plantings.

The large composting operation at the McEnroe Farm combines leaves, source-separated food waste from the farm's restaurant (as well as the Culinary Institute restaurants and the Omega Institute), and

manure from the animals—"clean waste." The composting process includes filling large caterpillar-like plastic bags that mulch in the hot sun. They are then opened—not one of the favorite tasks on the farm, according to Ray, who described the smell as putrid. The farm is the biggest user of the mulch, but some is sold.

It seems nothing goes to waste at the McEnroe Farm. Sauces, soups, and salsas are sold in the farm market store/restaurant on Route 22 in Millerton, making use of bruised tomatoes. The array of products includes zucchini bread, strawberry jam, and basil pesto made on the premises with fruits and vegetables from the fields.

Ray took me for a tour of the tomato houses and a drive through his fields in a spacious old Buick. McEnroe Farm grows about seventy-five acres of organic corn, something many corn farmers claim can't be done on a large scale. But Ray's corn looked phenomenally healthy. "Organic farming is not new," Ray said, observing that before chemicals were invented, everyone farmed organically. "The government has brainwashed farmers into thinking chemicals and fertilizers are the way to go."

Ray McEnroe is living testament to the fact that organic farming can be done profitably—and on a large scale. And he's the first one to admit he never thought it was possible.

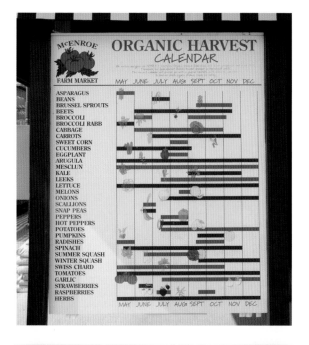

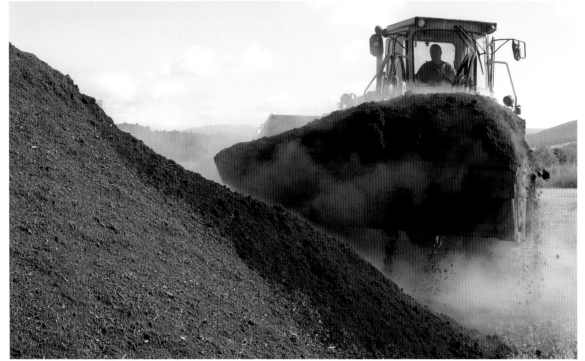

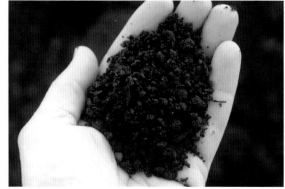

Left: a bucket loader fills up with steaming compost to put into a customer's dumptruck. *Top right:* a harvest calendar displayed at the farm store. *Bottom right:* the richness of compost can be seen in its dark color. *Opposite page, clockwise:* McEnroe Farm's cow barn; rolls of hay in a field; peak season for strawberry-picking is late June to early July.

PLEASANT VIEW FARM Millerton, Dutchess County

"We sell milk far away from here and someone there tells us what we'll be paid for it."

The year 2009 is the sixty-fourth year Pleasant View Farm will be showing their cows at the Dutchess County Fair. Owner Jeff Pulver reminds me of a simple yet startling fact: "If you don't have farms, you don't have food." He went on to say farmers are "stewards of the land," and if you take farmers away, you will have "Route 9 everywhere," referring to the commercial road running north to south through the county. He believes development is necessary but needs to be controlled, and agriculture needs to be part of the master plan in every county.

I wondered how Jeff, a third-generation dairy farmer in some of the most beautiful countryside in the region, made a viable living. I had passed through Pulvers Corners and asked Jeff about the origin of the name. "There were Pulvers on both sides of the road a century ago," he explained.

Jeff's grandfather started farming more than three hundred acres in Millerton in 1936. "Labor isn't cheap or available like it was for my granddad," Jeff observed, saying he has just three full-time employees who milk the cows. "But my grandfather didn't adapt to technology. He did things without regard to new, more profitable methods—he stabled each cow individually instead of as a group." Jeff's father took over the dairy operation, and Jeff knew he would follow his father in the business after graduating from SUNY Cobleskill, where he studied animal husbandry.

When Jeff mentioned he feeds his cows genetically altered seed, he elaborated on his philosophy of farming. "You must use technology to make a profit," he said. However, he also noted that he took his cows off BGH (bovine growth hormone), which is given to make the milk run out of them quicker. "The cows were getting old faster, and when

Swiss brown cows are naturally very curious and friendly. *Opposite page:* a view of the farm at sunrise, looking over the cornfields.

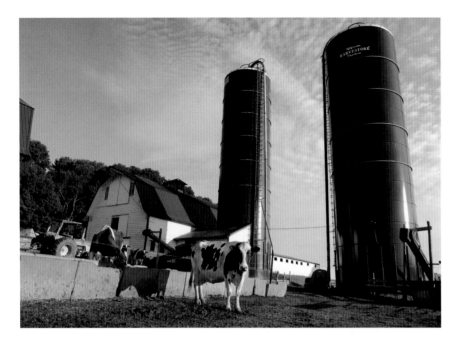

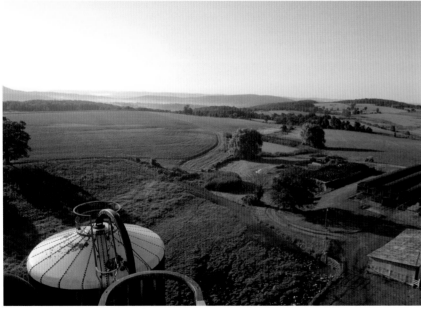

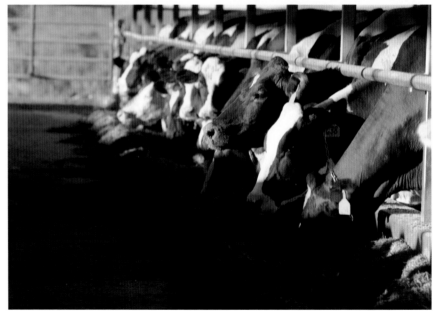

you stress the animals, they don't live as long," he explained.

The Pleasant View Farm has been forced to change with the times. In the late 1980s they started milking more cows, more "producing units," as Jeff referred to them. They didn't sell off any calves. They were milking eighty cows, then one hundred, and soon didn't have enough space.

Jeff took out a mortgage on the farm and bought new equipment and storage area for the feed. This was the first time the farm had a mortgage—and the first time any Pulvers ever had to make monthly payments. "There was a time when the farm would be your retirement, like it was for my father," Jeff said wistfully. "Those days are gone." Jeff went on to explain they had to sell off twenty acres in the mid-1990s at $5,000 an acre, a low price for farmland in Dutchess County. The Dutchess Land Conservancy took the mortgage off the farm when the Pulvers sold it to them in the mid-1990s. A deed restriction states the land can be farmed forever but not divided. This is a way farmers (and communities) are discovering they are able to preserve farmland and open space—and survive.

The Pulvers have also had to diversify their business. Jeff's wife, Linda, runs a greenhouse and dried flower shop on the property, where pumpkins and fall produce are sold, followed by wreaths

Jeff Pulver in his barn. *Opposite page, clockwise from top left:* the barnyard; Jeff driving to the fields just after sunrise; cows enjoying their meal after the morning milking; view of the farm from the top of the eighty-foot silo.

and boxwoods. She studied floriculture in college at SUNY Cobleskill, where she met Jeff nearly twenty-five years ago.

Pleasant View Farm wholesales a great deal of milk to a Massachusetts firm, Agrimark Coop, as well as to other New England companies, including Cabot. "We sell milk far away from here and some-one there tells us what we'll be paid for it. We have no control over the price or the weather," Jeff said, summing up the plight of a dairy farmer.

As we sat on the porch of his house looking out at the mountains of farmland surrounding us on all sides, Jeff reflected: "There's lots of pride in these hills."

RONNYBROOK FARM Pine Plains, Dutchess County

"If our cows could talk, they'd say nice things about us."

Time slows down in the magnificent rolling hills of the upper Hudson Valley where seven hundred acres of Ronnybrook Farm span Dutchess and Columbia Counties. As I approached, a herd of cows grazing in a field near the side of the road became visible, free to roam into a nearby barn. The cows huddled together as if they were about to cross the road—which they did, after my car passed.

Owner Ronny Ossofsky waited for me in front of one of the barns. We met six months previously at a Cheese Festival in the city of Hudson. At the time, I said, in jest, I couldn't possibly eat more cheese; I could feel my arteries clogging. Ronny casually remarked he had had a heart transplant recently— "not to worry!"

Ronny owns four farms along with about 150 to 175 cows. He was born in Millerton, where his father owned a dairy operation, and grew up in the business "just loving the animals." Ronny is a people person, as well as a cow person. "I slept with the cows," he told me, going on to mention involvement with an international business sideline that flourished in the 1970s. "We sold embryos all over the world; I loved that too."

In the early 1980s Ronny added two additional farms to the original one owned by his family. Taxes were high and land was valued for development, not farming. "I was going to do bottling, but had very little money to invest in the business," he confided. But Ronny decided to take a risk: He took out a mortgage on the farm and on July 4, 1991, at the Greenmarket in Manhattan, sold three products— whole milk, skim milk, and cream-lined milk. Soon after, the *New York Times* wrote an article about Ronnybrook's excellent products and *New York* magazine touted their chocolate milk. The press attention flooded the farm with sales.

Two newborn calves: one is one day old (right), the other two days old. *Opposite page:* just before a cold February sunrise, dairy cows wait to be called into the barn for feeding.

In 1991 Ronnybrook products were somewhat unique. "We started making milk and yogurt with no stabilizers or hormones; while not organic, it's minimally processed," Ronny explained, going on to say the milk is not homogenized. "Most people allergic to milk are allergic to the processing." Homogenization smashes the fat particles and makes them small, which looks good in the milk bottle with no cream on top. But our bodies are set up to digest real milk. The processed mixture goes directly into the bloodstream and is not broken down. It takes more time for the body to process the milk from Ronnybrook—the way nature intended.

Ronny believes grass-fed cows give the best-tasting milk: Each animal eats about 120 pounds of food daily. Unless it's below zero, the cows go out to graze every day. As we toured the farm, I noticed the cows heading into their individual stalls in one of the barns; each had its own space and, interestingly, Ronny said, every cow always returns to the same pen. "Hi girls!" he said, taking me through the cow barn. "If they could talk, they'd say nice things about us," Ronny smiled, proud of how well his animals are treated. Ronny's dairy employs twenty people and sells 2,250 gallons per day or 18,000 pounds of milk per week to the Hudson Valley Fresh label. When I visited, they were remodeling the building to make more yogurt, a growing part of the business.

Ronny asked me to don a mesh hairnet as we walked through the processing plant area of the farm. I watched two women filling enormous plas-

Cows in the field in July. *Opposite page, clockwise from top left:* the milking parlor; milking is mechanical, with the pumps put on and taken off each animal by hand; Ronny models on his truck; milk bottling.

tic tubs with butter about to be churned by hand. "The containers used here are chemical free," Ronny explained, adding that they cost 50 cents rather than 3 cents apiece, a contributing factor to the higher price of Ronnybrook products.

Our tour ended in Ronny's office, its walls strewn with photos of his prize-winning show cows at various competitions throughout the country. Ronny maintained that he will never grow into a large conglomerate—and never sell out to one.

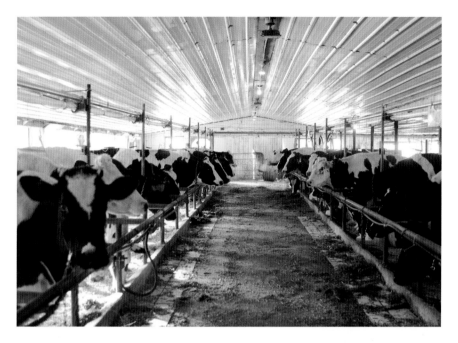

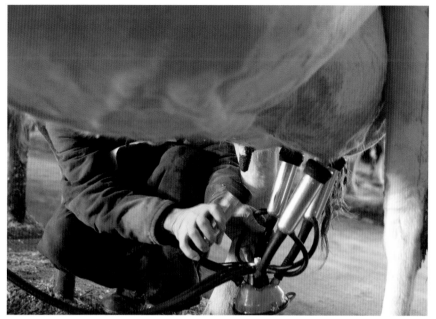

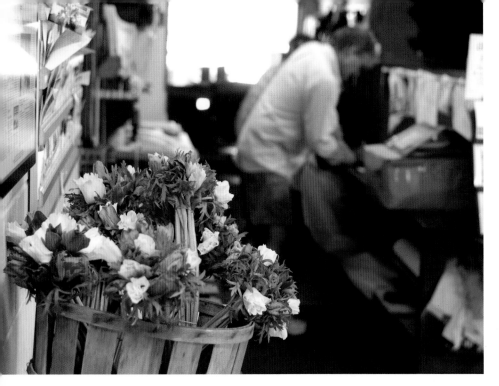

F. W. BATTENFELD & SON Red Hook, Dutchess County

"Names like Violet Hill Road in Rhinebeck and Violet Avenue in Poughkeepsie evolved from this cottage industry."

The name Battenfeld is synonymous with anemones—and Christmas trees—in Dutchess County. Since 1906, this 260-acre farm has been a family business, with the Christmas tree business starting in 1956. Current owner Fred Battenfeld notes that the season for flowers is September through May, which dovetails nicely with tree season. His grandfather and great-uncle began the business together. In the early twentieth century, wealthy Hudson River estate owners brought gardeners from Europe to re-create the magnificent gardens they had visited abroad. Dutchess County was once the violet capital of the country. "Names like Violet Hill Road in Rhinebeck and Violet Avenue in Poughkeepsie evolved from this cottage industry," Fred reminded me. Gradually, gardenias, then orchids, replaced violets as the most popular corsage flowers. As the violet market decreased in the early 1950s, the Battenfeld's business transitioned into anemones.

In summer, planting is the main activity. When I visited in July, Fred showed me eight greenhouses filled with 140,000 sprouting green plants. In just a couple of months, these drab-looking warehouses would be transformed by thousands of colorful blooms. From February through April, 50,000 to 60,000 anemones are sent to Manhattan, Boston,

and Washington. "We take the flowers to New York City, and they are sent via FedEx all over the country," he told me.

As the cost of heating the greenhouses rises, so does the price of the flowers. Local flowers are still a better buy, however, and residents enjoy patronizing a community business. Battenfeld's retails the flowers directly to customers who drive in. They can buy flowers just about any time in season; a self-service cooler on the premises keeps the anemones fresh.

In addition, more than one hundred acres of the farm are dedicated to Christmas trees. With about 1,200 trees per acre, this means that each year there are thousands of trees to choose from.

Fred always knew he would take over the business after graduating from Cornell University's Agriculture School. "I enjoy being self-employed, having the flexibility to manage my time and decide what is important," he told me. His son, Lance, the fourth generation of the family, will ultimately take over the reins and—maybe—allow him to slow down.

A hand-painted sign announces the farm. *Opposite page, clockwise from top left:* fresh cut anemones waiting for customers while Fred Bettenfeld reviews paperwork; acres of Christmas trees await cutting; fresh cut anemones in a cooler ready for customers; two of Battenfeld's many greenhouses filled with anemones.

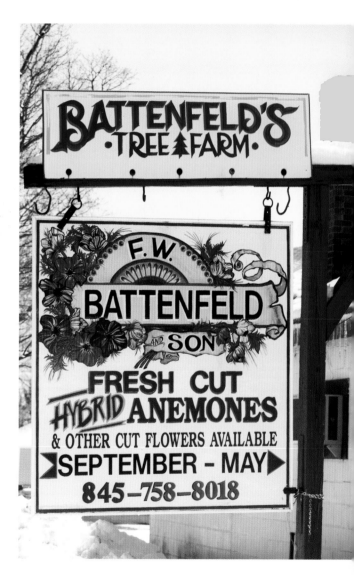

GREIG FARM Red Hook, Dutchess County

"We're on the suburban frontier and we're becoming an endangered species."

Greig Farm has been known for pick-your-own fruits and vegetables in the Hudson Valley for decades. As Norman Greig told me the story of his family farm, I recalled several excursions there to pick raspberries, blueberries, and apples when my son was a child. Now I sat in Norman's home, just steps away from a farmers market and winery leased to local businesspeople.

Norman's father, Robert Greig, originally from Canada, grew up in Port Washington, Long Island. He started farming part-time in 1942 and eventually quit his cooperative extension position to farm full-time on 108 acres. (The farm is now more than five hundred acres.) Norman attended Cornell, like his father, and assumed he would have a career outside of farming. But when Norman's father told him he had decided to sell the farm, Norman asked him to reconsider. During that last year at Cornell, he took agriculture courses, and he has been involved with running Greig Farm since 1972.

The world of farming has changed dramatically. When Norman's father farmed in the mid-twentieth century, there were two dairies on the one-hundred-

An old tractor with the Greig Farm name. *Opposite page, clockwise from left:* a view of Greig Farm, including raspberry bushes and apple trees; ripe yellow raspberries, with a mellow sweet flavor, are ready to pick; dew-covered blueberries.

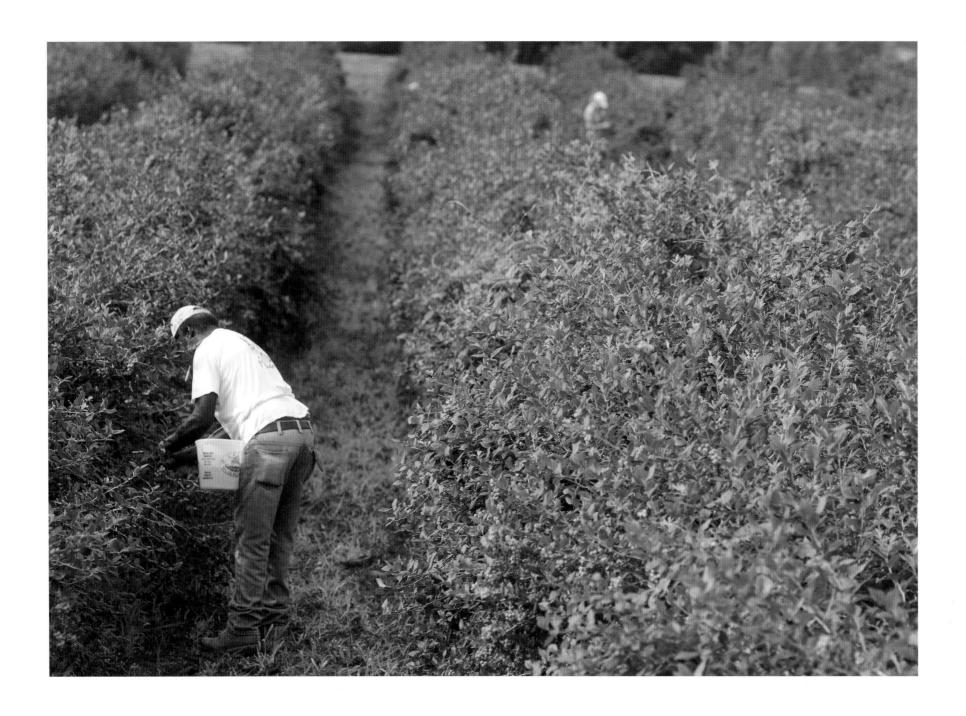

acre property, with forty cows each. Apples were planted on ten acres and strawberries on another ten. In later years, both crops were advertised as pick-your-own, although it was the wholesale business that sustained the farm. In 1980, the pick-your-own area was enlarged to thirty-five acres.

When the *New York Times* wrote an article about the farm in the early 1980s, they were completely picked out. "We need that kind of write-up every year," Norman joked. He then expanded the pick-your-own business so that it would be continuous, with various crops ready to be harvested from May through October.

A watershed year was 1992, Norman told me—when IBM moved out of the Hudson Valley. "Before that time, there were stay-at-home moms looking for activities to do with their kids," he said. "Now there are two parents working with hardly any time to take the kids anywhere, even on weekends."

Norman's land abuts seventy-six homes, with developers encroaching on what was formerly farmland. Although he refuses to sell off any acreage to builders, there is constant pressure to do so. "If a piece of machinery is in operation, and there's some attendant noise, we get seventy-six phone calls," he said, referring to complaints from the same people who claim they like being surrounded by a farm. "We're on the suburban frontier and we're becoming an endangered species."

There are also difficulties with diversification. Despite the fact that a successful music festival was held on the farm for a couple of years, it is now vir-

tually impossible to host it in Red Hook again. The town passed a three-page zoning ordinance shortly after the gathering. "They started taxing tents," Norman explained.

Norman noted how marketing often gets short shrift by farmers, although it should be a primary concern. "Every day is a deadline and those deadlines are absolute," he said. "Farming is very real that way."

Jerry Polius (above) has been working at Greig Farm for 28 years and is seen picking blueberries (on opposite page) and holding a handful of freshly picked blueberries (right). *Top right:* Norman Greig.

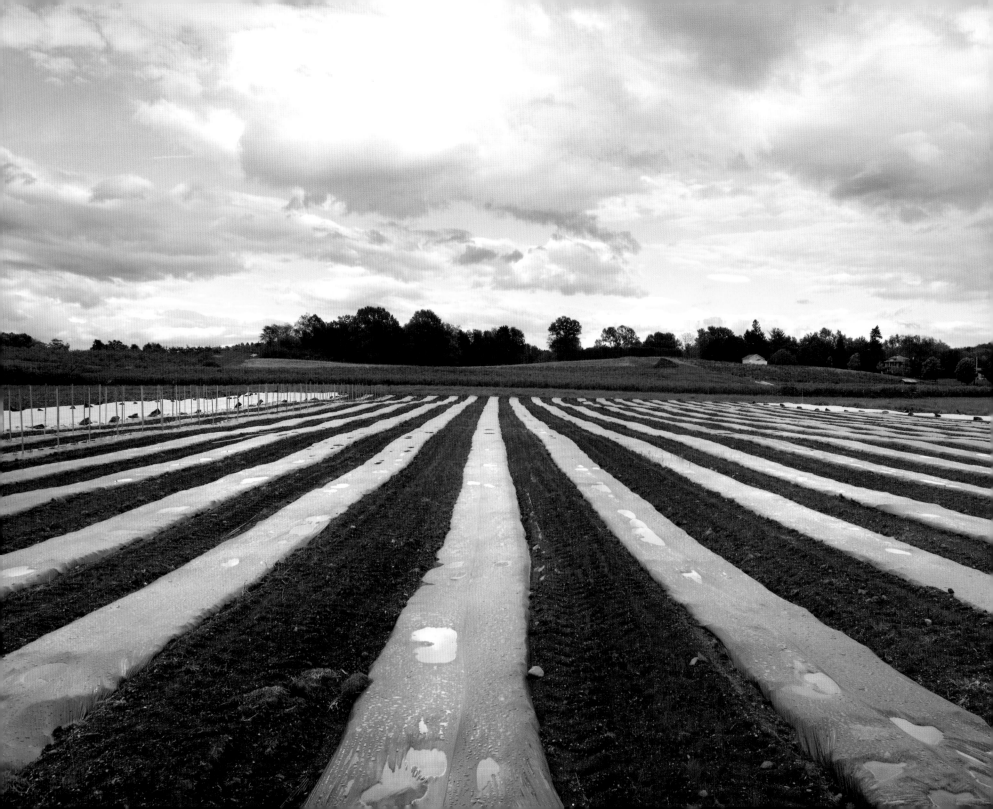

HEARTY ROOTS FARM Tivoli, Dutchess County

"My dream after graduating Vassar was to grow vegetables in Dutchess County."

*M*iriam Latzer's no-frills rugged good looks and enthusiasm for a rural lifestyle remind me of people I knew in college during the late 1960s who were planning to "live off the land," with guidance from *The Whole Earth Catalog.* Who could imagine a burgeoning demand for organic produce coupled with the advent of the computer age would make such a lifestyle viable decades later? As Miriam explained, "I buy seeds in February and know what crops I will have for the entire year." She uses Google spreadsheets that track what crops are growing each month and how much produce will be available to sell to members of the Community-Sponsored Agriculture group she started with her partner, Ben Shute.

Hearty Roots sells produce to local restaurants and farmers markets, as well as to their 300 members (75 in Tivoli, 75 in Woodstock, and 150 at three sites in Brooklyn). A weekly share costs $500; a half-share is $275 every other week. Miriam and Ben lease nearly twenty-five acres from two farmers, where they cultivate about fifty different varieties of organically grown produce. During the winter months there is an indoor farmers market in Red Hook where their greenhouse products are sold to local residents.

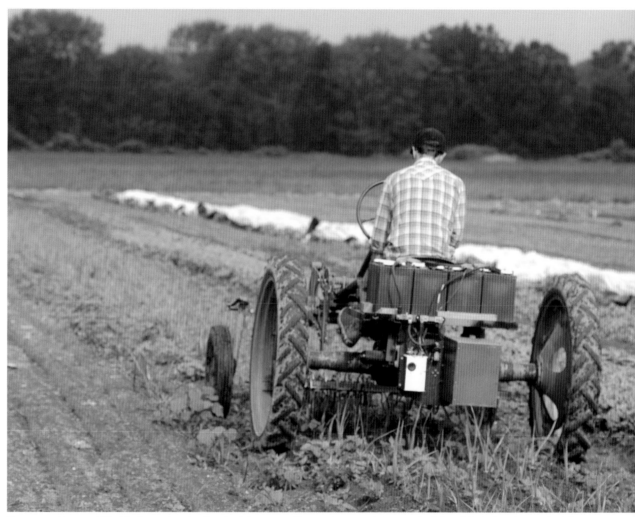

By converting an Allis Chalmers tractor to electric power, the environmental impact of fossil fuels has been significantly reduced at Hearty Roots. *Opposite page:* covered rows keep the soil warm to help germinate seeds.

Although Miriam has a graduate degree in urban planning, her face lights up when she talks about the New Zealand sheep farm where she lived during her junior year at Vassar College. "Can you believe they have ten million sheep there and only four million people?" For a decade after college she worked on a variety of farms in Minnesota, South America, Italy, Oregon, and Poughkeepsie. "My dream after graduating from Vassar was to grow vegetables in Dutchess County," she once told the head of the CSA where she worked in Poughkeepsie, never imagining she would have her own in Red Hook.

For Miriam, the best part of the business is growing things, having her "hands in the dirt." The farm is running at a profit now, enabling her to buy another tractor. "Right now, I'm converting this gas tractor to electric," she told me, explaining how she bought her Alice Chalmers for $2,500 from a farmer in Buffalo. A large washing machine, agitating as we spoke, is her version of a giant salad spinner.

When asked about future plans, Miriam said it's simple: "This is it . . . farming in Dutchess County. I found it," she enthused. "If I didn't love it, I wouldn't work like a dog for six months of the year—although I do wish I owned some land; all I own is machinery!"

Miriam and Ben, owners of Hearty Roots Farm. *Opposite page, clockwise from top left:* Miriam riding her bicycle through the field; Miriam adjusts row covers blown by the wind; rows of potatoes; row covers protect tender greens from a late spring frost.

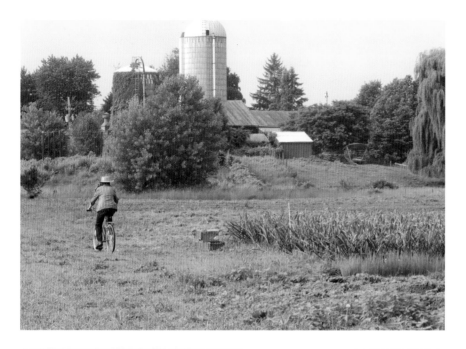

HIGHLAND DEER FARM Germantown, Columbia County

"The deer are not family pets, which the children learn at an early age."

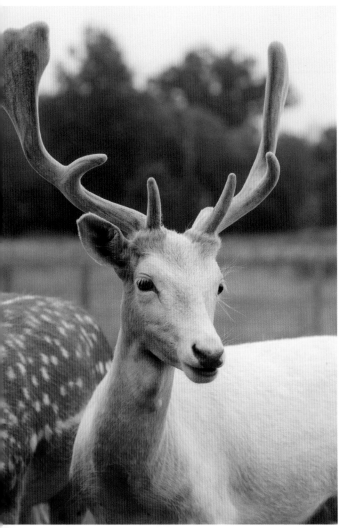

White fallow deer buck.

*A*fter a decade as curator of mammals at the Bronx Zoo, Mark MacNamara and his wife, Marty, who also worked at the zoo, decided to leave the city and buy land in Columbia County to start a commercial deer farm. The business grew gradually and now supplies fresh venison, buffalo, and ostrich burgers to restaurants from October through March. I first sampled Highland Farm's dried venison at the Kingston Farmers Market. As I drove up to what was once a fifty-acre dairy farm, I saw four ostriches loping along a fenced area, as well as deer and buffalo grazing. I had the feeling I was entering a zoo, rather than a farm!

The deer are raised from birth to eighteen months on pasture in a free-range state and fed on locally grown hay, grain, and produce, creating their fine flavor and tenderness. No steroids or growth hormones are used. They are then processed in a facility on the premises. Quality is maintained from breeding and feeding to packaging and shipping. Venison is low in cholesterol, fat, and calories.

Marty runs the business end of the operation, and she and Mark feel the farm was a wonderful place to raise their three children, who are now grown. Mark emphasized that the deer were not pets, something his children learned at an early age.

Today they are all busy with other careers and it's unlikely they'll join the family business.

Mark wanted to maintain the deer farm—which pays for itself—and continue working with zoos as a professional consultant. What evolved was a business called Fauna Research, through which Mark designs and produces equipment for commercial deer farms and zoos. "We made the equipment for ourselves and then began to manufacture and distribute it," he explained. When it is necessary to perform medical tests on deer and other animals, they need to be restrained, and it's better to do this without using drugs—hence, the TAMER was patented. The TAMER and other company products are now used in zoos and game parks across the country, as well as internationally. Disney's Animal Kingdom, for example, uses several Fauna Research items.

When we met, Mark had recently returned from a trip to the Scottish Highlands Wildlife Park. Jet lag is part of his routine these days. All items are custom-made to fit each facility. For example, Fauna Research manufactures giraffe penning systems. And the TAMER has been used for vaccinating, hoof and horn trimming, vet procedures, and weighing large animals such as elephants. An unusual area where these products are also employed is embryo

transplant work; embryos of rare animals can be preserved, thereby keeping the species alive.

There is a creative aspect to designing such items for various species. "Our clients like the fact I use the equipment on my animals at the farm," Mark told me. His favorite part of life on the farm is working with animals naturally and humanely and handling them well. Unexpectedly, his own needs on the farm propelled him into a burgeoning business he never imagined, and the venture has allowed him to keep his farm as well as travel the world.

Clockwise: venison kielbasa; Aoudad rams, an African breed; bison eating hay; ostrich. Highland Deer Farm is home to several of the same breeds of animals that Mark worked with—and enjoyed—at the Bronx Zoo decades ago.

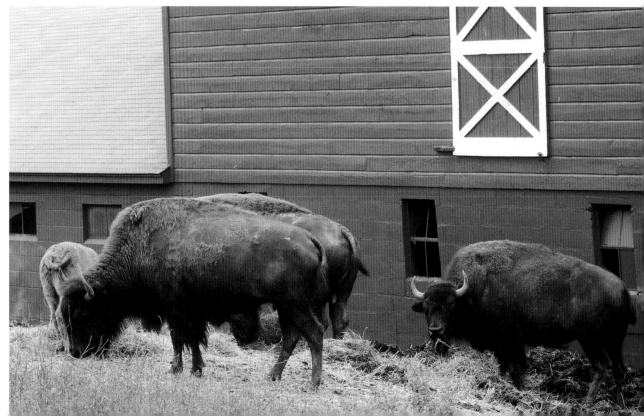

PHILIP ORCHARD Claverack, Columbia County

"I grow what I would want to pick, and I don't respond to fads."

How does a woman in her late sixties take the reins of the family business—an apple orchard—and run the place? Julia Philip was born in Richmond, Virginia, grew up in Princeton, New Jersey, and moved to Manhattan in 1952 after marrying John Van Ness Philip Jr., an editor at McGraw-Hill. On weekends and summers the family retreated to the Claverack farm, mostly for relaxation.

After her husband became ill, Julia gradually took over his responsibilities on the apple farm. "Maybe I'm just a bossy lady!" she laughed, trying to explain what she loves about her life of hard work, unlike many of her contemporaries who have eased up at the same stage of life and are playing golf. The orchard is a dynamic, ever-changing universe unto itself, and the owner must learn to understand its rhythms. "You are continually thinking about the weather and must be out there day by day to evaluate what needs to happen, what you have to do," Julia told me, describing the stressful existence of an apple farmer. Lest one forget, a single hailstorm can wipe out an entire season's crop in just an hour.

Julia, her daughter Leila, and I relaxed together over ice tea on a hot July afternoon at Talavera, the freshly painted homestead that has been the center of the Philip family for nearly three hundred years. (The home itself is named for the battle of Talavera de la Reina in Spain, Napoleon's first defeat in the Peninsula War.) We were surrounded by paintings of Philip family members, who had resided here for the past three centuries. Leila Philip's book, *A Family Place: A Hudson Valley Farm, Three Centuries, Five Wars, One Family*, beautifully relates the story of life on the farm at Talavera through several generations. Judge William Van Ness, a gentleman farmer, built this country house after being appointed to a position as a Columbia County judge in the early 1800s. Today, the farm consists of one hundred acres, including sixty acres of fruit

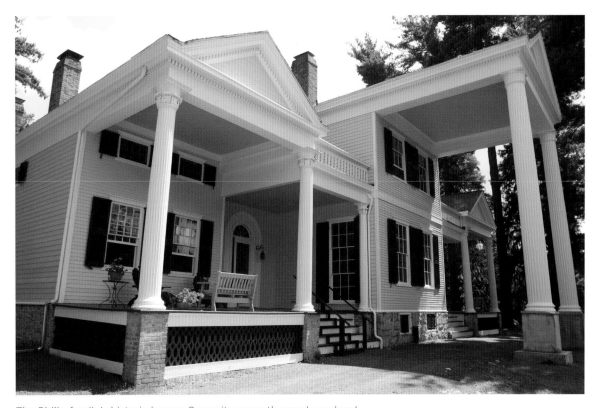

The Philip family's historic house. *Opposite page:* the apple orchard.

Leila laughed, describing the scene.) Julia obtained her spray license after her husband passed away. She has to buy the chemicals, know just how much to use, and calibrate the spray tank—not always a simple matter. You can easily waste spray, and materials are expensive. "The proper timing of the treatment is also critical," Julia told me, explaining how she has to virtually outsmart the pests by staying ahead of them.

Years ago the orchard had many varieties of apples: Cortlands, Macouns, Golden Delicious, Mutsu, and Macintosh. Nowadays there are additional types, including Jonna Golds, Rhode Island Greenings, Spartans, Empires, and a host of heirloom apples. "I grow what I would want to pick, and I don't respond to fads," Julia said, when I asked how she chooses what to plant. These new types of apples require variations in maintenance. The orchard also produces five varieties of pears. In recent years Julia introduced raspberries, a cash crop but one more thing to think about during the berry's short growing season.

"There is a sense of history here, and I enjoy being a caretaker of the land," Julia told me. Passionate commitment to her farm is central to the life of this delightful woman with nerves of steel.

trees that produce around five thousand bushels of apples and pears every year.

Now in her mid-eighties, Julia Philip has been successfully running the orchard since 1992 with the help of one employee, a jack-of-all-trades. He has come from North Carolina for the past twenty years from December through March to prune the three thousand trees (fifteen varieties, each with its own orchard). The weight of the trees must be balanced by tapering them top to bottom so the sun can reach the entire tree. Fruit grows better that way, and one can actually select the branches to bear fruit and control crop production.

"We either innovate or die!" Julia commented, referring to the shift from wholesaling to pick-your-own. To a great degree, it is that attitude that has allowed the farm to adapt and flourish over the centuries. Julia attends "fruit school" each February, a program offered by the Cornell Cooperative Extension. ("She was the only woman fruit grower in the room!"

A wall of tools in the barn. *Opposite page:* Julia Philip; a graffiti wall in the barn with names of farm workers dating back more than three decades.

THE FARM AT MILLER'S CROSSING Philmont, Columbia County

"I'm often wholesaling produce by cell phone in the middle of planting."

Katie Smith and Chris Cashen have been married since 2000, which is when they purchased the family farm from Chris's parents, who had taken it over in 1975. His grandfather had farmed there in the 1950s. Chris, the youngest of nine children, was the only one who wanted to continue farming. However, his parents, as well as six of his nine siblings, live on contiguous property, and their lifestyle is one of an extended family.

"Chris's aunts often take care of the kids for us. It's a remarkable family—everyone gets along," Katie enthused. She explained how she never feels the isolation many women experience being largely housebound with four children under the age of five, including a son who was born only two weeks before my visit.

Katie and Chris run a two-hundred-acre farm together: Sixty acres are planted with vegetables, seventy-five are pasture, and the rest is a stream corridor. They also rent land from a neighbor to graze a small herd of beef cattle. "Diversity keeps us going, but breaks our backs," Chris told me. Katie boasted that they grow sixty varieties of vegetables, adding, "My eating habits decide what we'll grow!" The Cashens participate in three farmers markets every week and have two Community-Supported Agriculture organizations—one local and one in

Manhattan—each with one hundred members. Wholesaling their crops in the market at Menands, near Albany, is the largest part of their business.

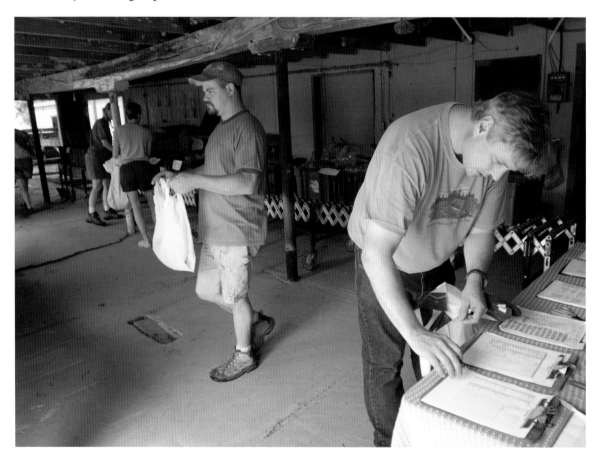

Community-Supported Agriculture participants picking up their shares of produce. *Opposite page:* kale growing in the field to be cut and harvested.

Their different talents and interests make for an excellent working partnership. "I don't think my husband ever balanced a checkbook until he met

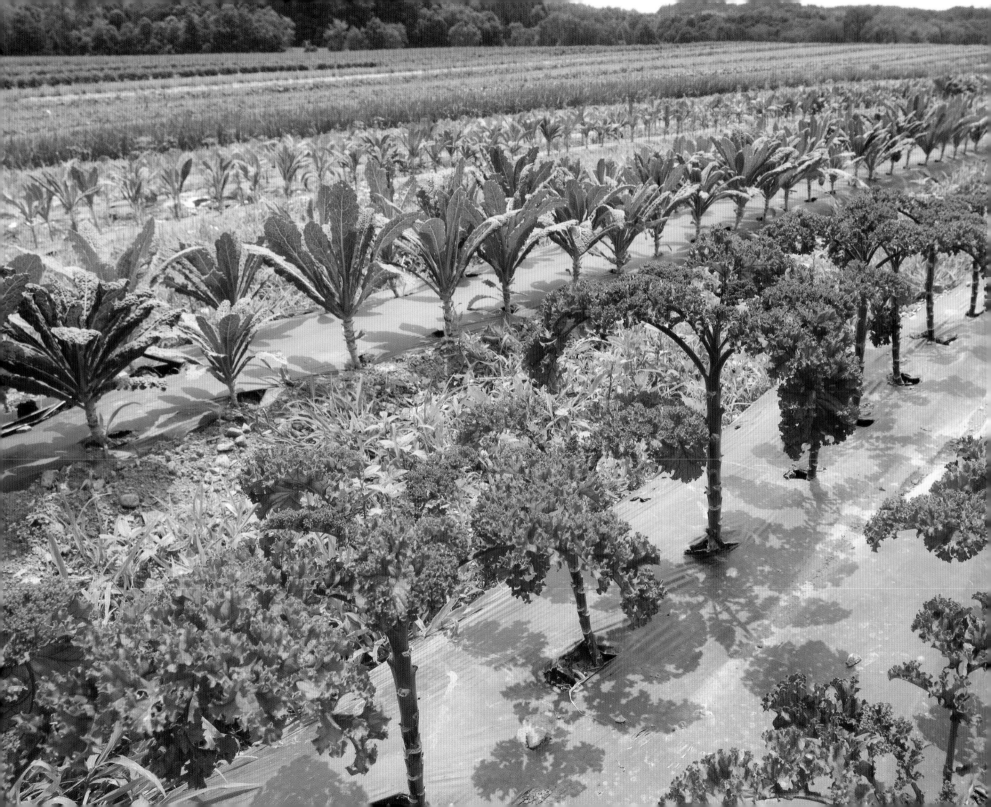

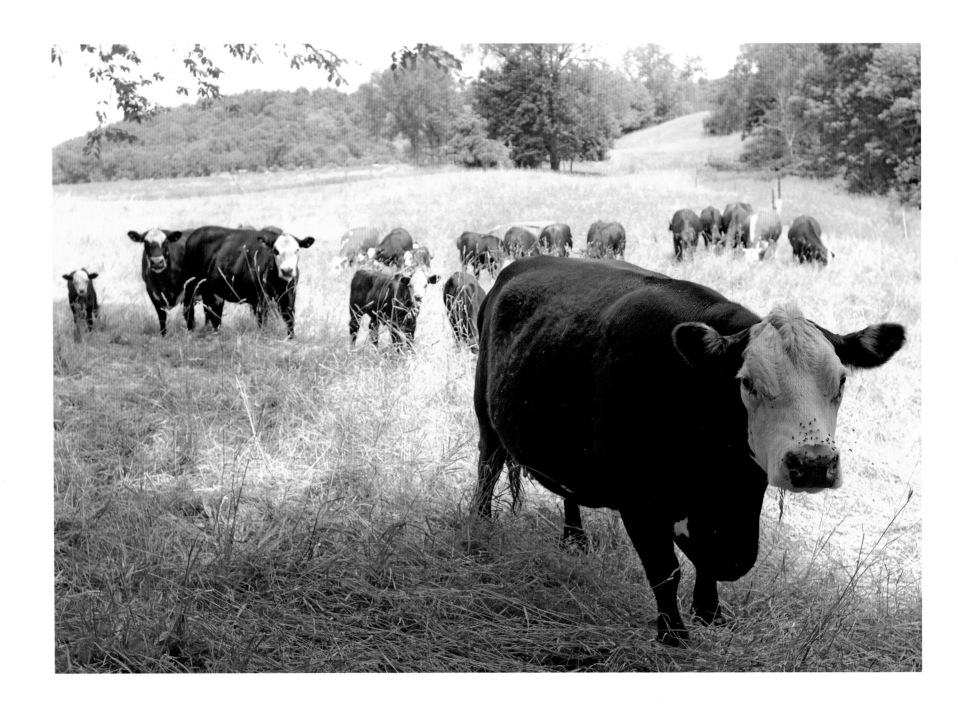

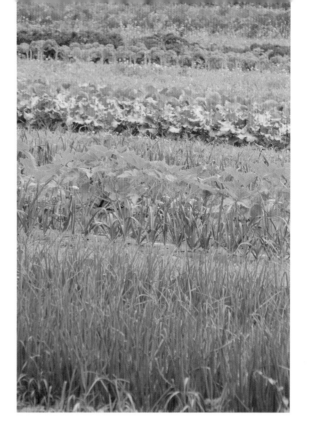

Above: flowers for sale, ready for planting in the garden. *Right:* rows of vegetables and greens where Katie and Chris harvest dozens of crops each week during the summer months. *Opposite page:* grass-fed cattle.

me!" Katie laughed, going on to explain she was attracted to farming, despite the fact she studied environmental science in college. "I enjoy economics and the number crunching."

The farming is what excites Chris, but he finds he's moving more into the role of manager as the farm employs more people. "On my tractor it's bliss, but I always have to check in. I'm often wholesaling produce by cell phone in the middle of planting," he explained, ambivalent about the technology.

Chris often sends two people with a truck to the farmers market, hoping they will take the same pride in what they're doing as he does. "It's difficult to instill that drive for perfection in workers for hire," he observed. "I'll fret about the arugula not being just right, or a hole in a head of lettuce. If one box isn't perfect and a red leaf lettuce falls apart, we hear about it the next day. In this business, you're only as good as the last case you've sold!" Quality is a big concern at Miller's Crossing. "If the produce isn't top-notch, it's like walking around with a big A on your chest," Chris joked, making reference to Hester Prynne in *The Scarlet Letter.*

Chris explained the cycle of work at the farm, beginning with a massive spring planting. All season, from April through October, they must weed, irrigate, and harvest, as well as continually re-seed the land. There are times they are harvesting ten, twenty, or thirty vegetable crops each week. "It's often overwhelming," he sighed, explaining that as the farm has become medium size, they have had to accept a seven-day workweek along with the growth.

As I was leaving, I asked Chris the origin of the farm's name. He explained: The Albany to Boston railroad line once passed through Philmont, where the train stop was called Miller's Crossing, after the Millers, one of the first families to settle Philmont.

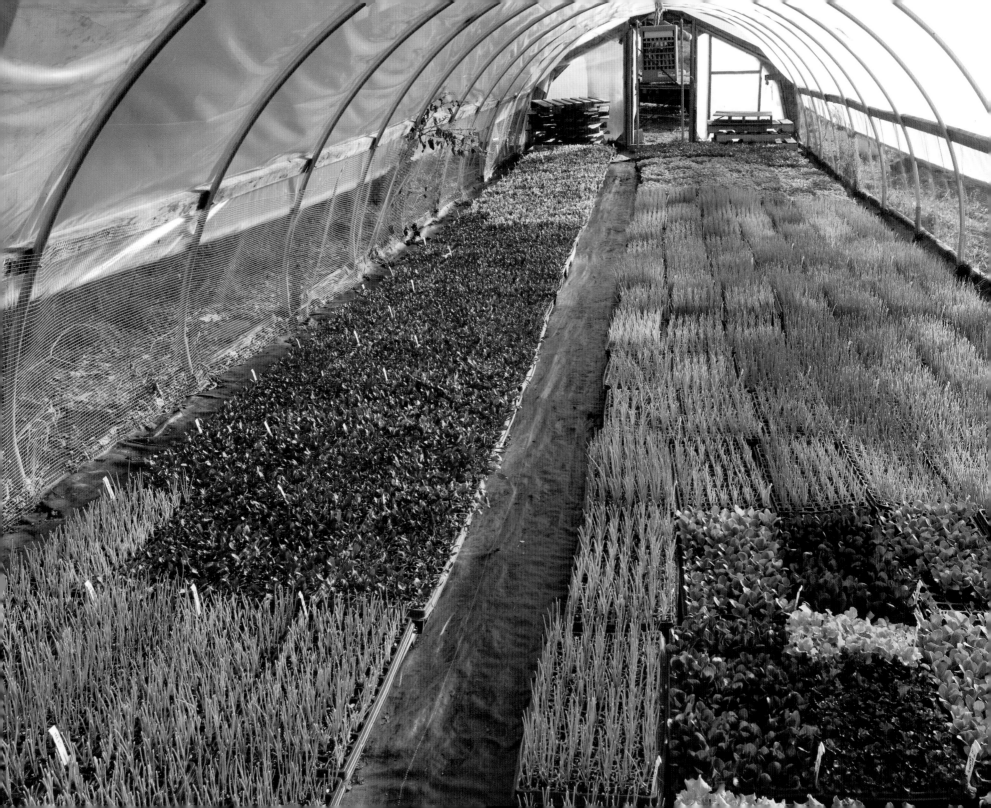

HAWTHORNE VALLEY FARM Harlemville, Columbia County

"In 2007, newborn calves began being raised with their mothers, a practice unheard of in the modern dairy industry."

I purchased Hawthorne Valley Farm yogurt in the health food store for years before meeting the woman who has been a driving force there for more than two decades as chief administrator, Rachel Schneider. Her husband, Steffen, is the lead farmer of the four-hundred-acre operation that includes dairy cows, sows, boar, and stock for farm-raised pork and grass-fed beef. There are also thirty-five varieties of organically grown vegetables.

Rachel and Steffen had lived on a Wisconsin farm before settling in Harlemville, where they raised two children who have since moved into fulfilling careers outside the area. "Our kids both attended the Rudolf Steiner School here," Rachel told me. The school is still an integral part of the community, with three hundred students in grades kindergarten through twelve.

Rachel's efficient, business-like manner belied the impression some have that this is a laid-back hippie-run operation. In the summer of 1972, a group of people committed to the land and a way of life began the Rudolf Steiner Education and Farming Association, known as the "Farm School." Out of this idea grew the school, the farm, a visiting students program, and a store/bakery open to the public. While many alternative-lifestyle farms failed, almost forty years later Hawthorne Valley Farm is

Farm apprentices transplant chives in a field during the first week of June. *Opposite page:* in early spring, greens and plants to be transplanted later in the season grow in the greenhouse.

thriving. The original goal was to integrate the arts, education, and agriculture—to combine the natural world and the world of work.

Biodynamic agriculture is based on Rudolf Steiner's (1861–1925) theory of balancing the deli-cate interrelationship among people, plants, and animals. He provides a sustainable model for agriculture that involves balancing forces in the soil and nature along with medicinal plants and herbs such as yarrow, dandelion, and nettle. Compost is treated before

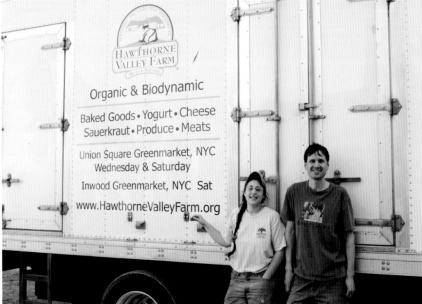

being used; the added preparations are a homeopathic balancing tonic for the soil that with water, air, and sun serve to render chemicals unnecessary.

At the core of the operation is the fact that biodynamic agriculture can never become industrialized. Wisely, a decision was made to add value to the few products created here and sell them directly through farmers markets and a store. In this way the farm retains quality control over all their products. A Community-Supported Agriculture group with 225 shares in Columbia County and a few in New York City is an integral component of the business.

A regional training program involving twelve local farms—known as CRAFT (Collaborative Regional Alliance for Farmer Training)—attracts students from around the country. Participants train from April through October in a range of agricultural tasks including composting, cover cropping,

tillage, greenhouse and dairy management, and rotational livestock grazing. There is also a business component that shows how to create budgets and keep records.

The sixty-head herd of cows, a mix of Brown Swiss, Jersey, and Holsteins, are at the heart of the Hawthorne Valley Farm. From them, an array of artisan cheeses, yogurt, and milk are produced. The cows are given no hormones or antibiotics and are grass-fed on the farm's pastureland throughout the year. In 2007, newborn calves began being raised with their mothers, a practice unheard of in

the modern dairy industry, though the reason cows give milk is to feed their young. The farmers have observed that the calves pasturing with the milking herd are stronger, larger, and have a healthier coat. Cows, crops, and people coexist here in keeping with the mission of Hawthorne Valley Farm—"to nurture the land that nurtures us."

Left to right: a sheep; chives and lettuce in a greenhouse in Paril; young pigs. *Opposite page, clockwise from top left:* rows of bushy lettuce in June; cows in their stalls in the barn at mealtime; the farm store; Sarah Shapiro and Ron Borkovitz, co-managers of Greenmarket, Hawthorne Valley's New York City farmers market. While there is diversity of livestock at Hawthorne Valley Farm, the sixty-head herd of cows is the heart of the business, where the farm's renowned cheeses, yogurt, and milk originate.

GRAZIN' ANGUS Ghent, Columbia County

"We plant the best grasses—high in both sugar and carbohydrates—which make for well-marbled, healthy beef."

The September 11th attacks and their immediate aftermath was the major reason Dan Gibson resigned his corporate position and sold his home in the Manhattan suburbs. His son and daughter, both in college in Manhattan at the time, had witnessed the fall of the Twin Towers.

"My wife Susan and I were sitting on the porch of our Katonah home and saw a photo of this dairy farm for sale in the *New York Times* Real Estate section," he told me. "I said, 'let's go look at it!'" The Gibsons purchased the 450-acre farm in early 2002 and asked Jim and Eileen Stark, a couple experienced in working the property, to join them as partners in a new venture, raising free-range cattle. The Gibsons own the real estate and equipment, and Jim continues to operate and repair most of the farm machinery. The Gibsons and Starks split the profits—when they exist. "We fought like brothers on lots of issues," Dan remarked, explaining many of his ideas about how to do things were alien to local farmers.

Dan's dream was to raise top-of-the-breed, grass-fed *and* grass-finished, registered Black Angus cattle, a goal he has accomplished. He explained how many farmers raise Black Angus cattle purely on grass for nine months, but during those last few months before slaughter they are "finished" with

corn feed and antibiotics in the finishing lot. It takes Dan three years to finish a steer; by then, he has wintered them three times. "The grass isn't free," he said smiling. "We plant the best grasses—high in both sugar and carbohydrates—which makes for

well-marbled, healthy beef." There is a remarkable difference in taste.

Dan refers to the past eight years, his farming career, as an education process. The vast majority of health benefits are in the fat of the cattle (the omega-

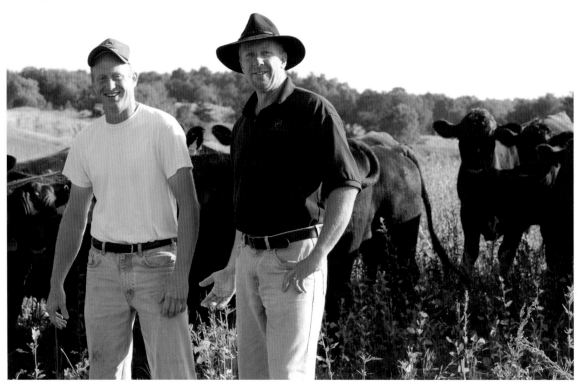

Jim Stark (left) and Dan Gibson, owners. *Opposite page:* the "eggmobile," a henhouse on wheels, is moved from field to field, rotating the pasturing of the chickens just like the steers.

3 fatty acids). "Time is an important factor in this business," he said, "time to marble up the beef so it will taste better." Most steers live twelve to fifteen months before being slaughtered. Grazin' Angus had thirty-five head of cattle processed in 2007, and in 2008 will have nearly one hundred. A large part of the farm's business consists of selling directly to consumers on the property, as well as going to farmers markets in Manhattan, Albany, and nearby Chatham. Some local restaurants serve their products as well.

Dan pointed over the hill to his pasture-raised chickens in the eggmobile, a moving shelter that continually spreads manure and provides "the best tasting omega-3 eggs the world knows." He mentioned how people in New York City pay $5 a dozen for these superior eggs. "Free range means nothing: All chickens need to have is access to the outside for fifteen minutes each day to be considered free range," Dan explained. "Most free-range chickens in this country never see grass, let alone taste it!"

When I asked Dan if he ever looks back on his urban life and regrets his decision to leave it all behind, he responded, "I love every day here!" In his corporate life he used to have a problem getting up in the morning. "I feel better about what I do now than anything I've ever done in my life," he said. Dan is providing safe, clean, slow food. "I'm just a farmer practicing the new old way of farming," he said, smiling at the irony. "The farmers around here once laughed at my ideas, but now they're pretty self-congratulatory and say, 'We knew you were on to something!'"

Grazin' Angus invites visitors to shop at their farm store and enjoy scenic views of the farm. *Opposite page:* a grass-fed angus steer that has been wintered three times. It takes time to marble up the beef so it tastes much better than conventionally processed meat.

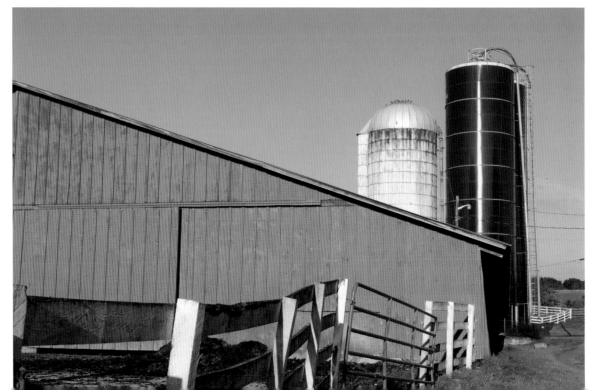

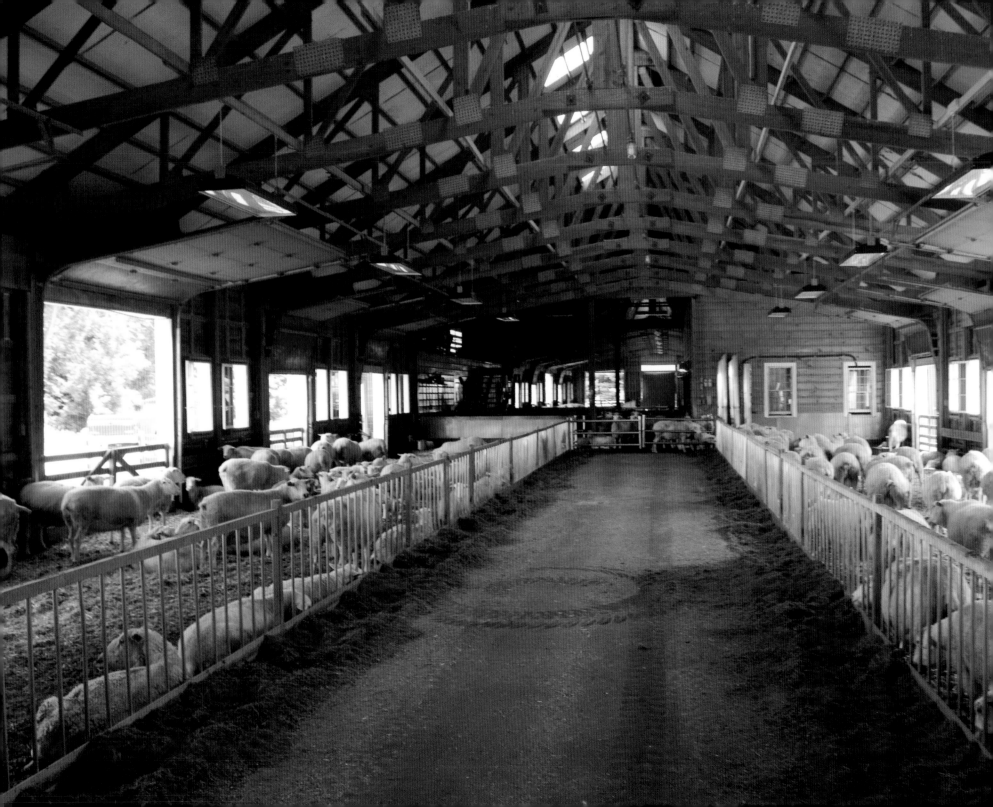

OLD CHATHAM SHEEPHERDING COMPANY Old Chatham, Columbia County

"We sell everything we make—about 200,000 pounds of cheese and 2,000 pounds of yogurt a year."

ecades ago, Dutchess County native Tom Clark, owner of Old Chatham Sheepherding Company, exhibited sheep as part of a 4-H project at the county fair—and won a blue ribbon. He loved visiting his grandfather's farm and graduated from the Cornell School of Agriculture. He then ran a private equity firm in Greenwich, Connecticut, until 1979, when he started work in Albany and bought a home with acreage in the rolling hills of Old Chatham.

In the early 1990s Tom decided to start a sheep farm. "I did some research and decided to do cheese and dairy," he said, explaining how he decided the farm would raise a milk breed of East Friesian sheep, a specialized market. Tom started building up a flock that now consists of about one thousand animals, making it the largest sheep dairy farm in the United States. The beautiful red barns—including a restored Shaker barn—are kept meticulously clean. Tom and his wife, Nancy, began with a farmhouse and a group of Cornell agricultural students who helped them decide what to do with the business. They were confident the Clarks could run a country inn as well as a farm—and the students turned out to be right. By 1997, two years after opening, the establishment had earned the distinguished Relais & Chateaux designation. However, in June 1999, when the chef left

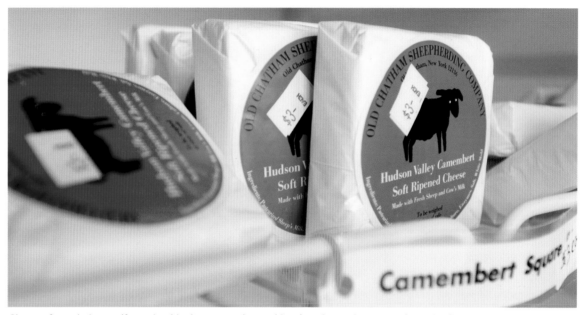

Cheese for sale in a self-service kiosk next to the parking lot. *Opposite page:* sheep in their barn.

to open her own restaurant, Tom decided to convert the inn into a home. The Clarks lived on the six-hundred-acre sheep farm, and Tom managed the operation with the help of a small staff, overseeing the farming and cheese production. Nancy is a licensed cheese maker and develops new products.

The sheep are milked year-round, but the cheeses are not aged: They are made fresh every week, and milk is needed on a daily basis. "We sell everything we make—about 200,000 pounds of cheese and 2,000 pounds of yogurt a year," Tom told me, going on to say the protein in sheep's milk yogurt is double that in cow's milk and the calcium content is 50 percent greater.

Tom also explained the farm's "light treatment breeding program," in which modifications of day length are used to induce the sheep to ovulate. The sheep now get pregnant in May and give birth in the fall. "I love having farmland that's productive, growing good crops, and running a business that

is continually improving," Tom observed, explaining how breeding the sheep properly and feeding them well makes a difference in the outcome of the cheeses. His aim is to perfect every piece of the operation. "We need more diverse genetics now," he said, explaining how the importation of sheep semen has become difficult, affected by concerns about mad cow disease.

During processing, probiotic cultures are added to the mix. "Non-fat yogurts take fat out of their products but substitute additives," he noted, because many people believe a non-fat product is healthier. Sheep yogurt is expensive, since a sheep produces only a half-gallon of milk per day while cows often give ten times that amount.

Reflecting on the changes his growing business has undergone, Tom mentioned how he timed starting an organic farm just right in the early 1990s. The Old Chatham Sheepherding Company's black sheep logo on a bright green background jumps out at consumers on specialty store shelves well beyond the Hudson Valley.

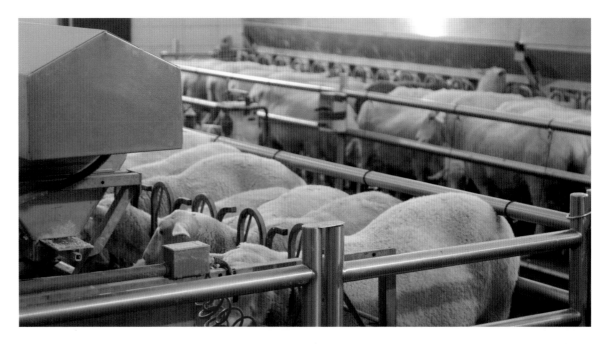

Clockwise from top: sheep in high tech stainless steel feeding room; a lone sheep in feeding parlor exit area waits for others; two sheep gazing through the barn door. *Opposite page:* There's one in every crowd . . .

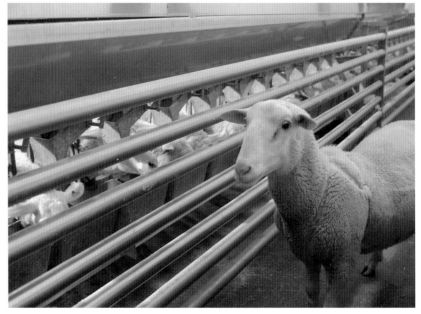

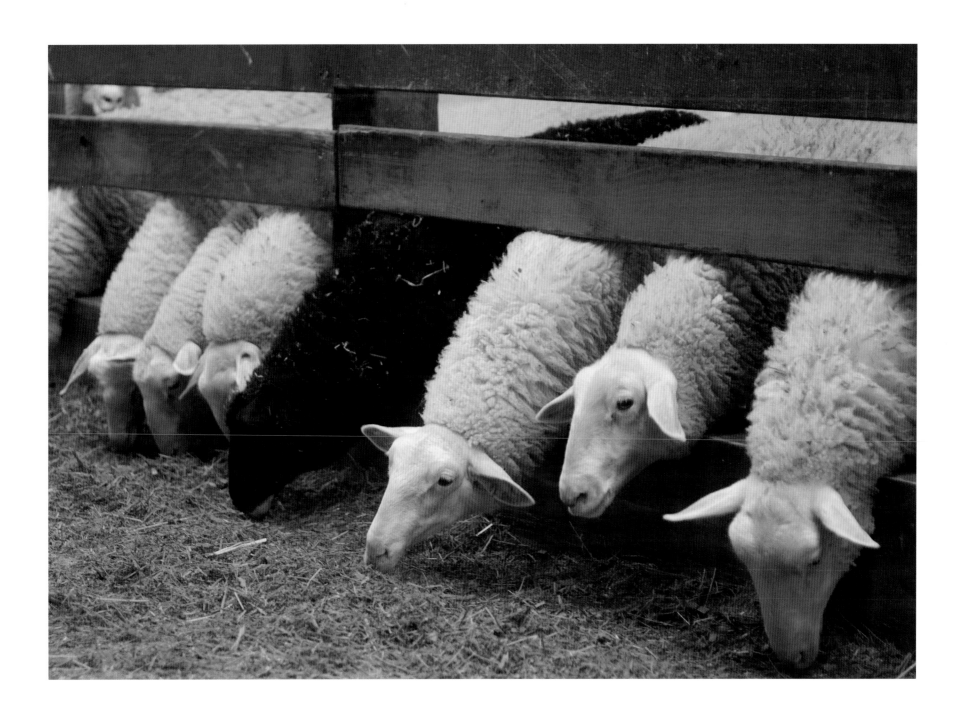

SPRUCE RIDGE FARM Old Chatham, Columbia County

"When I bend down to pick up something I dropped, four or five alpacas come nibbling at my ear and sleeve. They're quite charming creatures!"

A picturesque, perfectly manicured forty-eight–acre farm in pastoral Columbia County is home to a lively herd of alpacas, owned by Jeff Lick and Steve McCarthy. Both men worked in the banking industry before starting an alpaca business in 1997. They now care for nearly seventy of these gentle creatures; and it happened quite by accident. Jeff had been reading an organic gardening magazine that claimed alpaca manure made excellent compost. A neighbor (near their former weekend home in Rhinebeck) raised alpacas, and they asked to "borrow" some manure for their flowerbeds.

When Steve and Jeff moved farther north to Old Chatham, their new property, a former horse farm, included several barns and acres of fields. They realized there would now be enough space to raise alpacas and figured the animals would keep the grass down as well. "Alpacas are light grazers, environmentally friendly, compared to other types of livestock; their feed intake is quite low," Jeff explained. "You can have a small amount of land and four to ten animals per acre."

While sitting on the terrace of their beautiful home, Jeff explained how alpacas are members of the *cameloid* family that includes vicunas and llamas, as well as alpacas. "I fell in love with alpacas,"

Jeff told me, explaining that they are smaller than llamas, and weigh only about 150 to 200 pounds. In the spring the alpacas are sheared for summer heat, looking rather gawky without their fleece, quite different from the way they look in zoos. Their "wool," called fiber, comes in twenty-two natural colors ranging from white to black.

There are only 100,000 alpacas in the United States today, and New York State is seventh of the fifty states in the number of animals. Ohio is first, since the original importers of alpacas to the United States (in 1984) reside there. Alpacas have come to North America from Peru, Bolivia, and Chile and are DNA blood-typed and registered like animals in the horse-breeding business.

Steve and Jeff started out with only a few alpacas and soon decided to breed their livestock. Jeff explained that there are alpaca shows like horse and dog shows. "We go all over the country in the fall to show our best animals and compete," he said. Spruce Ridge Farm has won blue ribbons in the full fleece category. The animals are judged 50 percent on fleece and 50 percent on the rest of their formation. Gradually, this second career became a full-time enterprise. "I love the animals, but they aren't our pets," Jeff explained. "They have a Zen

calm about them, and when I bend down to pick up something I dropped, four or five come nibbling at my ear and sleeve. They're quite charming!"

Steve is more involved with the animals, whereas Jeff focuses on the facilities. "I always wanted to raise some kind of animal," Steve told me. But as a banker, he knew the realities of any business. He summed up the twenty-first-century farmer's dilemma: "If you stay in farming today, you must add value to the process." The alpaca farm in Old Chatham is involved in sales, boarding, consulting, and selling fiber and alpaca products.

Steve shared how, during summer evenings, the crias (baby alpacas) have a ritual of running and leaping through the fields. "It's a joy to watch," he enthused. "Life doesn't get much better than this!"

Clockwise from left: Jeff Lick with his alpacas; naturally curious and friendly, alpacas come to inspect a visitor; yarn made at Spruce Ridge. *Opposite page:* an alpaca, recently shorn, hence the tracks in its fur.

Yarn made from the fiber of Spruce Ridge Farm's Alpacas

More Available $5/ounce

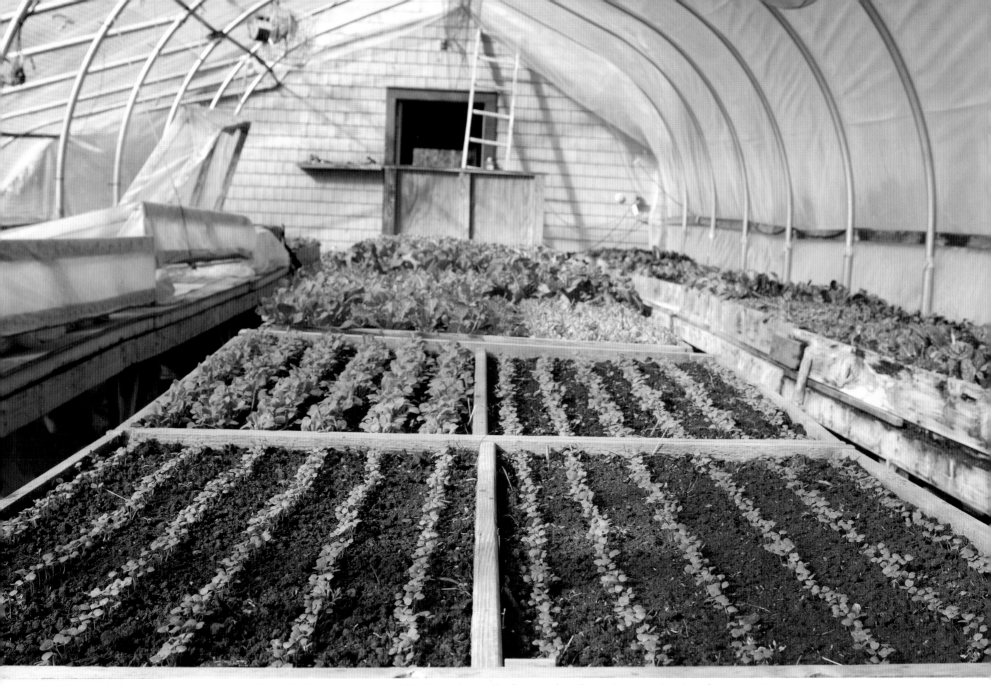

Young salad greens growing in a greenhouse in November to be sold in December at the farm market. *Opposite page:* ripening cherry tomatoes.

CATSKILL MOUNTAIN FOUNDATION FARM Maplecrest/Hunter, Greene County

"Rather than controlling the growing process, seeds are respected, not manipulated."

On a former softball field thrives a farm of about five acres—one of only three farms in the country practicing an approach to growing food that uses no chemicals or additives. Farmer Kenji Ban, originally from Okayama, Japan, and now manager of the Catskill Mountain Foundation's Natural Agriculture Farm at Sugar Maples, explained how Natural Agriculture differs from organic farming that uses manure and compost, feeding the soil rather than the plants.

Natural Agriculture proponents do not believe manure benefits the natural soil. They feel everything needed by plants is already present in the soil. The practice involves changing the way we think about nature and responding to the world with a different mind-set. The farm here was started in 2004. The cultivation of such crops year after year enriches the soil. Kenji's assistant, Kancha, is a Sherpa from Nepal who resides in Windham, New York.

Peter Finn, president and CEO of the Catskill Mountain Foundation (CMF), emphasized that the principles and practice of Natural Agriculture began in the early twentieth century in Japan, where agriculture was seen as an art rather than an industry. The harmonious interconnection of light, soil, water, and air restores the purity of the food supply. "Rather than controlling the growing process, seeds

are respected, not manipulated," Peter explained. "Our crops are healthier, more disease-resistant, stay fresh longer, and taste better."

Kenji and Peter took me for a walk in the garden amid the soybeans, green onions, red potatoes, asparagus, snow peas, and zucchini—all crops that add nitrogen to the soil. Hay adds organic material and helps the soil with microorganisms. "The soil needs living things, like earthworms," Kenji explained, while his toddler picked up one such worm and proudly showed his father. "Even the weeds are good for the soil." Kenji pointed out how the cloves planted between rows of crops add nitrogen naturally.

Peter's family has roots in the Catskills that go back generations. His grandparents bought land in Hunter in 1900, and he fondly recalls many summers in the Catskills during his childhood. In the early 1990s, Peter and his wife, Sarah, started spending more time in Hunter and became increasingly involved in the community. In 1998 they formed the CMF and transformed a sleepy village into a multicultural enclave with a performing arts center, theater, bookstore, natural foods market, and cafe. In 2000 the CMF began publishing a free regional full-color magazine distributed throughout the Hudson Valley Catskills, further engaging the com-

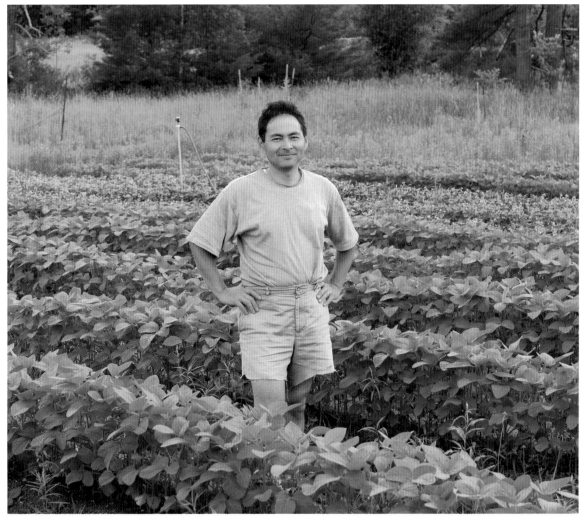

Farm manager Kenji Ban, trained in Natural Agriculture in Japan. *Opposite page:* basil in a raised bed growing in front of heirloom tomatoes in the greenhouse.

in Japan filled with antiquities. Peter's sister, Dina, handled the account. As she learned more about the Japanese organization, she suggested the collaboration of the small farm in Hunter and Shumei. They agreed and sent an expert to help with the farm. Kenji arrived in Hunter, New York, in 2000.

The goal of the CMF is to create a model Natural Agriculture farm for the Northeast. Eventually there will be a renewable energy component and a solar-heated greenhouse with geothermal heating and cooling. There are Shumei projects in Colorado Springs, Santa Cruz, and Hollywood, as well as Maplecrest.

Natural Agriculture involves more than technique; it includes relating to the natural world through one's heart, not only one's head. And it means listening, respecting, and responding to, rather than dictating, the needs of nature. It results in a lifestyle that creates inner harmony as well as connection with one's community and environment, a philosophy of life the Finns have brought to fruition in a small part of the Catskills.

Peter would like to see the mountaintop (as it is called by locals) evolve into an international arts destination. A visit to the Natural Agriculture farm will be a cultural and educational experience, yet also fun for travelers. And judging from what the Finns and their devoted employees have accomplished in the first ten years of the CMF's existence, it is likely the next decade will realize this dream.

munity in special activities and cultural events. Now in its second decade, the CMF has generated more than $30 million in grants, donations, and revenues that it has invested back into the community.

During the week, Peter is the CEO of Ruder Finn Public Relations in Manhattan. The agency has several museums as clients, and in 1993 Shumei became one of them. They were opening a museum

ARMSTRONG ELK FARM Cornwallville, Greene County

"The elk antlers contain all twenty-eight amino acids a human being needs to live."

Les Armstrong has been raising elk for medicinal purposes since 1996, when he started with just five of these gentle creatures, called *wapiti* (white rumps) by Native Americans. As I drove through the rural back roads of Greene County and pulled into his driveway, I could see dozens of elk grazing.

Soon after we met, Les explained he had been a dairy and cattle farmer and wanted to keep his farm going. It has been in his family since 1863. "Financially, shifting things around to raise elk was a wise decision," he said, reflecting on the changes the farm has undergone. "They consume one-third of what a cow consumes and one-quarter of what a horse eats." Cattle can finish off an entire farm's harvest, but elk don't eat much. The females live to be around thirty; the bulls only survive to approximately twenty, making them cost-effective and low-maintenance animals. Interestingly, Les named his elk bulls after the different Catskill Mountain ranges.

When their "velvet antlers," are pulverized, the resulting powder is used as an antidote to soothe arthritis pain. The Armstrong farm has customers from a range of locales, including Florida, Spain, and Buffalo, without doing any aggressive advertising. "And elk are the only animal with ivory teeth," Les noted. "The antlers of an elk contain all twenty-eight amino acids a human being needs to live," he told me, intimating that perhaps this is why they have medicinal properties. Les dries the antlers before sending them to Maine, where they are made into capsule form before being sent to customers. The powder reputedly boosts the immune system. "I can get 1,800 capsules per pound of antler," Les said, explaining the antlers grow extremely fast, becoming huge within four months, when they naturally fall off and are then harvested.

According to Les, the elk like to chase each other and play games like King of the Mountain.

"Unlike cows, they have distinct personalities; some are friendly, others are skittish," he said, adding that he sold off some unfriendly animals to other farmers, but "never for meat."

Ironically, Les is enthusiastic about his hobby of taxidermy. Sitting in his living room is like being surrounded by a silent zoo. "My hobby became a business and kept me home with the kids," he said, explaining that his wife, Deb, works for the Greene County Social Services Department. "My goal is for the farm to survive and not be overburdened by government regulations."

A one-day-old elk calf calling out to its mother. *Opposite page:* a bull elk stands inside a padded device used to harvest antlers without harming the animal.

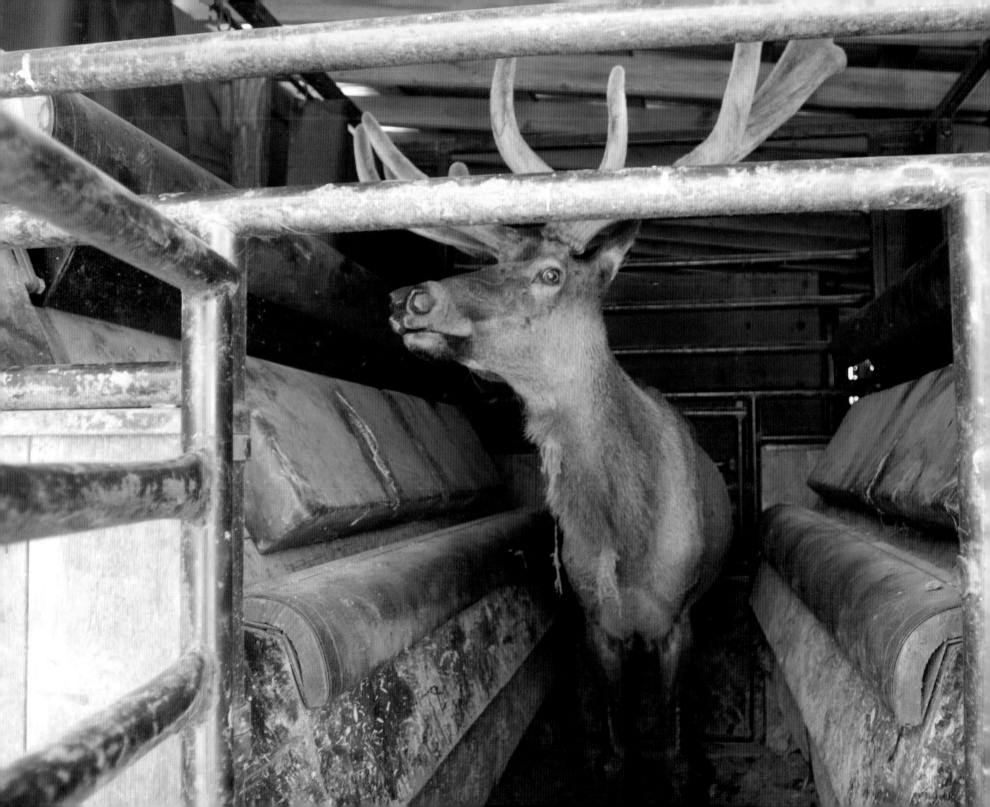

HULL-O FARM Durham, Greene County

"There are no Game Boy toys around here!"

To visitors at the door at the classic 1810 farmhouse of Hull-O Farm in the pastoral Catskills countryside, Sherry Hull may seem like she stepped out of central casting for a farmer's wife. A petite blond with a wide smile, usually wearing a form-fitting, lovely dress, she radiates welcoming hospitality. As we relaxed over tea in the cozy kitchen, it was difficult to believe two of her four children made her a grandmother several times over. One son partners with his father, Frank, on the farm.

"Let me get my cookbook," she said getting up to go into the living room and returning with a colorful compendium of family recipes she had assembled. The Hulls came from Somersetshire, England. "Frank's family actually named Durham, New York, after Durham, Connecticut, where they had settled previously," she told me. Old family photographs, framed and hanging on the living room walls, attested to her story.

The Hulls farmed on Meetinghouse Hill in Durham, New York, during the late eighteenth century, and Sherry and Frank are the seventh generation to carry on the family farming tradition ... with a twist. Hull-O Farm became a family vacation destination in 1994. The Hulls were forced to "think out of the box," coming up with this new business venture. Dairy farming wouldn't sustain them if

they wanted to remain farmers. Milk prices were falling, and the price of grain was rising. "In the late 1980s, we were working around the clock every day, producing two million pounds of milk annually, and all that didn't sell for enough money to support us!" Sherry remembered. "I had been a housewife and hostess my entire life when we opened to the public as a bed-and-breakfast the weekend my youngest son graduated from high school."

The three-hundred-acre property has four separate houses; the Hull's home has a wonderful large dining room with a fireplace. Guests enjoy a hearty breakfast and lunch there. "The Rose," a two-bedroom house where Frank's parents once lived, is now a homey place where families retreat in the evening. "Wonderful, kind-spirited people come here as guests," Sherry told me, smiling. Children delight in being able to gather eggs and milk cows in a relaxed, rural, yet educational setting completely removed from high-tech gadgets of all kinds. Sherry added, "There are no Game Boy toys around here!"

Frank and Sherry explained how their costs have risen astronomically. Diesel fuel for the tractors is exceedingly expensive. They now pay triple for fertilizer and double for feed, seed, and grain than they did only a few years ago. A 1,400-pound steer nets 50 cents per pound, but it costs $2,000 to

Sherry and Frank Hull. He is the sixth generation of his family on this farm. *Opposite page:* a view of Hull-O Farm, nestled in the northern Catskills.

raise the animal. They come home from an auction with $750, understanding all too well why they are in debt.

Grain-fed beef is a new enterprise the Hulls recently started. Frank took me downstairs and

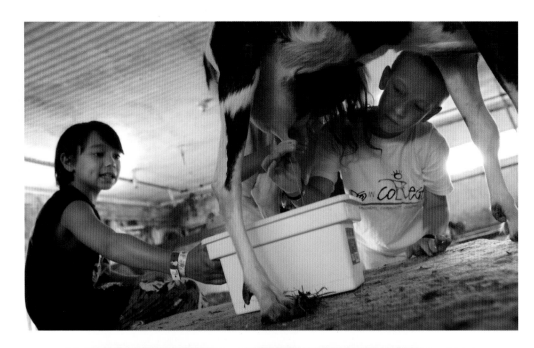

Clockwise from top left: Emily and Ryan Guzinski milking a goat with their cousin Chase Cosenza; Emily and Ryan bringing eggs they collected to the kitchen to be cooked for breakfast; Emily milking a cow with help from her older cousin Samantha Williams.

proudly showed off his new huge freezer and packing area. "The abundance of adrenaline in factory-slaughtered terrified animals affects the taste," he explained. "I used to shoot them in the field with my dad; they were totally relaxed and didn't see us coming." (Who realized the "fear factor" could make a difference in flavor?)

"There are two sets of people in the world—the givers and the takers," Frank told me, referring to his father's wisdom. "We're givers." And consistent with that philosophy, when guests leave Hull-O Farm they are given a dozen fresh eggs.

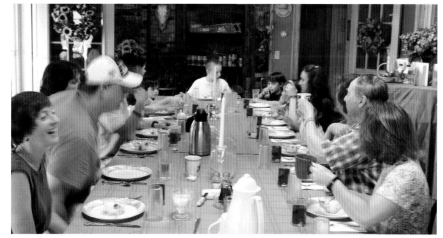

Clockwise from top: the extended Cosenza family has been vacationing at Hull-O Farm for six years. Here they enjoy Sherry Hull's famous fresh-from-the-farm breakfast; a boy visiting with his family feeds the goats; a young foal.

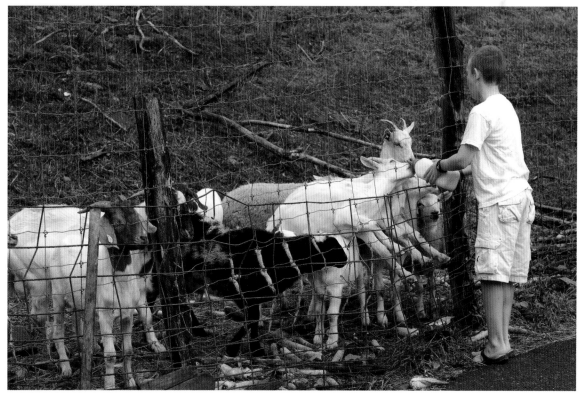

HEATHER RIDGE FARM Preston Hollow, Albany/Schoharie Counties

"I knew I could put the farm back intact using the marketing experience I had from my former career."

At one time, Carol Clement ran a pig farm and raised bees. "None of it is hard if you have the right fencing, equipment, and temperament," she commented about the two-hundred-year-old property where she has lived for more than three decades. She closed her advertising agency and marketing company in Windham in 1999 and began building up the farm by diversifying. She started making soaps and candles and gradually added more animals. Currently, there are ten head of cattle, two thousand chickens, one hundred turkeys, fifty sheep and lambs, forty pigs, and thirty beehives. The chickens are free-range, and the other animals are all grass-fed. No hormones or antibiotics are added to the mix; no chemical fertilizers are used on the pasture.

Years ago Carol produced a video on rotational grazing for animals and became excited about the concept. She came to a startling realization: "Hey, I could be a full-time farmer!" She also knew she would have to purchase some heavy equipment. The farm she owned was once a dairy operation, and horses were often used for hauling since the farm is situated on an exceedingly steep hill. "I knew I could put the farm back intact using my marketing experience from my former career," Carol said, "so I gradually bought up the surrounding lots." Car-

Hundreds of baby chicks in the chicken nursery. *Opposite page:* the sign outside the store welcomes visitors, mostly weekenders, who regularly visit Carol Clement's farm.

ol's husband, John Harrison, a telephone company employee, helps out in his spare time.

I met with Carol in her office with its adjoining gift shop and processing kitchen. "I enjoy dealing with customers and wanted to directly market my goods," Carol explained, showing me around. On weekends throughout the year, the area where we were sitting is transformed into a retail store. At one point, our conversation was interrupted by a UPS delivery. The large box contained more downy

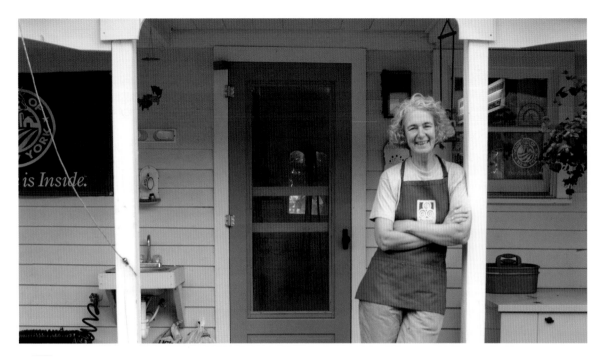

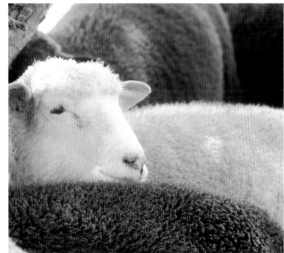

soft sheepskins to sell in the store to weekenders for whom her farm has become a destination. "I knew I had a better chance to make a living farming full-time if there were no middlemen involved," she said. From the hundreds of heirloom apple trees on the farm Carol gathers apple wood in small batches to sell in the gift shop: Her customers love to use it for barbecuing. Gourmet garlic and various fresh herbs are also available for sale in season.

Carol realized product diversity would add to the bottom line. Heather Ridge Farm recently started making fresh sausages: "They're organic, although not certified organic," she added. Customers are able to see how the animals are raised—that they are grass-fed and drink only mountain spring water. The shop also features local cheeses, maple syrup, and other products from neighboring farms. "I like seeing the pieces of the puzzle come together," she said, pleased with how the business has evolved. One point of pride is that the farm currently processes more than one hundred chickens each week.

As I walked the farm, I found the llamas that guarded the sheep against predators particularly intriguing: They would come right up to you if you approached too closely. Dogs, coyotes, and foxes prey on the chickens, occasionally making life on the farm a challenge. Electric fences keep the bears away, however. The couple own two dogs—shepherds Rafferty and Peig—working animals as well as pets, hence most interlopers are kept at bay.

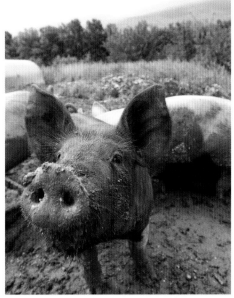

Clockwise from top left: sheep, along with the other animals on the farm, are all grass-fed and drink only mountain spring water; the pigs have a great view of the Catskills; llamas protect the sheep from coyotes, unafraid to come right up to inspect visiting humans; chicken are kept in "eggmobiles," houses on wheels with portable fencing to allow them a new pecking area every few days. *Opposite page, clockwise from top left:* Carol Clement; sheep huddle close; grinding chicken meat.

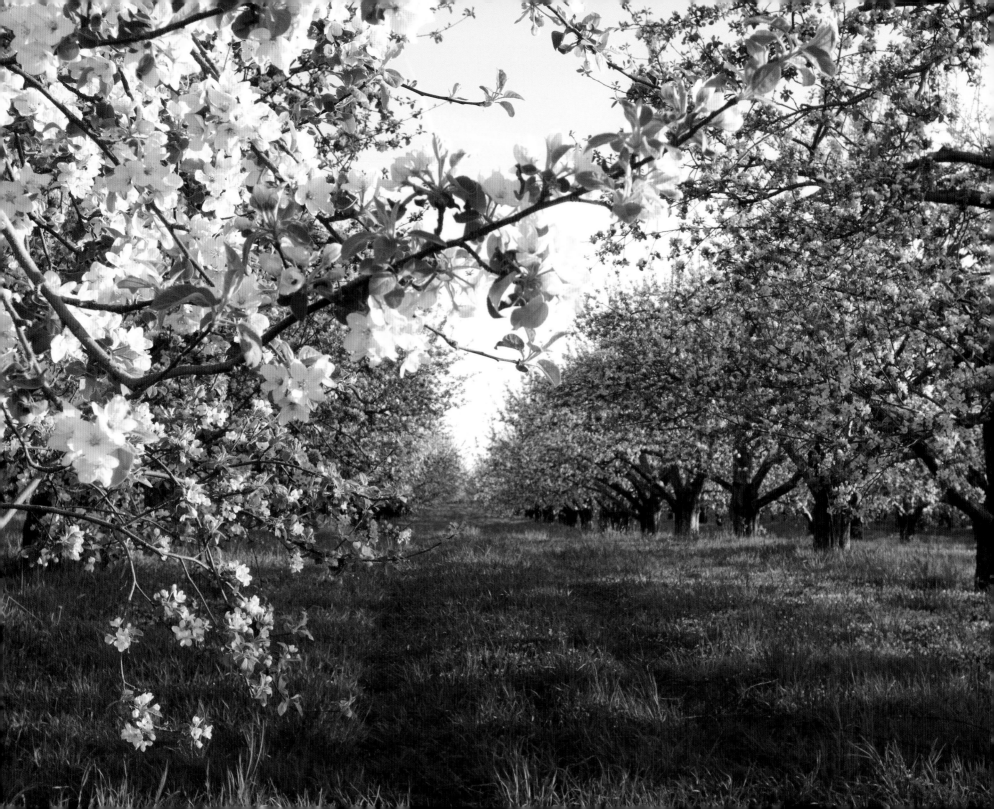

GOOLD ORCHARDS Castleton-on-Hudson, Rensselaer County

"A hailstorm can come out of nowhere, and five minutes later your entire income for the year is destroyed."

A native of Castleton-on-Hudson, Sue Goold Miller is a third-generation apple farmer, descended from the Albany family that started the Goold Carriage Company in 1838. Sue's grandparents bought the 160-acre farm (75 acres are actually apple trees) in 1910. Today Sue and her husband, Ed, run Goold Orchards, the largest farm in Rensselaer County.

A century ago the Goolds wanted to operate a sustainable apple farm and were the first in the county to do commercial spraying to achieve that goal. "Every pest that exists lives here in the Hudson Valley," Sue explained, referring to the difficulties confronting fruit growers along with the multitude of pollens that thrive in the region. Ed, an expert on spraying techniques, explained how knowing the right chemicals to use is only one part of being a successful apple farmer, especially useful while under strict state guidelines for integrated pest management. "At 3:00 in the morning you have to be out there spraying. You can be moving a few miles per hour on a tractor, but when a branch hits your face, it often brings tears to your eyes," he said, "and you have to keep going." The relentless daily routine is imperative to ensure any large-scale apple harvest.

You must be passionate about the lifestyle and have the personality to withstand unpredictabil-ity. "Farmers live like gamblers," Sue said, recalling some of the difficult times when nature wreaked havoc with their plans and finances. "Your crop can be wiped out if a hailstorm blows in the day before you plan to pick."

Goold's sells seventeen types of apples. I had been mispronouncing the name of my favorite, the Macoun. "It rhymes with clown," Sue corrected me. New varieties, like Fuji, Cameo, and Gala, sell well, but the McIntosh is still the most popular apple.

A honeybee pollinating an apple blossom. Bees are brought into the orchard specifically for pollination, and with-out them there would be no fruit. *Opposite page:* apple blossoms in May.

Ezekiel Phillips, longtime worker at Goold Orchards, pruning a tree to allow light in to the apples below, a necessary task for the ripening process. *Opposite page:* Ed Miller mowing in the apple orchard.

Customers desire perfectly formed fruit; they also like their apples red. "Americans buy with their eyes, while Europeans choose fruit with their taste buds," Sue commented, explaining what she learned after a business trip visiting French apple orchards.

The apple business changes seasonally, and the Millers enjoy the varied tasks: They prune in winter and fertilize, spray, and harvest during a three-month period. About four hundred to five hundred bushels of apples can be picked in one day, then they must be packed.

A recent addition to the business is Brookview Station Winery, named for the local train station. When Sue's grandparents first arrived at the farm a century ago, they came by train. "By diversifying into winemaking, the orchard will have something new and different to attract travelers," she mused. The orchard currently offers pick-your-own, an annual apple festival featuring a cider mill that operates year-round, and school tours. Their *Whistle Stop White* was already a gold medal winner at the Hudson Valley Wine Growers Association apple wine competition—quite an accomplishment considering the first vintage was produced in 2006. As I left the farm, Sue remarked: "If you have a large fortune, just plant apple trees ... and soon you'll have a small fortune!"

HUDSON RIVER VALLEY FARMERS MARKETS

Many of the farms featured in this book sell their produce at the following farmers markets. The list here includes the eight Hudson River Valley counties and the Albany region. Some of the farmers markets have easily accessed Web sites. For a complete list of farmers markets throughout the state of New York, go to www.agmkt.state.ny.us.

ROCKLAND COUNTY

HAVERSTRAW FARMERS MARKET
Maple Avenue
May through November
Sunday 9:00 a.m. to 2:00 p.m.

NYACK FARMERS MARKET
Main and Cedar Streets
Mid-May through November
Thursday 8:00 a.m. to 2:00 p.m.

PIERMONT FARMERS MARKET
Ash Street and Piermont Avenue
June through November
Sunday 9:30 a.m. to 3:00 p.m.

SPRING VALLEY FARMERS MARKET
Main and North Church Streets
July through mid-November
Wednesday 8:30 a.m. to 3:00 p.m.

SUFFERN FARMERS MARKET
Orange Avenue commuter parking lot
Mid-June through mid-November
Saturday 9:00 a.m. to 1:00 p.m.

WESTCHESTER COUNTY

BRONXVILLE FARMERS MARKET
Stone Place at Paxton Avenue
June through November
Saturday 8:30 a.m. to 1:00 p.m.

DOBBS FERRY FARMERS MARKET
Cedar and Main Streets
July through October
Wednesday 10:00 a.m. to 4:00 p.m.

HARTSDALE FARMERS MARKET
Hartsdale Train Station, DiSanti Plaza
July through November
Saturday 9:00 a.m. to 2:00 pm

HASTINGS FARMERS MARKET
Library, Maple Avenue
June through November
Saturday 8:30 a.m. to 1:30 p.m.

KATONAH LEWISBORO FARMERS MARKET
Route 121 (at John Jay High School)
June through November
Saturday 8:30 a.m. to 2:00 p.m.

LARCHMONT FARMERS MARKET
Chatsworth Avenue, Metro North upper lot
June through mid-December
Saturday 8:30 a.m. to 2:00 p.m.

MUSCOOT FARMERS MARKET
51 Route 100 at Muscoot Farm (Katonah)
Late May through October
Sunday 11:00 a.m. to 3:00 p.m.

NEW ROCHELLE FARMERS MARKET
Division Street and Leroy Place
July through mid-November
Friday 8:00 a.m. to 3:00 p.m.

OSSINING FARMERS MARKET
Main and Spring Streets
June through mid-December
Saturday 8:30 a.m. to 2:00 p.m.

PEEKSKILL FARMERS MARKET
Bank Street between Main and Park
Mid-June through mid-November
Saturday 8:00 a.m. to 2:00 p.m.

PELHAM FARMERS MARKET
Harmon Avenue, off Fifth Street
Mid-June through mid-November
Sunday 8:30 a.m. to 2:00 p.m.

PLEASANTVILLE FARMERS MARKET
Manville Road and Wheeler Avenue
June through mid-December
Saturday 8:30 a.m. to 1:00 p.m.

RYE FARMERS MARKET
Theodore Freund Avenue
June through mid-November
Sunday 8:30 a.m. to 2:00 p.m.

TARRYTOWN FARMERS MARKET
Patriots Park, Route 9
June through mid-November
Saturday 8:30 a.m. to 2:00 p.m.

WHITE PLAINS FARMERS MARKET
255 Main Street
May through November
Wednesday 8:00 a.m. to 4:00 p.m.

YONKERS FARMERS MARKET
1 Hudson Street (St. John's Church)
July through mid-November
Thursday 8:00 a.m. to 4:00 p.m.

PUTNAM COUNTY
BREWSTER FARMERS MARKET
208 East Main Street
Mid-June through mid-November
Wednesday and Saturday 9:00 a.m. to 2:00 p.m.

COLD SPRING FARMERS MARKET
44 Chestnut Street
Late May through late November
Saturday 8:30 a.m. to 1:30 p.m.

ORANGE COUNTY
FLORIDA FARMERS MARKET
Routes 94 and 17A
Late June through October
Tuesday 3:00 p.m. to 7:00 p.m.

GOSHEN FARMERS MARKET
Village Square
Mid-May through October
Friday 10:00 a.m. to 5:00 p.m.

MIDDLETOWN FARMERS MARKET
Erie Way
Mid-June through October
Saturday 8:00 a.m. to 1:00 p.m.

MONROE FARMERS MARKET
1010 Route 17—Museum Village
Late June through October
Wednesday 9:00 a.m. to 3:00 p.m.

MONTGOMERY FARMERS MARKET
36 Bridge Street, Senior Center
July through December
Wednesday 10:00 a.m. to 3:00 p.m.

NEWBURGH FARMERS MARKET
Route 9W and South Street
Mid-July through October
Friday 10:00 a.m. to 5:00 p.m.

Jams and other goodies for sale at Stuart's Farm in Granite Springs.

PINE BUSH FARMERS MARKET
Main and New Streets behind Town Hall
Mid-June through October
Saturday 9:00 a.m. to 2:00 p.m.

TUXEDO FARMERS MARKET
240 Route 17N—Tuxedo Train Station
Mid-June through October
Saturday 9:00 a.m. to 2:00 p.m.

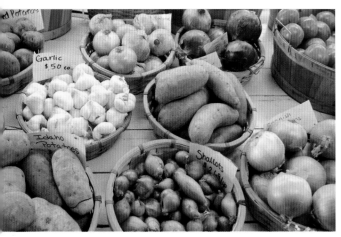

Fall harvest: potatoes, tomatoes, garlic, shallots, and onions for sale at Tantillo's Farm store.

WALDEN FARMERS MARKET
Village Square, in front of library
Late June through October
Thursday 11:30 a.m. to 4:00 p.m.

WARWICK VALLEY FARMERS MARKET
South Street parking lot, off Main Street
Mid-May through October
Sunday 9:00 a.m. to 2:00 p.m.

WEST POINT FARMERS MARKET
Main Street, near visitors center
Late June through early November
Sunday 9:00 a.m. to 2:30 p.m.

ULSTER COUNTY

ELLENVILLE FARMERS MARKET
Market and Center Streets
Late June through September
Sunday 9:00 a.m. to 2:00 p.m.

HIGHLAND FARMERS MARKET
1 Haviland Road
Mid-June through early October
Wednesday 3:00 to 7:00 p.m.

KINGSTON FARMERS MARKET
Wall Street between Front and John Streets
Late May through mid-November
Saturday 9:00 a.m. to 2:00 p.m.

MILTON FARMERS MARKET
1801–1805 Route 9W
Late July through late October
Saturday 8:30 a.m. to 1:30 p.m.

NEW PALTZ FARMERS MARKET
28 Main Street
Late June through October
Sunday 10:00 a.m. to 3:00 p.m.

ROSENDALE FARMERS MARKET
1055 Route 32 (Rec Center)
June through early November
Sunday 9:00 a.m. to 3:00 p.m.

SAUGERTIES FARMERS MARKET
Main and Market Streets
Late June through October
Saturday 9:00 a.m. to 2:00 p.m.

WOODSTOCK FARM FESTIVAL FARMERS MARKET
Maple Lane
Late May through late September
Wednesday 4:00 to 8:00 p.m.

DUTCHESS COUNTY

ARLINGTON FARMERS MARKET
Raymond and Fulton Avenues
Mid-June through October
Thursday 3:00 to 7:00 p.m.

BEACON FARMERS MARKET
Train station parking lot
Year-round
Sunday 10:00 a.m. to 4:00 p.m.

FISHKILL FARMERS MARKET
1004 Main Street
Mid-June through October
Thursday 9:00 a.m. to 3:00 p.m.

HYDE PARK FARMERS MARKET
Hyde Park Drive-In, Route 9
Early June through October
Saturday 9:00 a.m. to 2:00 p.m.

LAGRANGE FARMERS MARKET
120–130 Stringham Road
Mid-June through early October
Saturday 9:00 a.m. to 2:00 p.m.

MILLBROOK FARMERS MARKET
Front Street and Franklin Avenue
June through October
Saturday 9:00 a.m. to 1:00 p.m.

MILLERTON FARMERS MARKET
Dutchess Avenue between Main Street
 and Century Boulevard
Late May through mid-October
Saturday 10:00 a.m. to 2:00 p.m.

PLEASANT VALLEY FARMERS MARKET
Town Hall (1554 Main Street)
Mid-June through October
Friday 3:00 to 7:00 p.m.

POUGHKEEPSIE FARMERS MARKET
Main Street off Market Street
Early June through October
Friday 10:00 a.m. to 3:00 p.m.

RHINEBECK FARMERS MARKET
East Market Street across from firehouse
Mid-May through mid-November
Sunday 10:00 a.m. to 2:00 p.m.
Thursday 3:00 to 7:00 p.m.

WAPPINGERS FALLS FARMERS MARKET
Mesier Park, Main Street
Early June through October
Friday 3:00 to 7:00 p.m.

COLUMBIA COUNTY
CHATHAM FARMERS MARKET
15 Church Street
Mid-May through October
Friday 4:00 to 7:00 p.m.

HUDSON FARMERS MARKET
North Sixth and Columbia Streets
Mid-May through mid-November
Saturday 9:00 a.m. to 1:00 p.m.

KINDERHOOK FARMERS MARKET
Village Green
Early June through mid-October
Saturday 8:00 a.m. to 12:30 p.m.

STUYVESANT FARMERS MARKET
55 Riverview Street and County Route 26A
Early May through September
Friday 4:00 to 7:00 p.m.

GREENE COUNTY
CATSKILL FARMERS MARKET
Catskill Point (foot of Main Street)
Mid-June through late October
Saturday 10:00 a.m. to 2:00 p.m.

EAST DURHAM FARMERS MARKET
Irish Cultural Center—Route 145
July and August
Sunday 10:00 a.m. to 3:00 p.m.

ALBANY AREA
ALBANY FARMERS MARKET
20 Learned Street
Year-round
Saturday and Sunday 10:00 a.m. to 3:00 p.m.

ALTAMONT FARMERS MARKET
Orsini Park, train station
Early July through mid-November
Saturday 9:00 a.m. to 1:00 p.m.

CAPITAL DISTRICT FARMERS MARKET
Routes 32 and 378 (Menands)
Early May through October
Saturday 8:00 a.m. to 1:00 p.m.

COHOES FARMERS MARKET
Municipal parking lot on Remsen Street
Early June through October
Friday 4:00 to 7:00 p.m.

DELAWARE AREA FARMERS MARKET
391 Delaware Avenue
July through October
Tuesday 4:00 to 7:00 p.m.

DOWNTOWN ALBANY FARMERS MARKET
State Street and Broadway
Early May through October
Thursday 11:00 a.m. to 2:00 p.m.

EMPIRE STATE PLAZA FARMERS MARKET
North end of the plaza
May through October
Wednesday and Friday 10:00 a.m. to 2:00 p.m.

HARRIMAN CAMPUS FARMERS MARKET
Harriman State Office Campus, off Western
 Avenue
Early May through October
Thursday 10:00 a.m. to 2:00 p.m.

HILLTOWN FARMERS MARKET
2958 Route 145
Late May through October
Friday 4:00 to 7:00 p.m.

WATERVLIET FARMERS MARKET
Thirteenth Street and Second Avenue
Late May through Early October
Tuesday 2:30 to 5:30 p.m.

DIRECTIONS: IF YOU WANT TO GO

Driving directions and Web site contact information are given from the south heading north for twenty-eight of the forty-four farms included in the book. The farms that are not listed here are private and not open to the public.

DR. DAVIES FARM, Congers (page 3)
www.drdaviesfarm.com
From New York City, cross the George Washington Bridge and take the Palisades Interstate Parkway north to exit 5N. Make a right onto Route 303 North and go for 12 miles. Route 303 merges with Route 9W for a half mile. Turn left onto Route 304. The farm is located about 0.25 mile up on the left.

STONE BARNS CENTER FOR FOOD AND AGRICULTURE, Pocantico Hills (page 4)
www.stonebarnscenter.org
Take I-87 (New York State Thruway) north to Saw Mill River Parkway North to exit 23 (Eastview). Make a left at the light. At the stop sign, make a right onto Lake Road; it merges with Route 448. Continue about 1 mile. The entrance is on the left.

CABBAGE HILL FARM, Mt. Kisco (page 8)
www.cabbagehillfarm.org
Take the Taconic State Parkway north to exit Route 100. Turn left at Campfire Road. Make a right at Route 100/Route 133/Saw Mill River Road. Make a right at Crow Hill Road. Continue up the hill approximately 1 mile, and the farm will be on the right.

STUART'S FARM, Granite Springs (page 10)
62 Granite Springs Road
Granite Springs, NY 10527
914-245-2784
Take the Taconic Parkway north to the Underhill Avenue exit (Croton-on-Hudson/Yorktown Heights). Turn right onto Underhill Avenue. Make a left onto Route 118 (Saw Mill River Road). Turn left onto Quaker Church Road. Turn right onto Granite Springs Road. Go about 0.5 mile, and the farm is on the right side of the road.

ROGOWSKI FARM, Pine Island (page 19)
www.rogowskifarm.com
Take I-87 (NYS Thruway) north to exit 16. Merge onto Route 17 West. Take exit 126 for Route 94 toward Florida/Chester. Make a left onto Route 94. Continue on County Route 25 (Meadow Road). Make a left at County Route 6 (Pulaski Highway). Continue on County Route 26 (Glenwood Road). The farm is on the left.

BLOOMING HILL FARM, Blooming Grove (page 22)
www.bloominghillfarm.com
Cross the George Washington Bridge and take the Palisades Parkway north to Route 6 West to exit 130 (Monroe/Washingtonville). Bear right onto Route

208 *toward Washingtonville, keep left at the gas stations, and make a left at the sign for the farm.*

HODGSON'S FARM, Walden (page 27)
www.hodgsonfarm.com
Take I-87 (NYS Thruway) north to exit 17 (Newburgh). Follow signs to Route 17K West. Go 12 miles into the village of Montgomery. After crossing a small bridge, make the second right turn onto County Route 14 (Albany Post Road). The farm is less than 4 miles on the right side of the road.

STOUTRIDGE VINEYARD, Marlboro (page 29)
www.stoutridge.com
Take Route 9W north into the hamlet of Marlboro. Turn left onto County Route 14 (Western Avenue). Go 0.3 mile and take the first right onto Prospect Street. Continue on and you will see a large sign on the left indicating the winery at Ann Kaley Lane.

TANTILLO'S FARM, Gardiner (page 37)
730 State Route 208
Gardiner, NY 12525
845-255-6196
Take I-87 (NYS Thruway) north to exit 17 (Newburgh). Take the first right after the tollbooth (Route 300) and go 3 miles to the intersection of Routes

32/7/300. At the light make a left and continue on Route 300 until the intersection with Route 208. Make a right onto Route 208 and continue on for 4 miles to the farm.

LIBERTY VIEW FARM, Highland (page 40)
www.libertyviewfarm.biz
Take I-87 (NYS Thruway) to exit 18. Keep right and turn onto Route 299 East for about 1 mile. Make a right at County Route 22 (South Street). Turn left at Maple Avenue. Turn left again at Crescent Avenue. The farm is 0.3 mile up the road.

SAUNDERSKILL FARMS, Accord (page 46)
www.saunderskill.com
Take I-87 (NYS Thruway) north to exit 19 (Kingston). Follow the signs to Route 209 South (Ellenville). The farm is located in the town of Accord, off Route 209, on the right side of the road.

DAVENPORT FARMS, Stone Ridge (page 49)
www.davenportfarms.com
Take I-87 (NYS Thruway) north to exit 19 (Kingston). Follow the signs to Route 209 South (Ellenville). The farm store is located in the town of Stone Ridge, off Route 209 on the left side of the road.

MISTOVER FARM, Pawling (page 58)
www.mistoverllc.com
Take I-684 north to the end. It becomes Route 22. Follow Route 22 North to Pawling. Turn left on River Road (there is a Citgo gas station on the corner). Go to the end and turn right onto West Dover Road. The farm is on the right, across from Deerfield Ponds.

SPROUT CREEK FARM, LaGrangeville (page 60)
www.sproutcreekfarm.org
Take the Major Deegan Expressway to I-87 (NYS Thruway) north and exit at Taconic State Parkway north. Take the Taconic to the Noxon Road exit heading toward LaGrangeville. Make a left onto County Route 21 (Noxon Road) and a right onto Lauer Road. The farm is on the right, just up the road.

WIGSTEN FARM, Pleasant Valley (page 62)
www.wigstenfarm.com
Take the Major Deegan Expressway to I-87 (NYS Thruway) north and exit at the Taconic State Parkway northbound. Take Route 55 West exit toward Poughkeepsie, staying on Route 55. Make a right onto County Route 46 (Freedom Road). Turn left onto U.S. Route 44 and make a right onto County Route 72 (North Avenue). Make a left onto County Route 73 (Sherow Road). Continue on Wigsten Road for 0.3 mile to the farm.

HAHN FARM, Salt Point (page 65)
www.hahnfarm.com
Take the Major Deegan Expressway to I-87 (NYS Thruway) north. Exit at the Taconic State Parkway northbound. Take the Salt Point Turnpike exit. Head south for 3 miles on Route 1125 (Salt Point Turnpike). The farm is on the left side of the road.

MCENROE ORGANIC FARM, Millerton (page 79)
www.mcenroeorganicfarm.com
Take the Bronx River Parkway to Hutchinson River Parkway North. Get off at the exit for I-684 North; then take the exit for Brewster. Follow Route 22

North. Stay on this road until you see the large sign for the farm store/cafe on your right. (The farm itself is down the road on Coleman Station Road.)

RONNYBROOK FARM, Pine Plains (page 87)
www.ronnybrook.com
Take the Major Deegan Expressway to I-87 North. Exit at Taconic State Parkway northbound to the Millbrook exit. Take Route 44 East to Route 82 North and go approximately 16 miles. Make a right onto Route 199 (Church Street). Turn left at Chase Road. Make a right at Prospect Hill Road and bear left to stay on that road to the farm.

F. W. BATTENFELD & SON, Red Hook (page 91)
www.anemones.com
Take I-87 (NYS Thruway) north to exit 19. Follow the signs for Route 209 North (Rhinecliff Bridge). After crossing the bridge, at the second light, make a left onto Route 9G. Make a right onto Route 199 East, passing straight through the village of Red Hook. The farm is on the right, and there is a prominent sign.

GREIG FARM, Red Hook (page 92)
www.greigfarm.com
Take I-87 (NYS Thruway) north to exit 19 (Kingston). Follow the signs for Route 209 North (Rhinecliff Bridge). After crossing the bridge, at the second light, make a left onto Route 9G. Go about 3 miles and make a right onto Kelly Road. At the stop sign make a left onto Budds Corners Road. Then make a right onto Pitcher Lane and you will see the farm.

Philip Orchard, Claverack (page 103)
270 Route 9H
Claverack, NY 12513
518-851-6351
Take I-87 (NYS Thruway) north to exit 21. Make a left off the exit onto Route 23 and follow signs to the Rip Van Winkle Bridge. After crossing the bridge, continue north on Route 23 until the junction of Route 9H. Make a left onto Route 9H and continue through Claverack. The orchard is on the right side of Route 9H; watch for the sign.

Hawthorne Valley Farm, Harlemville (page 111)
www.hawthornevalleyfarm.org
Take the Major Deegan Expressway to I-87 (NYS Thruway) and exit at the Taconic State Parkway northbound. Exit at Route 217/Philmont/Harlemville. Make a right off the exit ramp and go for 1.5 miles; the farm is on the left.

Grazin' Angus, Ghent (page 114)
www.grazinangusacres.com
Take I-87 (NYS Thruway) north to exit 21. Make a left onto Route 23 East crossing the Rip Van Winkle Bridge. Make a left onto Route 9 and a right onto Prospect Avenue in Hudson. Make a slight right onto Columbia Street, which becomes Route 66. Go 7 miles and make a left onto Bartel Road. The farm is at the end of the road.

Old Chatham Sheepherding Company, Old Chatham (page 119)
www.blacksheepcheese.com
Take I-87 (NYS Thruway) north. Get off at exit 21A and head toward I-90 East. Take exit B-1 and merge onto I-90 West toward Hudson/Albany. Get off at exit 12 (US 9 North). Turn right at Kingman Road. Make a right at Bunker Hill Road. Make a left onto County Route 32. Make a left onto Route 66 and a slight right at Shaker Museum Road to the farm.

Catskill Mountain Foundation Farm, Maplecrest/Hunter (page 125)
www.catskillmtn.org
Take I-87 (NYS Thruway) north to exit 19 (Kingston). Make the first right after the tollbooth (Route 28 West). Go about 25 miles to the Phoenicia exit. In the village, turn onto Route 214 and take it to the end, which is the intersection with Route 23A. Make a left onto Route 23A and go through the village of Hunter. Make a right onto Route 296. In Hensonville, make a right at the stop sign and follow the road into the center of Maplecrest. The farm is on the right in the middle of the village.

Hull-O Farm, Durham (page 131)
www.hull-o.com
Take I-87 (NYS Thruway) north to exit 21. Make a left off the exit to Route 23 West. Continue on Route 145 North for 7.5 miles. Make a left onto Stone Bridge Road (at the Zoom Flume sign). Go 3.5 miles, and the farm will be on the right side of the road.

Heather Ridge Farm, Preston Hollow (page 134)
www.heather-ridge-farm.com
Take I-87 (NYS Thruway) north to exit 21. Make a left off the exit onto Route 23 West. Exit at Route 145. At the junction of Route 81, turn west and go for 1 mile into the hamlet of Potter Hollow. There is a fork in the road; take the right fork for 3.2 miles (Scott Patent Road). The name of the road changes to Broome Hollow as you climb the hill and the county changes. You will see the sign and a yellow farmhouse on the right side.

Goold Orchards, Castleton-on-Hudson (page 139)
1297 Brookview Station Road
Castleton-on-Hudson, NY 12033
518-732-7317
Take I-87 (NYS Thruway) north to exit 21A (I-90 East). Go 6 miles and merge onto I-90 West. Take exit 11 (East Greenbush). Make a right onto Columbia Turnpike and another right onto Route 150 (Schodack Valley Road). Stay straight and go onto South Old Post Road. Make a right onto Brookview Station Road. The farm is about 1 mile along at the end of the road.

ACKNOWLEDGMENTS

I would like to express my gratitude to all the farmers included here who gave generously of their time to explain why they chose to farm and what their daily lives are like. All of them created space in their busy schedules to spend hours showing me their land and describing their businesses. Without their openness and willingness to share their stories, this book would not exist.

Maurice Hinchey, U.S. congressman for the 22nd District, has been a champion of small farms for decades. As one of the few members of Congress who are not bought and paid for by special interests, he has taken courageous stands on difficult issues, including many in the agricultural sphere, throughout his stellar career in government. For more than three decades he has worked diligently for all of us in his district. I am proud to have his contribution to this book.

Enormous thanks are due Mary Norris, whose excellent suggestions during the publication process were greatly appreciated. I am also grateful to Scott Watrous, president of The Globe Pequot Press, for his support.

I would like to thank Realtor Robert Ferris, whose family has farmed in Dutchess County since 1728. Three years ago he suggested I write a book about Hudson River Valley farms, and I promised I would do so!

Lastly, I am grateful to Eric Schlosser, author of *Fast Food Nation*, and Michael Pollan, author of *The Omnivore's Dilemma* and *In Defense of Food*. These three books should be essential reading for all Americans. The ramifications of our eating habits will reverberate for generations to come.

—Joanne Michaels

I wish to express my deep thanks to all of the farmers who opened their doors and their fields to me and my probing camera, always with great generosity and genuine offers to let me see and capture the beauty of their efforts and of their land. Although I had already spent plenty of time on farms, it was inspiring to see the work they are doing and a great learning experience, especially in the context of all of the growing awareness about the nature and origins of our food. I owe a big thank you to Joanne Michaels for asking me to be part of this wonderful project. Mary Norris, our editor at The Globe Pequot Press, was always accessible, cheerful, and positive—a pleasure to work with. Location photography requires a good support system, so I am grateful for the able and steady support of my studio assistants Kari Stewart and Dan Hamilton.

—Rich Pomerantz

ABOUT THE AUTHOR

Joanne Michaels is the author of seven books, including *The Hudson Valley and Catskill Mountains: An Explorer's Guide; Let's Take the Kids: Great Places to Go in New York's Hudson Valley; Hudson River Journey; Adirondack High; and The Joy of Divorce*. She is also the host and producer of *The Joanne Michaels Show*, a regionally syndicated cable television program. In addition, Michaels is president of JMB Publications, a company that has distributed regional books to historic sites and gift shops throughout the Hudson Valley for more than twenty years. The former editor-in-chief of *Hudson Valley* magazine, her byline has appeared in several national magazines. She lives in Woodstock, New York.

ABOUT THE PHOTOGRAPHER

Rich Pomerantz is a freelance photographer whose photographs regularly appear in national and regional lifestyle, travel, and house and garden magazines, as well as in calendars and garden and trade books. He has created assignment photographs for diverse clients from major corporations to individuals and families. *Hudson River Valley Farms* is his third book of photographs, following *Wild Horses of the Dunes* about the famous Chincoteague ponies and the acclaimed *Great Gardens of the Berkshires*. Rich teaches photography at the New York Botanical Gardens in addition to workshops at his studio and other regional venues. Rich works out of his studio and garden in Litchfield County, Connecticut.